Star of Boston
The Life of Mary Baker Eddy

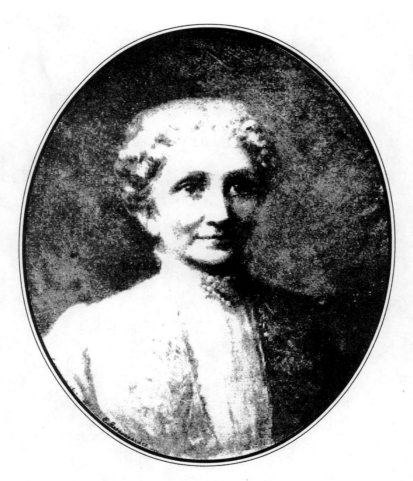

Mary Baker Eddy

Portrait by
Emilie Hergenroeder

Star of Boston

The Life of Mary Baker Eddy

by

Helen M. Wright

OTHER BOOKS BY HELEN M. WRIGHT

Mary Baker Eddy: A New Look
Mary Baker Eddy's Church Manual & Church
 Universal & Triumphant
Mary Baker Eddy: God's Great Scientist, Vol. I
Mary Baker Eddy: God's Great Scientist, Vol. II
Mary Baker Eddy: God's Great Scientist, Vol. III
If Mary Baker Eddy's Manual Were Obeyed
America: Cradle for the Second Coming of the Christ
Mary Baker Eddy Reveals Your Divinity
Humanity's Divinity
Made Whole Through Our Marriage To God
Mary Baker Eddy, Leader Forever (44 page pamphlet)
Mary Baker Eddy, Leader Forever (112 page pamphlet)

NOTE: The author was a personal friend of Gilbert C. Carpenter. There are references throughout this book where she recounts a comment from Mr. Carpenter concerning Mary Baker Eddy or another quote. Such a reference is denoted as "A Carpenter Item."

The following abbreviations are used in this book:
S&H—Science and Health
Mis.—Miscellaneous Writings
Ret.—Retrospection and Instrospection
Pul.—Pulpit and Press
'00, '01, '02—Message for 1900, 1901, 1902
My.—First Church of Christ, Scientist and Miscellany
DCC—Divinity Course and General Collectanea

ISBN: 1-886505-12-8

Copyright ©1998
Helen M. Wright Publishing, Inc.

Printed in the United States of America

Acknowledgments

I am deeply grateful to my staff who have read and criticized this entire manuscript—especially to Elizabeth Zwick for her judicious, intelligent editing, and to David Keyston who was always on hand to encourage and help me over the rough spots and to get this book ready for the printer.

Dedication

This book is dedicated to the
spiritually-minded reader—you.

Star of Boston
The Life of Mary Baker Eddy

Contents

Illustrations

Other than those from Christ & Christmas *in Part III.*

Several pictures are from Lyman P. Powell's, Mary Baker Eddy,
A Life Size Portrait, *while the drawings are from Sibyl Wilbur's,*
The Life of Mary Baker Eddy.

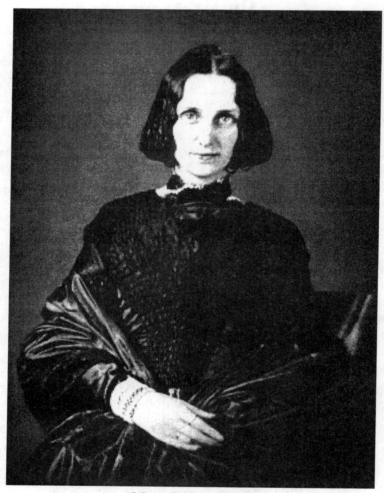

Mary Baker Eddy
This is the earliest known photograph
of her, taken in the early 1850's.

Introduction

During the nineteenth century and the first decade of the twentieth century the foundations of the modern world were laid. Electricity was harnessed; automobiles and airplanes were invented; Einstein formulated the special theory of relativity. But the most significant and least recognized contribution was the mighty, crowning and triumphant discovery of Christian Science by Mary Baker Eddy, a discovery that would fulfill Bible revelation and show us that our own real Mind is God, infinite good.

Mrs. Eddy's work on earth came as divine revelation. This is brought out in her statement to James Henry Wiggin, as reported in *My.* 318:32. Because Mr. Wiggin had helped Mrs. Eddy, editorially, to make clearer to the man in the street some of her statements in Science and Health, she invited him to visit one of her classes. Mr. Wiggin saw things differently from Mrs. Eddy and when she began her attack on agnosticism, Mr. Wiggin could control himself no longer, and burst out with, "How do you know there ever was such a man as Christ Jesus?"

To this Mrs. Eddy made the firm reply, "*I do not find my authority for Christian Science in history, but in revelation. If there had never existed such a person as the Galilean Prophet, it would make no difference to me. I should still know that God's [infinite good's] spiritual ideal is the only real man in His [infinite good's] image and likeness.*"

It was important to Mrs. Eddy that Christian Scientists, as well as the public in general, have a correct concept of who she was as the Discoverer and Founder of Christian Science, the one chosen to fulfill Jesus' promise and prophecy of the "Comforter," who would bring the Second Com-

ing of the Christ, and teach all men their true identity as one with God, having "the kingdom of God within" their own consciousness as their true Mind.

Mrs. Eddy knew what she had done for mankind. To students she one day said, "As Mary Baker Eddy I am the weakest of mortals, but as the Discoverer and Founder of Christian Science, I am the bone and sinew of the world" (Emma C. Shipman Reminiscences).

Knowing this Mrs. Eddy wrote: "For the world to understand me in my true light and life, would do more for our Cause than aught else could. This I learn from the fact that the enemy tries harder to hide these

Mary Baker Eddy leaving on her drive from her home at Pleasant View.

two things from the world than to win any other points. Also Jesus' life and character in their first appearing were treated in like manner. And I regret to see that loyal students are not more awake to this great demand in their measures to meet the enemies' tactics."

2

Part I

Mary Baker Eddy and the Fulfilling of Isaiah 54

The Grand Promise Of Isaiah 54

How did Mary Baker Eddy gain her great revelation of evil's unreality? How did she gain the realization and conviction of our present perfection, in reality? She tells us, "God had been graciously preparing me during many years for the reception of this final revelation..."

Isaiah's prophecy of the Second Coming of the Christ sheds light on this preparation and its significance. Listen to the burning words of Isaiah 54, "Sing, O barren, thou that didst not travail with child: for more are the children of the desolate than the children of the married wife, saith the Lord. Enlarge the place of thy tent, and let them stretch forth the currents of thine habitation: spare not, lengthen thy cords, and strengthen thy stakes. For thou shalt break forth on the right hand and on the left; and thy seed shall inherit the Gentiles, and make the desolate cities [our consciousness] to be inhabited—[to find that the kingdom of God is within us. It is our own real true Mind]."

What is the momentous triumph foreshadowed in these words?

Chapter 53 of Isaiah has long been recognized as a prophecy of the coming of the Christ, in Jesus. The spiritually-minded reader has seen that Isaiah's chapter 54, on the other hand, is a prophecy of the *second* coming of the Christ.

Surely Isaiah speaks of Mary Baker Eddy when he says, "For the Lord hath called thee as a woman forsaken and grieved in spirit....For a small moment have I forsaken thee; but with great mercies will I gather thee." As one follows Mary Baker's life and the suffering she endured, it becomes ever more apparent how true was Isaiah's scriptural prophecy concerning her.

In the following pages we will examine how Isaiah 54 foreshadows the life and work of Mary Baker Eddy and what it promises for us through her revelation.

Isaiah 54 foretells a great event unfolding, an event which can illumine the time of upheaval and transformation we find ourselves in today. Amidst the momentous closing days of the 20th century Isaiah directs our attention to another period of impending change, the beginning and middle of the 19th century in New England, where Mary Baker Eddy was being "graciously prepared" for fulfillment of Isaiah's prophecy. To understand what God, infinite good, was preparing for us through her, let us start by looking at what the stage was like when Mary Baker Eddy entered the scene.

New England in the Nineteenth Century

In New England in the first half of the nineteenth century, a great intellectual upheaval was stirring beneath the surface, preparing for a new spiritual order. There was a spirit of prophecy abroad in the land, the culmination of centuries of religious and intellectual searching.

Even before the Pilgrims had set forth for the New World, two hundred years earlier, their minister, John Robinson, had told them, "The Lord has more truth yet to break forth out of His [infinite good's] holy Word....I beseech you remember, it is an article of your church-covenant, that you be ready to receive whatever truth shall be made known to you."

4

This divine admonition, partially understood, caused the most spiritually-minded to grapple with "things unseen" to mortal vision. It prepared the way for America to become the cradle for the Second Coming of the Christ, though not until Mary Baker Eddy's great revelation broke forth in the latter half of the nineteenth century was John Robinson's prophecy, as well as Isaiah's, fulfilled.

On the other hand, despite this questing spirit, New England in the 1800s was still a land largely under the spell of Jonathan Edwards, who depicted God as a vengeful deity holding sinners over the "pit of hell....worthy of nothing else but to be cast into fire." At this time Christian churches as well as other religions taught that God was a manlike being sitting on a throne. Having read and been taught that God made man is His image and likeness, people assumed that if man is material, then God must be material too, must be a bodily entity like man. Religionists in Mrs. Eddy's childhood had a fiery hell awaiting those who did not believe the "religion" taught them. This strongly held belief would not change until Mary Baker Eddy, in the Second Coming of the Christ, brought the "Comforter" promised by Jesus, revealing God as Love.

However, even in the early 1800s, wherever individual thought was least fettered by materialism, human misconceptions, and church dogma, a deep-felt spiritual perception began to rise to higher freedom. Newborn ideas crowded to the fore in both pulpit and press. It was a time of mighty wrestlings with human beliefs—a time of free thinking.

Isaiah 54 says, "Behold, I have created the smith that bloweth the coals in the fire, and that bringeth forth an instrument for his work." Like the smith of prophecy an atmosphere of freer thought was blowing on the coals of human consciousness, preparing them to understand the spiritual revelation that would soon flow from the mighty spiritual pen of Mary Baker Eddy, the holy instrument that Mind was bringing forth.

Forthright thinkers entertained mounting visions that furthered comprehension of things unseen—the unseen verities of God, things spiritual, unseen to the physical senses, "the reign and rule of universal harmony which cannot be lost or remain forever unseen."

A sturdy faith in the self-reliant individual was dawning and growing. A group of thinkers known as transcendentalists—Ralph Waldo Emerson, Henry David Thoreau, Bronson Alcott, Margaret Fuller and others, emphasized the *goodness* of God, the goodness of man, and limitless possibilities for the human race.

Emerson wrote, "Jesus saw with open eye the mystery of the soul....Alone in all history, Jesus estimated the greatness of man. One man was true to what is in you and me. He saw that God incarnates Himself in man, and evermore goes forth anew to take possession of His World. He [Jesus] said, in this jubilee of sublime emotion, 'I am divine. Through me, God acts; through me, speaks. Would you see God, see me; or see thee, when thou also thinkest as I now think.'"

Emerson had glimpsed the fact Mary Baker Eddy would make so clear, that how we *think* is all important. Emerson's words would help prepare people to receive her instruction, "Hold thought steadfastly to the enduring, the good, and the true, and you will bring these into your experience proportionately to their occupancy of your thought" (S&H 261:4).

The consequences of not following this advice can be disastrous. Buddha tells a poignant story of a young father who made this mistake, with tragic results,

"A young widower, who loved his five-year-old son very much, was away on business when bandits burned down the entire village and took his son away. When the widower returned and saw the ruins, he panicked. He took the charred corpse of an infant to be his own child. He cried uncontrollably, pulling his hair and beating his chest.

He organized a cremation ceremony, and collected the ashes and put them in a beautiful velvet pouch. Working, sleeping, or eating he always carried the bag of ashes with him, and every night he would weep anew over his loss.

"One day his real son escaped from the robbers and found his way home. He arrived at his father's new cottage at midnight, and knocked at the door....The young father, who was still carrying the bag of ashes, asked, 'Who is there?' The child answered, 'It's me, Papa. Open the door. It's your son.' In his agitated state of mind, the father thought some mischievous boy was making fun of him. He shouted at the child to go away; and he continued to cry for his lost child. The boy knocked again and again, but the father refused to let him in. Some time passed and finally the child left. From that time on, father and son never saw each other."

Buddha concluded, "Sometimes, somewhere, you take something [wrong] to be the truth, and if you cling to it, then when the real truth comes and knocks at your door, you will refuse to open it."

This seems to be the case with nearly all of us. How few accepted the truth Jesus taught, even though Jesus demonstrated the allness of infinite good! The people of his time clung to their preconceived notions. The same was to happen with Mary Baker Eddy in the *Second* Coming of the Christ.

"Who can set boundaries for the possibilities of man?"—since man is one with God, with our real Mind.

We ourselves set man's boundaries with the limits we place on our own thought.

Literature in the Early New England Time

It is possible that no one would have been prepared to respond to Mary Baker Eddy's revelation, had not literature during this early New England period been blessed

with wholesome vigor and common sense. Bronson Alcott, another of the pioneers of the time, wrote in his *Journal*, "I read not the gospel of wisdom from books written by man, but from the page inscribed by the finger of God."

Theodore Parker in his eloquent sermon "The Transient and the Permanent in Christianity," fired with the new American spirit of revolt, challenged the most sacrosanct doctrines of historic Christianity. He questioned the authenticity and inspiration of the Bible itself, and declared heretically "...it is not so much by the Christ who lived so blameless and beautiful eighteen centuries ago that we are saved directly, but by the Christ we form in our hearts and live out in our lives that we save ourselves, God [infinite good] working with us both to will and to do." This truly great sermon resulted in Parker's virtual ostracism by his more respectable townsmen, but it reflected infinite wisdom and fueled the flame of expanding understanding.

Parker concluded, "Let the transient pass, fleet as it will, and may God send us some new manifestation of the Christian faith, that shall stir men's heart as they were never stirred; some new word which shall teach us *what we are* in the image of God....give us the Comforter, who shall reveal all needed things!..." Little did this great preacher realize how soon the "Comforter," the Second Coming of the Christ, would arrive and fulfill Jesus' prophecy of the "Comforter" that would "abide with you forever....and teach you all things, and bring all things to your remembrance, whatsoever I have said unto you" (John 16:16 & 26).

New England Was Thinking For Itself

The leading idea of the thinkers of this time was the supremacy of mind over matter. In the words of Bronson Alcott, "the exaltation of mind and spirit runs through the period like a theme with endless variations." Even Abraham Lincoln, remote from Boston geographically, and

from Alcott intellectually, wrote, in the spirit of the times, "Happy day when—all appetites controlled, all passions subdued, all matter subjected—mind, all conquering mind, shall live and move, the monarch of the world."

New England was thinking for itself; and from these broader horizons and rarefied thought there was no returning. The time had arrived for the fulfilling of Isaiah 54, with the advent of Mary Baker Eddy, the Second Coming of the Christ, the "Comforter" prophesied and promised by Jesus, just as nineteen centuries earlier the time had come for the fulfilling of Isaiah 53, which prophesied the work of Christ Jesus on earth.

This was the atmosphere into which the infinite good we call God placed its Christ-minded holy instrument, Mary Baker Eddy. She thought in a time of mental prodigies; she wrote in an age of literary masters.

The spiritual eye quickly notes Mary Baker Eddy separated herself from the transcendental writings not only by her more radical attitude toward the material world, but also by a spiritual dominion that was lacking in idealists of the utopian breed.

Mrs. Eddy wrote, "Science lays the axe at the root of error, and cutting down the belief of Life in matter, of Soul in body, and God in man, exchanges fable for fact, turns thought into new channels away from personality to Principle through which alone man is able to reach Life."

This denial of corporeal personality—denial of the finite mortal sense of things—meant taking up the cross, taking it up in a practical and real sense.

Mary Baker Eddy was called "as a woman forsaken," as Isaiah had predicted. "For a small moment have I forsaken thee; but with great mercies will I gather thee," the prophecy promised.

At the beginning Mary Baker Eddy was rejected and had little influence, but today the revelations of Truth that came to her consciousness a century and a quarter ago are

sweeping the world in an ever-swelling tide. Everywhere science, theology, and medicine are being influenced by Mary Baker Eddy's teaching and are adopting more spiritual ways. Helping this tide are intelligent, spiritually-minded thinkers who are today broadcasting in their writings ideas Mary Baker Eddy wrote and taught 120 years ago, though these writers seldom mention Christian Science or give Mary Baker Eddy credit.

If this reminds us of St. John's complaint to Jesus, "We saw one casting out devils in thy name, and he followeth not us: and we forbad him, because he followeth not us," we can take heart in Jesus' response, "Forbid him not: for there is no man which shall do a miracle in my name, that can lightly speak evil of me. For he that is not against us is on our part" (Mark 9:38-40).

We can be even more heartened that some of the best minds of our century have not hesitated to give credit where due. The great physical scientist, Albert Einstein, had a firm grasp of what Mary Baker Eddy had accomplished and publicly acknowledged it. One such instance is recorded in an affidavit made by Mrs. Mary Spaulding, librarian for New York City's Fifth Church Reading Room and wife of the famous violinist, Alfred Spaulding. Einstein was a frequent visitor to this Christian Science Reading room and often had conversation with Mrs. Spaulding. On this occasion Einstein said—and these are the exact words of the statement of Mrs. Spaulding's affidavit:

"Science and Health is beyond this generation's understanding. It contains the pure science. And to think that a woman knew this over eighty years ago."

Einstein marveled that a woman a hundred years ago had discovered the nothingness of matter, which the advanced physicists of today have seen for themselves; in Einstein's words, "Matter as matter does not exist."

Until Mary Baker Eddy brought the Second Coming of the Christ, and fulfilled Jesus' promise and prophecy of

the "Comforter," psychologists, doctors, physical scientists believed and accepted the Adam dream state of thinking that matter was real. Now all are beginning to glimpse the truth, that matter is merely an illusion, hypnotic suggestion only. All are coming to see that consciousness, Mind, is all that is real, eternally.

The importance and influence of Mary Baker Eddy's revelation is incalculable. Not long ago the Dean of Medicine at the University Medical School in Rochester, New York, told his class of medical students that between 1920 and 1940 a revolution occurred in medicine, because of the "many wonderful Christian Science healings" that doctors, surgeons, and nurses had observed. He said this viewing caused the medical profession to try to "clean itself up." Doctors began telling patients to think positive thoughts, to avoid negative thoughts, and to "cast out fear."

As early as 1930 the world famous Mayo brothers, Dr. William James Mayo and Dr. Charles Horace Mayo, let the world know that they sent their "incurable" patients to Christian Science practitioners, and *they were healed*.

The Dean said that since 1940 several attempts have been made to "bring medicine more into line with the spiritual approach." This has been a major step forward for medicine. Spiritually-minded doctors are continuing to awaken. Dr. Larry Dossey, author of *Healing Words*, says, "Any time any technique affects the human body, it is the business of medicine to know more about it. I would defend this as a legitimate research project...If doctors don't open up this possibility they're not being good scientists. I think we need to get over our religious indisposition on this point of view."

Today a college professor may lay his hand on a desk, saying, "This feels solid, looks real, but it is not here other than in our consciousness." A famous early 20th century astronomer who discovered great sighting places, places where major observatories could be built, would be de-

11

lighted with the wonderful progress in astronomy, and flights into outer space, but he would be amazed at the advance in understanding. The great astronomers today are saying, as Einstein saw, that the stars are not "up there," but are only in our consciousness.

Do We Know What We Have in These Books?

Ruth Steiger, a friend of this author, told me that she was one day told by the librarian of another church in New York City which Einstein frequented, "I wish you had been here sooner. Einstein just left. He stopped at the counter before leaving and said, "I wonder if you folks realize what you have in these books."

Do *we* know what we have in these books? Are we working to bring it out? In her *Message for 1901*, page 30: 4, Mrs. Eddy wrote, "We err in thinking the object of vital Christianity is only the bequeathing of itself to the coming centuries. The successive utterances of reformers are essential to its propagation....and the consciousness which is most imbued struggles to articulate itself."

These "successive utterances of reformers" are not limited to Christian Scientists. Today the world's foremost physical scientists are joining Einstein in seeing and struggling to articulate the truth Mary Baker Eddy uncovered a hundred and twenty years ago, namely, that there is no matter; all is consciousness—"all is infinite Mind and its infinite manifestation" (S&H 468:10).

In his prophecy of the Second Coming of the Christ, as already quoted, Isaiah, (chapter 54) urges, "Enlarge the place of thy tent, and let them stretch forth the currents of thine habitation: spare not, lengthen thy cords, and strengthen thy stakes. For thou shalt break forth on the right hand and on the left." Truly the revelation Mary Baker Eddy brought mankind is breaking forth to bless humanity on every hand.

12

A Sense of Mission

The greatest upheaval in the history of mankind is to-day taking place. Why? Because of the advent of Mary Baker Eddy who brought the Second Coming of the Christ, which shows you that "you have sovereign power to think and act rightly." Why do you, in reality, have this power? Because, as Jesus taught, "the kingdom of God is within you;" it is your real, true Mind, your true consciousness.

In the April *Christian Science Journal*, 1889, page 4, we find Joshua Bailey's article, saying "Today Truth has come through the person of a New England girl, born of God-fearing parents, in the middle walk of life;...gifted with the fullness of spiritual life, and giving from the cradle indications of a divine mission and power, that caused her mother 'to ponder them in her heart.'"

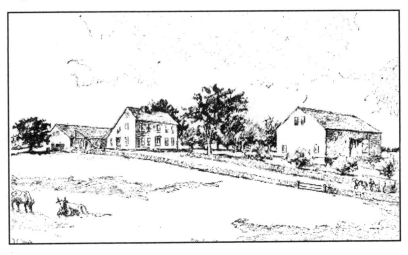

Mary Baker Eddy's childhood home in Bow, N.H.

Mary Baker Eddy was born in New England, in the year 1821, on the 16th day of July. Her destiny was to fulfill Jesus' promise and prophecy to send the "Comforter" which would transform the world's thinking. It would

show mankind's spiritual reality—show it to be the omnipresence of present perfection. Today the "Comforter" is educating mankind that evil is unreal, that it is only illusion, hypnotic suggestion. Mary Baker Eddy's teaching is leading humanity into all truth, awakening all humanity to their oneness with infinite good, to their present perfection, and the full understanding that "the kingdom of God is within you"—is your real Mind.

Early in 1821, Abigail Baker—in a modest farmhouse, in the small town of Bow, New Hampshire—was in the attic gathering wool to spin into yarn. "Suddenly she was overwhelmed by the thought that she was filled with the Holy Ghost, and had dominion over the whole earth. At that moment she felt the quickening of the babe. Instantly she thought, 'What a sin I am guilty of—the sin of presumption!'" (*Golden Memories*, Clara S. Shannon, p.2)

Try as Abigail might she could not shake the sense of holy import. Shocked by her own thoughts of her child's spiritual purpose Mary's mother confided to her friend Sarah Gault, "I don't know what I shall do to stop this blasphemy," whereupon Sarah reminded her of Biblical promises that comforted Abigail.

It would be some months before little Mary would make her appearance, a child who would indeed show divine tendencies. As this child grew, no doubt Abigail Baker had much to "ponder...in her heart," for the girl early showed abilities of healing and discernment. Mrs. Eddy, writing to a friend in 1899, said, "I can discern in the human mind, thoughts, motives and purposes;...it is the gift of God. And this phenomenon appeared in my childhood; it is associated with my earliest memories, and has increased with years." (Quoted in a pamphlet by Judge Septimus J. Hanna, 1899.)

Mrs. Eddy later added, "It is a consciousness wherewith good is done and no evil can be done...and has increased with my spiritual increase. It has aided me in healing the sick, and subordinating the human to the divine."

14

The simple but profound incidents of healing in Mary's youth occurred in her home, in the schoolyard, and among relatives, as well as animals. Her healings were the result of her outpouring of love for those who needed love most. Mary loved the farm animals and, as she told Irving Tomlinson, she nursed baby lambs and chicks, singing hymns to animals that were in discomfort.

This healing love caused her father, if he found a weakling in the flock, to say, "Here is another invalid for Mary." Tomlinson relates that then Mary would tenderly take her mild-eyed charge and nurse the fleecy little patient to health and strength. Mrs. Eddy said, "I would take the little chicks, that seemed sickly or perhaps dying, into the bosom of my dress and hold them until I heard a fluttering sound and found the chicken active and strong...."

When Mary's brother, George, cut his leg with an ax and was bleeding badly, Mary's father had five-year-old Mary put her hand on the wound, and George stopped crying. When the doctor came he said he had never seen such a wound heal so quickly. These healings by little Mary disturbed her father. He did not know it was the God that was Love that Mary believed in. So he "prayed for her soul."

Tomlinson reports that in school Mary also healed and transformed those who showed bad tendencies. "Many peculiar circumstances and events connected with my childhood throng the chambers of memory," Mrs. Eddy recalled. In one instance she tells of hearing her name called repeatedly, until she answered, "'Speak, Lord; for Thy servant heareth.'"

Mary was learning that divine service means daily deeds in service to a loving God, as she would later make clear in Science and Health.

Early on, a sense of mission lodged in Mary's consciousness. Even as a tiny child, when asked, "What are you going to do when you grow up," she would answer, "I will 'ite a book" (*The Life of Mary Baker Eddy*, Sibyl Wilbur).

At the age of nine Mary told her beloved brother, Albert, that she wanted to be a scholar, "because when I grow up I shall write a book."

In *Retrospection and Introspection* Mrs. Eddy tells us, "From my very childhood I was impelled by a hunger and thirst after divine things—a desire for something higher and better than matter, and apart from it,—to seek diligently for the knowledge of God [infinite good] as the one great and ever-present relief from human woe." Mary's faithfulness was a pilgrimage in spiritual perception. When she discovered that Daniel prayed three times daily, she formed the habit of doing likewise.

Why did Mary Baker later find the element of spiritual healing?

She found it because "she sought for it as men quest for buried treasure."

"Thou Shalt Not Be Put to Shame"

Isaiah 54 promises, "Fear not; for thou shalt not be ashamed: neither be thou confounded; for thou shalt not be put to shame." How true these words ring. Though quiet and modest in her own right, Mary Baker was fearless and forthright in the service of Truth.

Never in her long life would Mary be content to settle for mere opinions. Her opinions soon climbed up into convictions. Quick to catch the point, she never remained long the uncommitted spectator cautiously and objectively weighing evidence. She soon became the passionate and prophetic proponent of profound conviction. No grays crept into the warp and woof of her mentality. The scarlet thread of spiritual conviction ran conspicuously and untiringly through all the thinking of the fourscore years and ten of her extraordinary life.

Mary's steadfastness was evident from childhood. Then, as later, she would not turn aside from what she knew

to be true even when standing firm brought the world's wrath down upon her.

For Mark Baker, Mary's father, as well as for many New Englanders in the early 1820s and beyond, *new ideas were heresy*. Mary had been gently learning, through experience, that God is ever-present Love, but the theology of her parents was trying to teach her something quite different, as they tried to win their daughter from dreaded "heresy."

Mary Baker yearned for the tender, loving God that is divine Love, and experiences in her early life affirmed to her that God is Love. But Mary had been born into the world of Calvinism where thoughts of God as Love were considered almost profane. When Mark Baker discovered that Mary was rejecting the belief of everlasting punishment, he was greatly displeased. Not only did he fear her soul would be lost, but, being a man of some importance in the church, his pride was wounded. Mark Baker's thundering assertions upset the entire household.

By nature and upbringing Mary was an obedient child, but she could not alter her convictions that God was a God of Love. Her father's relentless theology emphasizing belief in everlasting punishment made Mary sick, and as Mark continued storming, Mary became seriously ill.

Finally her mother told her to rest in God's Love. Mary prayed, and as she did her happiness returned, the fever abated and she felt borne up by an inner joy. She tells us that as she went to God in prayer, seeking God's guidance, "a soft glow of ineffable joy came over me. The fever was gone, and I rose and dressed myself, in a normal condition of health....The physician marveled; and the 'horrible decree' of predestination—as Calvin rightly called his own tenet—forever lost its power over me" (*Ret.* pp.13-14).

Mary Baker had been healed instantly, to the physician's great surprise. At that time she, of course, did not know or question why, but years later she determined, "I must know the Science of this healing."

17

The illness and recovery strengthened Mary's conviction of the absoluteness of God's Love. When an all-important church meeting came, and it was Mary's turn to go forward, she tells us she was ready for the minister's doleful questions. She told him she was willing to trust God, but she could not believe in the doctrine of everlasting punishment or the decree of unconditional election. The minister was startled. Mary's father, Mark, sat stiffly, his face set and scowling. Abigail, Mary's mother, was alert, straining to hear. Mary's trust in God was evident.

Next, the minister asked when Mary had experienced "a change of heart." Mary was by now in tears. She said she could not give a specific date. The minister wanted to know how she felt when the new light dawned within. Mary paused, then replied that she could only repeat what the Psalmist had declared, "Search me, O God, and know my heart; try me and know my

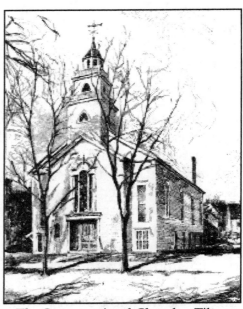

The Congregational Church—Tilton

thoughts and see if there be any wicked way in me, and lead me in the way everlasting."

Mary spoke these words with such pure conviction that many of the church members wept. This was not to be the last time that her most deeply felt convictions held firm in the face of great pressure to conform.

Though only twelve years of age Mary Baker was already fulfilling the scriptural prophecy of Isaiah 54, "Fear

not; for thou shalt not be ashamed: neither be thou con-
founded; for *thou shalt not be put to shame.*"

"A Woman Forsaken and Grieved in Spirit"

Isaiah 54 promises, "thou shalt forget the shame of thy
youth, and shalt not remember the reproach of thy widow-
hood any more."

Ever more, as Mary Baker's life unfolded, would these
words fit her experience. One meaning of "widow" in
Webster is "to deprive of something greatly loved or
needed; make desolate." Before Mary Baker discovered
Christian Science in 1866, she was indeed a *"widow,"* for
she was deprived of the deep understanding of the Christ
Science that would heal and bless. This widowhood would
be reflected over and over in the circumstances of her life
until it drove her to the full and final revelation of Truth.

In 1843 Mary Baker married George Washington
Glover—a marriage destined for early widowhood, des-
tined to last less than a year. At George Glover's death,
Mary freed his slaves, a daring thing to do in those days.
Under the loving care of her husband's Masonic friends,
she was escorted to New York where her brother George
was waiting to greet her.

In August Mary was once again under the Baker roof.
In September her son, George Washington Glover, II, was
born. For Mary, always in frail health, this was a fearful
ordeal. Her family despaired of her life; and from then on
until Mary Baker Glover discovered Christian Science, she
was an invalid.

Painful as it seemed at this time, her marriage and
early widowhood, far from being a retracing of footsteps,
was a move toward a goal. No human marriage could
stand in the way of the destiny prophesied in Isaiah 54,
"For thy Maker is thine husband; the Lord of hosts is his
name; and thy Redeemer the Holy One of Israel; The

God of the whole earth shall he be called."

The words of Isaiah would be fulfilled to the letter, "For the Lord hath called thee as a woman forsaken and grieved in spirit, and a wife of youth, when thou wast refused, saith thy God. For a small moment have I forsaken thee; [this seemed true; for the next few score years were to be years of great suffering both mentally and physically]; but with great mercies will I gather thee. In a little wrath I hid my face from thee for a moment [how true this seemed from the human mortal standpoint]. But with everlasting kindness will I have mercy on thee, saith the Lord thy Redeemer."

Mary's path was to lead upward despite devious windings until new peaks of thought were to come into view, pointing the path of discovery in the years that lay ahead.

Mary Glover's illness made it impossible for her to take care of little George, so he was farmed out to the care of others. After Mary's mother, Abigail, died, and Mary's father, Mark Baker, took a second wife, Mary was no longer welcome in her childhood home. She moved in with her sister, Abigail Tilton, who was five years older. This was not a happy arrangement. When Mary voiced opinions conflicting with those of her sister, Abigail would protest, "Mary, do you dare to say that in my house?" Mary's decisive reply was, "I dare to speak what I believe, in any house." This daring to speak what she believed fitted her to fulfill Isaiah's prophecy concerning her.

These were sad days for Mary Glover. She was separated from and yearning for her child. It was humiliating to live as a dependent in the Tilton home where controversy and even acrimony often invaded the atmosphere.

But *hope* came to sustain Mary through months of helplessness; *patience* came to endure the times of dependence; *courage* came for the coming years. Mary's Christian qualities overcame the human weakness, and she went forward in her pursuit of true healing—healing of heart and mind as well as of body.

20

Then a way seemed to open for Mary out of her difficulties. Ill as she continued to be, Mary had remained always gracious, and beautiful in appearance, and her name had been coupled with more than one suitor for her hand. Now Dr. Patterson (a doctor of dentistry), a cousin of Mary's stepmother, assured Mary he would give a home to George, her son, with whom she yearned to be reunited. Mary accepted Patterson's proposal. Unfortunately, she was to find herself sadly deceived.

Looking back in 1891, across the years, to the decision she made in 1853 and its painfully disappointing consequences, she would write, "My dominant thought in marrying again was to get back my child, but after our marriage his stepfather was not willing he should have a home with me."

What a terrible disappointment and sorrow this must have been to the grieving mother! Without her son, the years of being wife to Dr. Patterson would prove as drab as any years could be for a woman always vibrant in mind, but trapped in a suffering body.

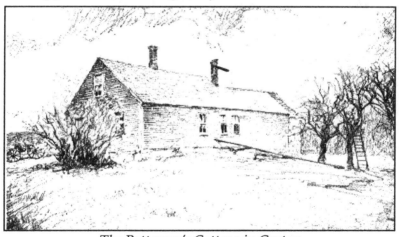

The Patterson's Cottage in Groton

After two years the Pattersons moved to North Groton. The new home was a lonely spot for Mary. Woods and mountains hemmed in her home, and deep discouragement seemed to bear down upon her spirit and block every ef-

fort to recover. For a short period little George was allowed to come and visit his invalid mother, but soon the boy was taken to Minnesota and told that his mother was dead. They were not to meet again for many years.

If Mary Patterson could have known of Isaiah's prophecy concerning her mission, surely it would have been a great comfort at this time. Isaiah prophesied, "I have sworn that the waters of Noah should no more go over the earth; so have I sworn that I would not be wroth with thee, nor rebuke thee. For the mountains shall depart, and the hills be removed; but my kindness shall not depart from thee, neither shall the covenant of my peace be removed, saith the Lord that hath mercy on thee."

This yearning mother, deprived of the affection of her only child, was later to be called "Mother," and be loved by the millions whose *SPIRITUAL BIRTH* would spring from her revelation of Truth. They would learn from her remarkable book, Science and Health, that human life must be redeemed, not ignored, that faith must be proved by works, that an acceptance of Spirit, divine understanding, as the Life of man, can begin at once to banish from experience the grosser forms of illusion, including all the ills that flesh is heir to.

Her book would explain the healings of Jesus as natural manifestations of his divine consciousness of reality, and declare that the same truth he knew could produce the same results today in the healing of physical disease, as well as in the regeneration and reformation of character. Readers would find in Science and Health a power that would move them deeply. They would see in it the fulfillment of Jesus' promise and prophecy of the "Comforter,"—the Second Coming of the Christ.

In Search of Healing

"O thou afflicted, tossed with tempest, and not comforted." To this "afflicted" one, who would fulfill Jesus'

prophecy of the "Comforter," and bring the Second Coming of the Christ, Isaiah promises, "Behold, I will lay thy stones with fair colours, and lay thy foundations with sapphires. And I will make thy windows of agates, and thy gates of carbuncles, and all thy borders of pleasant stones [which stand for sacred, deep, and beautiful spiritual thoughts and ideas]. And all thy children [those who follow the teachings of the Second Coming of the Christ] shall be taught of the Lord....In righteousness shalt thou be established: thou shalt be far from oppression; for thou shalt not fear: and from terror; for it shall not come near thee."

What a comfort it would have been to Mary Glover Patterson, as she read these words, to have known they were a prophecy of what lay ahead as her own life work. Suffering greatly and confined to her bed, she was left much alone. In solitude, separated from all human solace, she pursued her lonely effort to break the fetters of disease. But in this very suffering and solitude, infinite good was laying a foundation of "pleasant stones" with "fair colours," for proportionately as Mary weaned herself from human dependence, came the necessity for leaning on the divine, and the more she leaned—the more she turned to her Bible for help—the more she felt the support of the everlasting arms.

Mary Baker had been adhering perhaps since a teenager to certain dietetic theories, and in her twenties she had studied textbooks on homeopathy. For her to discover Christian Science her thought would have to be far removed from material methods as having anything to do with the healing process. More and more, now, she lifted her thought to God, until lifting her thought to God became more natural to Mary than walking.

It was while she was an invalid in North Groton that Mary made a solemn "promise to God that if He restored her health, she would devote her future years to helping

23

sick and suffering humanity." (*The Discovery of the Science of Man*, Doris Grekel, p.43)

As she looked back on this promise years later, Mrs. Eddy felt it marked the beginning of a new period in her life. It was during this period that an incident occurred which kept alive the hope of finding divine healing and gave her the opportunity to begin her fulfillment of that sacred vow.

A mother brought a baby with inflamed eyes to Mary Patterson and asked her to implore God to heal her child. Mary's heart was filled with compassion as she lifted her thought to God. As she recalls the event, "Mrs. Smith, of Rumney, N.H., came to me with her infant whose eyes were diseased, a mass of inflammation, neither pupil nor iris discernible. I gave the infant no drugs,—held her in my arms a few moments while lifting my thought to God. Then returned the babe to her mother, healed."(*Footprints Fadeless*, Mary Baker Eddy, p.6)

The child's sight was restored. This wonderful healing was enough to overpower discouragement, and renew endeavor.

Outwardly, however, little change was evident in Mary Patterson's life. In 1860 the Pattersons moved to near-by Rumney. The next year, 1861, war broke out between the North and South. The main issue was the immorality of slavery. For Mary Patterson slavery also meant a material body bound in the chains of chronic illness, under the lash of pain. But the weapons of her warfare were not carnal, but mighty through God to the pulling down of strongholds. (See II Cor. 10:4.)

The Civil War continued raging. In the West, Mary's son George had enlisted and would serve throughout the war. While in the army he heard of his mother's whereabouts and wrote to her. Imagine the depths of emotion that must have stirred within this lonely mother in the New Hampshire hills when George's letter reached her! But not

24

until George Glover was thirty-four years old and had a wife and two children was the letter followed by a visit to his mother.

Meanwhile, another tragedy struck. Dr. Patterson, aiding the Union effort, was captured by the enemy, and held prisoner in the South.

For Mary at this time, neither the things that had been, nor the things that were, held any promise for the future, but the hope of something spiritual, something vital, remained paramount in her consciousness.

"As early as 1862 Mary began to write down and give to friends the results of her Scriptural study, for the Bible was her sole teacher" (S&H viii: 28). These early glimmerings were like "the first steps of a child in the newly discovered world of Spirit" (ibid).

Time would tell that Mary's *heritage* was greater than any land or human ancestry could bestow—that infinite good had claimed her as its own and was doing its will with her. It would show that *her history is a holy one*, found in her inspired writings and their continuous healing and redemption of humanity. But the accomplishment of this prophecy was still hidden in the future, awaiting the complete fulfillment of Isaiah 54.

Phineas Parkhurst Quimby

Before Daniel Patterson had left for the South in the civil war, he had answered a circular received from a doctor in Portland, Maine, a Dr. Phineas Parkhurst Quimby, who gave no medicine but cured patients by talking to them. The Pattersons had heard that Dr. Quimby performed remarkable cures through his drugless method. When Dr. Patterson had written to him, seeking his help for Mary, Mr. Quimby had replied that he was sure he could cure Mrs. Patterson.

An unlettered man, a clockmaker by trade, Quimby

had been giving public exhibitions of mesmerism for several years. He was not a spiritualist or a religionist, but after discovering that he could help the sick, he forsook the trickery of the platform for a generous and earnest endeavor to benefit the suffering. He sought humanly to control the thoughts of those who came to him for help, a method we today call mesmerism and hypnotism, or control by the *human* mind. Quimby passed on in January of 1866. He would not have been known to posterity had it not been for his brief association with Mrs. Patterson as his patient.

In 1859 Mary Patterson had made the solemn promise to God, infinite good, that if He, infinite good, raised her up to health she would devote her life to the healing of mankind.

Since childhood Mary had cherished the scriptural promise, "And these signs shall follow them that believe; ...they shall lay hands on the sick, and they shall recover." These words rang true to Mary, for, as we have seen, many incidents of a spiritual nature had illumined her childhood and young adulthood. She remembered how, as a child, she had heard her name being called again and again until her saintly mother had told her to answer in the words of Samuel, "Speak, Lord; for thy servant heareth."

Mary had never forgotten that when she had turned to God for help, long ago, her childhood fever had yielded. She recalled other healings as well, as when an insane man at her school had become harmless as Mary spoke to him. Only recently the blind baby had received sight.

With experiences such as these in thought Mary Patterson studied the accounts of spiritual healing in the Bible, earnestly convinced that spiritual healing was still possible. Thus it was that while Dr. Patterson was gone, Mary journeyed to Portland, Maine, full of hope and expectation, to be treated by Dr. Quimby in October of 1862. Quimby dipped his hands in water and rubbed her head vigorously after explaining the psychological origin of her illness.

Mrs. Eddy later recalled that she found temporary relief from suffering after her first visit with Mr. Quimby. She told Tomlinson, "At first my case improved wonderfully under his treatment." With her deep faith in God she felt this improvement must be of God. She could not conceive of any other source that could have such a remarkable effect on her.

But she must know *HOW* the healing was done. Mary did not realize that Dr. Quimby was a mesmerist and not at all inclined toward religion.

We can see that this period could be regarded as the most dangerous part of Mary's search. Why? Because coupled with her respite from unceasing pain, was the false impression that she had reached her journey's end. Perhaps what saved her was her high expectations. She thought of Mr. Quimby's practice as a mode of divine healing. She did not accept the premise that Quimby's human mind (alias mesmerism), however well intentioned, could have healed her.

Nor could she believe that the human mind could help her to heal others, as she was continuing to do. Indeed, while Mrs. Patterson was making her visits to Dr. Quimby, she healed patients that he had given up, including one patient, Mary Ann Jarvis, whom she healed of consumption, as related in Science and Health, p. 184:27.

Because of Mary's own great spirituality she felt instinctively that any power that could truly help her must come from God. She sought its Science in her talks with Quimby. In his notes she found nothing beyond personal mesmerism; strive as she would, she could not find the light she sought, because it was not there.

Mary Patterson had to search further. But infinite good was leading. Though she had no hint that the attainment of her heart's desire lay only two years ahead, the urge of her search persisted stronger than ever. Her uncovering of mesmerism, hypnotism, and mortal mind illusion, and her

teaching concerning it, would soon be delivering millions from false beliefs.

The Dropsy Cure

It was about this time that Dr. Patterson escaped from his captors in the South and rejoined his wife. After her husband's return, Mary continued to prescribe remedies for herself and others. The desire to heal had drawn her to allopathy and homeopathy, which she had been studying for some years. Now infinite good needed to point Mary away from all material remedies.

One very special case was destined to influence her thinking greatly. (See S&H p. 156.) It concerned a woman with dropsy, whose physicians had given the case up. Mary took the case and prescribed according to her understanding of homeopathy. There was soon noticeable improvement. Mary became concerned about overdoing the remedy; but the patient would not give up the remedy that had brought her relief. Without telling the patient, Mary administered unmedicated pills. The improvement continued, and the patient was cured.

Many years later Mrs. Eddy spoke of that cure as "...a falling apple to me—it made plain to me that mind governed the whole question of her recovery. I was always praying to be kept from sin, and I waited and prayed for God to direct me."

Recalling this event to Irving Tomlinson Mrs. Eddy again described it as the falling apple. She said it had been the "enlightenment of the human understanding" and contrasted this with her later discovery of Christian Science in 1866 which came as "the revelation of the divine Mind."

Why was this case important to Mary? Because first, the same remedy that had been powerless when administered by the doctor, became powerful when she prescribed and administered it. Second, the unmedicated pills were

28

as effective as the medicated ones. Mrs. Eddy (then Mrs. Patterson) saw that both the thought of the physician and the thought of the patient were the determining factors in the case; matter was not a factor.

Later, after her discovery of Christian Science, Mrs. Eddy would write that "the physician must know himself and understand the mental state of his patient....'Cast the beam out of thine own eye.' Learn what in thine own mentality is unlike 'the anointed,' and cast it out; then thou wilt discern the error in thy patient's mind that makes his body sick, and remove it...." (*Mis.* 355).

The Second Coming of The Christ

Christ Jesus said that greater works than he had done would be done. It would be Mary Baker Eddy who would do the greater work. Why? She was the final and inevitable rung in the ladder lifting us from earth to heaven.

We read in Hebrews VII, verse 3, that Melchisedec, who was "like unto the Son of God," came "without father, without mother, without descent, having neither beginning of days, nor end of life; but made like unto the Son of God; abideth a priest continually."

Notice that Melchisedec had no earthly father or mother. He had no belief of material origin to hinder him, no birth and therefore no death.

Next came Jesus, who had an earthly mother. In Hebrews VII:15 we read, "...after the similitude of Melchisedec there ariseth another priest who is made, not after the law of a carnal commandment, but after the power of an endless life." This was Jesus the Christ, who was made "a priest forever after the order of Melchisedec." Of Jesus, Mrs. Eddy writes, "He expressed the highest type of divinity, which a fleshly form could express in that age" (S&H 332:29). Notice that he had ONE human parent, a mother. "He was appointed...to appear to mortals in such

a form of humanity as they could understand as well as perceive." It is important here to see that he had only *one* human parent.

Nearly two thousand years elapsed until the Second Coming of the Christ came with the writings of our Leader, Mary Baker Eddy, and with it, the fulfilling of Jesus' promise and prophecy of the "Comforter" that "shall teach you all things," and "abide with you forever" (John 14). The greatness that we need to note here is that though Mary Baker Eddy was saddled with the belief of having both a human father and a human mother, she was able through her Christ Mind to fulfill scriptural prophecy concerning her and bring the promised "Comforter" that would teach us all things, spiritually.

This second appearing in the flesh of the Christ Truth, "hidden in sacred secrecy from the visible world" (S&H 118:7) would fulfill Jeremiah's prophecy, *the Lord hath created a new thing in the earth, a woman shall compass a man.*" Mary Baker Eddy's great revelation of the omnipresence of present perfection would compass (include) the teaching of Christ Jesus.

Mary Baker Eddy would prove that each one of us, though born of human parents, can lay off *"the first death," human birth*, and the fleshly beliefs about ourselves—can lay off the Adam dream that makes us think we live in a matter body. And as we "exchange the pleasures and pains of sense for the joys of Soul," we are using our infinite harmonious Christ-expressing selfhood. What a great revelation! "Step by step since time began we see the steady gain of man."

Think of it, dear reader! Mary Baker Eddy was, to human sense, wholly material, being born of *two* parents in belief—unlike like Melchisedec who appeared "without father, without mother" and unlike Jesus who was born of a Virgin. Yet Mary Baker Eddy, in the Second Coming of the Christ, had the enormous task of teaching all mankind how to overcome all error as Jesus had done.

30

Through her writings we can learn "the truth that will make [us] free"—learn to have dominion over all sin, disease and death. It is now just a matter of obeying the written word, practicing what we read in Mary Baker Eddy's writings.

In 1864 the Great Revelation Still Lay Ahead

In 1864 Mary Baker Eddy's great revelation lay just around the corner, but Mary's path to it still lay through suffering. At the end of the Civil War the Pattersons were reunited, living in Lynn, Massachusetts, but Mary Patterson seemed to have emerged from one disappointment only to endure another. Dr. Patterson became unfaithful, a cruel blow. His final unfaithfulness and desertion would take place two years later when he was again unfaithful and this unfortunate marriage would end in divorce.

Years later Mary Baker Eddy was to write,

"Note this,—that the very message or swift winged thought, which poured forth hatred and torment, brought also the experience which at last lifted the seer to behold the great city [true consciousness] the four equal sides of which were heaven-bestowed and heaven-bestowing.

"Think of this, dear reader, for it will lift the sackcloth from your eyes, and you will behold the soft-winged dove descending upon you" (S&H 574:19).

A few years down this long painful road, Mary Baker Eddy would write, "*The very circumstance* which your suffering sense deems wrathful and afflictive, Love can make an angel entertained unawares" (S&H 574:27). And again, "Trials are proofs of God's care.... The broadest facts array the most falsities against themselves, for they bring error from under cover. It requires courage to utter truth; for the higher Truth lifts her voice, the louder will error scream, until its inarticulate sound is forever silenced in oblivion" (S&H 97).

31

Meanwhile, at the age of 46, Mary Patterson was again alone. She knew not which way to turn. Her only financial support was an annuity of two hundred dollars a year. In *Retrospection & Introspection* she wrote, "Previously the cloud of mortal mind seemed to have a silver lining; but now it was not even fringed with light." Many a brave adventurer, when all seemed lost, has asked the questions that faced her: Had all her struggles been in vain? Were all her hopes illusions? Mary was to find her answer in the dawn of light that lay ahead—in the breaking of the dawn wherein the haven, heaven, lay revealed.

How aware was Mary Baker Glover Patterson of her divine destiny, at this point? How aware was she of the divine revelation soon to flood her Mind? In *Miscellaneous Writings*, p. 127, Mrs. Eddy writes,

"When a hungry heart petitions the divine Father-Mother God for bread, it is not given a stone,—but more grace, obedience, and love. If this heart, humble and trustful, faithfully asks divine Love to feed it with the bread of heaven, health, holiness, it will be conformed to a fitness to receive the answer to its desire; then will flow into it the 'river of His pleasure,' the tributary of divine Love, and great growth in Christian Science will follow."

Again she wrote, "The new birth is not the work of a moment. It begins with moments, and goes on with years; moments of surrender to [the infinite good we call] God, of child-like trust and joyful adoption of good; moments of self-abnegation, self-consecration, heaven-born hope, and spiritual love.

"Time may commence, but it cannot complete, the new birth; eternity does this; for progress is the law of infinity. Only through the sore travail of mortal mind shall soul as sense be satisfied, and man awake in [infinite good's] likeness. What a faith-lighted thought is this! that mortals can lay off the 'old man,' until man is found to be the infinite good that we name God, and the fullness of the stature of man in Christ appears.

"Let us then divest our thought of the mortal and material view which contradicts the ever-presence and all-power of good; let us take in only the immortal facts, which include these, and where will we see or feel evil?" (See *Mis.* 14:2.)

And here we see the fruit of the years of loneliness and disappointment. Infinite good had been weaning Mary away from the material to the spiritual, until she could finally lay off the "old man." The time was ripe for the discovery of the divine revelation, when the fullness of the stature of man in Christ would appear.

As the door closed on the Quimby years, another door opened—a door that was never to shut.

The Great Revelation's Time Had Come

It was February 4th, 1866, a bitterly cold winter night; the streets were covered with ice. Mary Patterson left her home in Swampscott to attend a temperance lecture in Lynn. She slipped on the icy sidewalk, and fell with such force as to injure herself severely, sustaining a concussion of the brain and an injury of the spine, and rendering herself insensible.

A doctor was called. Mary was carried into a nearby house, where she remained unconscious until the following morning. Then, at her insistence, with greatest care she was removed to her own home, the doctor despairing of any recovery for her.

Now Mary was lying in her upstairs bedroom. The doctor had left some homeopathic medicine but Mary Patterson did not take it. She turned instead to Scripture; she knew her healing rested on "that consciousness which God bestows" (S&H 573:7).

The Bible was open to the healing of the man sick of the palsy. "And, behold, certain of the scribes said within themselves, "This man blasphemeth. And Jesus knowing their thoughts said, Wherefore think ye evil in your

hearts? For whether is easier, to say, Thy sins be forgiven thee; or to say, Arise and walk? But that ye may know that the Son of man hath power on earth to forgive sins. Then said he to the sick of the palsy, Arise, take up thy bed, and go unto thine house. And he arose and departed to his house."

Mary Glover Patterson's eyes lingered on the verse, "For whether is easier, to say, Thy sins be forgiven thee; or to say, rise and walk." Mary at that moment perceived that the same Principle healed both sin and sickness. In this perception she saw in Jesus' words the golden thread that forever holds man in the image of his Maker, which we today know is our own right Mind, the kingdom of God within our consciousness, that is Love. Reverently, humbly, Mrs. Patterson felt the presence of the infinite good we call God.

In early editions of Science and Health Mary tells of reading also that morning from the third chapter of Mark where "our Master healed the withered hand on the Sabbath day." She describes how, "as [she] read, a change passed over [her]; the limbs that were immovable, cold, and without feeling, warmed; the internal agony ceased, [her] strength came instantaneously, and [she] rose from [her] bed and stood upon [her] feet, well" (1881, S&H, Third Ed. p. 156).

Mary Glover Patterson left her bed and, to the utter astonishment of those in the next room who were waiting for her to die, she walked in, healed. When she greeted the pastor at the door he thought he was seeing an apparition.

When the doctor came he expressed such incredulity and disbelief that it seemed to strike at Mary and she felt weakened and could not stand. But as she again turned to her Bible and read from the ninth chapter of Matthew (the healing of the palsied man) Jesus' words, "Arise and walk" spoke to her strongly, and again she arose in strength, and the claim of relapse dissolved.

When interviewed in later years, Mrs. Eddy recalled that as she lay in her room that morning, so close to death, "...the dear ones around me said, 'If you can't live, tell us something, do tell us something as you always do, of your views.'...I said to them, 'Why, I can't conceive in this vestibule that there is death. It does not seem death to me; life seems continuous, and my Father's [infinite good's] face dearer than ever before."

"The clergyman entered and said, 'You seem near heaven. Do you realize that you cannot recover?' I said, 'They tell me so, but I cannot realize it.' And he said to me, 'I must see you again; I am engaged now, but I will call in a little time. I want to see you again, living if I can.'

"He stepped out....I requested the others to leave the room and they did. Then I rose from my bed perfectly sound; never knew health before, always an invalid. I went down stairs....The clergyman returned. He was so startled he did not know whether to conclude it was me in the body or out. He said, 'What does this mean?' I said, 'I do not know.'

"The doctor came....He said, 'How was this done?' I said, 'I cannot tell you in any wise whatever, except it seemed to me all a thing or state of my mental consciousness. It didn't seem to belong to the body, or material condition. When I awakened to this sense of change I was there, that is all I know.'He said, 'This is impossible,' and immediately I felt I was back again, and I staggered. He caught me and set me in a chair, and he said, 'There, I will go out. If you have done that much, you can again.'...When I felt myself back again I felt more discouraged than ever.

"As I sat there it all seemed to come to me again with such a light and such a presence, and I felt, '*It is all the mind*. These are spiritual stages of consciousness,' and I rose right up again. And then I felt I never could be conquered again.

In Science and Health (p. 108) Mrs. Eddy wrote of this experience,

"When apparently near the confines of mortal existence, standing already within the shadow of the death-valley, I learned these truths in divine Science: that all real being is in God [infinite good] the divine Mind, and that Life, Truth, and Love are all-powerful and ever-present; that the opposite of Truth—called error, sin, sickness, disease, death—is the false testimony of false material sense, of mind in matter; that this false sense evolves, in belief, a subjective state of mortal mind which this same so-called mind names *matter*, shutting out the true sense of Spirit. ["Error," she said, "comes to us for life, and we give it all the life it has."]

"My discovery that erring, mortal, misnamed *mind* produces all the organism and action of the mortal body, set my thoughts to work in new channels, and led up to my demonstration of the proposition that Mind is All and matter is naught as the leading factor in Mind-science."

With this discovery Mary rose from her bed, healed.

The Years of Waiting Were Over
The Unfolding Demonstration

The years of waiting were over! At last the darkness was past. And though many a weary mile still lay ahead, the great adventure to find the Christ Science was at hand, merging into the revealment of Truth. Discovery had come at last. It was to lengthen into years of expanding revelation.

From that day in February 1866 forward, Mary lived for one purpose only: to bring her revelation of reality to a world sunk in materialism. Reading in the New Testament of Jesus' healing work, Mary Baker Eddy had glimpsed God and his relationship to man in an entirely new way—and found herself healed. She had seen that human birth is the first death. It pulls the wool over our eyes so that we "see

36

through a glass darkly," and no longer remember our pre-existence where we knew the truth about ourselves, that our own real and true Mind is Love; and this true Mind sees only as Love sees.

We have seen how, as the woman scripturally prophesied to bring the "Comforter," the Second Coming of the Christ, Mary Baker Eddy had been fitted for her part through steady constant unfoldment. As human kinships had been found wanting, the relationship between the infinite good we call God and Its offspring had become ever more real to her.

Forty-six years of terrible suffering now lay behind, years our Leader would later term "gracious preparation." The spiritual impulsion that had loosened her grasp on human aid had tightened her hold on changeless Love, and Mary was prepared to completely yield to the divine purpose.

On page 24 of *Retrospection & Introspection* she writes, "I then withdrew from society about three years,—to ponder my mission, to search the Scriptures [as we see her doing in *Christ and Christmas* in Picture No. 3, entitled "Seeking and Finding"], to find the Science of Mind that should take the things of God [of infinite good] and show them to the creature, and reveal the great curative Principle,—Deity [infinite Love, our real, true Mind, "the kingdom of God within [us]."

For these next three years she studied the Scriptures, making copious notes on their spiritual meaning; she healed others and began to teach what had been revealed to her. In Science and Health, she writes:

"The search was sweet, calm, and buoyant with hope, not selfish nor depressing. I knew the Principle of all harmonious Mind-action to be God, and that cures were produced in primitive Christian healing by holy uplifting *faith*; but I must know the Science of this healing [so that we could use this Christ Science just as we use the science of mathematics to work out any problem], and I won my way to

absolute conclusions through divine revelation, reason, and demonstration."

Mary foresaw the inevitable struggle with old theology. Old theology had no conception that the fundamental error of mortal man is the belief that man is matter, but Mary heard the whole world's cry for deliverance from the woes of the flesh and material thinking. She reached out with eager comprehension to understand and receive divine Science so that she could translate its message in terms humanity could understand and demonstrate.

At first she says the translation was but a feeble attempt to express in writing the vision that was unfolding. As she persevered, never faltering or failing, the divine inspiration was gradually formulated and systematized so that it revealed the Principle and laws of eternal Life, Truth, and Love.

On page 25 of *Retrospection* she tells us, "...the Scriptures had a new meaning, a new tongue. Their spiritual signification appeared; and I apprehended for the first time, in their spiritual meaning, Jesus' teaching and demonstration, and the Principle and rule of spiritual Science and metaphysical healing,—in a word, Christian Science."

Again on page 25 of *Retrospection* she states, "I named it *Christian*, because it is compassionate, helpful, and spiritual. God [infinite good] I called *immortal Mind*. That which sins, suffers, and dies, I named *mortal mind*. The physical senses, or sensuous nature, I called *error* and *shadow*. Soul I denominated *substance*, because Soul [true identity] alone is truly substantial. God I characterized as individual identity, but His [infinite good's] *corporeality I denied*. The real, I claimed as eternal; and its antipodes, or the temporal, I described as *UNREAL*. Spirit I called the *reality*; and matter, the *unreality*."

On page 28 (ibid.), Mary Baker Eddy explains, "I had learned that thought must be spiritualized in order to apprehend Spirit [infinite good]. It must become honest, un-

selfish, and pure in order to have the least understanding of God [infinite good] in divine Science. The first must become last. Our reliance upon material things must be transferred to a perception of and dependence on spiritual things. For Spirit [infinite good, understanding, present perfection] to be supreme in our affections, we must be clad with divine power. [We must follow the admonition she later wrote, "Know then that you possess sovereign power to think and act rightly."] Purity, self-renunciation, faith, and understanding must reduce all things real to their own mental denomination, Mind, which divides, sub-divides, increases, diminishes, constitutes and sustains, according to the law of God [infinite good]."

Mrs. Eddy tells us she "had learned that Mind reconstructed the body, and that nothing else could. How it was done, the spiritual Science of Mind must reveal. It was a mystery to me then, but I have since understood it. All Science is a revelation. Its Principle is divine..."

The Years 1866 to 1868
Mary Patterson and Her Healings

In March of 1866 the Pattersons took a room in the Russell home. From here, a few months after Mary's healing in February, Dr. Patterson again proved unfaithful, deserting Mary for another woman. When he first proved unfaithful and the pair asked forgiveness, Mary forgave them. But when Daniel betrayed her a second time, deserting her again to run off with another woman, Mary told him he could not return. She had taken him back after his first affair, but she did not after the second.

Mrs. Patterson stayed on with the Russells, reading and studying the Bible and writing as understanding opened for her. Mary felt God-impelled to gain a demonstrable understanding of what had been divinely revealed to her, and to impart this understanding to others. For most of

her life she had been seeking an understanding of how to heal physical ailments in the way Jesus did. From her past experiences she had become convinced that all ailments had a mental nature, and could be cured by a change of mind. She now saw that one must see that his own real Mind is God, "the kingdom of God within" and that this is the healer of all ailments.

Unfortunately, the Russells became increasingly hostile toward what Mary Baker Glover (as she now called herself) was writing and devoting her time to, and when she did not have the $1.50 for the week's rent, they evicted her.

Mary Glover was faithfully following the daystar of Christian healing, and it placed extraordinary demands on her as she walked in the way Christ points out. For example, when Mary's sister Abigail offered her a home if Mary would give up her "theory of divine healing," Mary had to refuse.

When Mary had been asked to give up her son, she was an invalid and had neither the strength nor the understanding to resist. But now, having had the divine revelation, she told her sister: "I must do the work God has called me to do." She had learned that "no man having put his hand to the plough, and looking back, is fit for the kingdom of God."

Hour after hour through the years 1866 to 1870 Mary spent in Bible study, writing down what she was learning from the perspective of revelation. At this time "it looked as if centuries of spiritual growth were requisite to enable me to elucidate or to demonstrate what I had discovered; but an unlooked-for, imperative call for help impelled me to begin this stupendous work at once, and teach the first student, Hiram S. Crafts, in Christian Science." (See *Mis.* 380:7.)

A call came to her from a child with an inflamed finger. Mary Baker Glover had sought refuge with the Phillips, whose fifteen year old son was suffering from a very pain-

ful infected finger which had kept him out of school for several days. Mrs. Glover asked the boy if he would like her to heal it. When he assented she asked him not to look at the finger or allow others to look at it. He was obedient. The next morning all were amazed, for there was no evidence of the painful felon that had kept the boy in agony.

Mary did not consider this healing a miracle, but said it "is natural, divinely natural. All life rightly understood is so" (*The Life of Mary Baker Eddy*, Sibyl Wilbur, p. 140-1).

Wherever Mary went now, she healed. On the beach in the summer of 1866, Mrs. Glover saw a seven-year-old boy, George, whose mother had left him there while she did an errand. The child had club feet and had never walked. When the mother returned she was stunned to see her George walking hand in hand with a strange woman. The two women looked into each others eyes, and wept. The child was completely and permanently healed. And so the healings, hundreds of them, continued.

Still Mary had no place to call home. In 1866, alone, Mary Baker Glover was forced to change her residence ten times. For the next few years she lived in various homes—the Crafts', the Winslows', the Websters', Mrs. Bagley's, the Wentworths', and others. Why the many moves, when Mrs. Glover so loved everyone she came in contact with?

An early student explained, "...It was unfortunate that at this time in her life Mrs. Glover, with her small income, was obliged to live with people who were without education or cultivation. It was never Mary's custom to keep apart from the family. She invariably mingled with them and through them kept in touch with the world. She had a great work to do; she was possessed by her purpose, and like Paul the apostle...she reiterated to herself, "This one thing I do." Of course simple-minded people, who take life as it comes from day to day, find any one with so fixed an object in life, a rebuke to the flow of their own animal spirits [and so grew to resent her]."

41

In these first years of revelation, both inner calm and outer turbulence were Mary's lot. During the germination and unfoldment of this holy work she found the last tie which bound her to family and home, broken. Dearly as she loved her family and all connected with her childhood home, Mary *submitted to this severing*.

One protests, why was this added burden necessary? Surely infinite good would not inflict continued suffering needlessly! Why were ceaseless toil, self-renunciation and rejection and the sundering of almost every natural or human tie of affection now laid upon Mary Glover after her years of physical suffering?

Our Leader herself supplies the answer, for it was during these years of trial that it became clear to her what her mission was. In *Retrospection*, p. 30, Mrs. Eddy writes,

"It is often asked why Christian Science was revealed to me as one intelligence, analyzing, uncovering, and annihilating the false testimony of the physical senses. Why was this conviction necessary to the right apprehension of the invincible and infinite energies of Truth and Love, as contrasted with the foibles and fables of finite mind and material existence?

"The answer is plain. St. Paul declared that the law was the schoolmaster, to bring him to Christ. Even so was I led into the mazes of divine metaphysics through the gospel of suffering, the providence of God, and the cross of Christ. No one else can drain the cup which I have drunk to the dregs as the Discoverer and teacher of Christian Science; neither can its inspiration be gained without tasting this cup."

Mrs. Glover Finds a Student

Mary's recovery from her fall on the ice was a revelation from the divine Mind. She had glimpsed "Life in and of Spirit; this Life being the sole reality of existence." (See *Mis.* p. 24). However, it was not until the latter part of 1866

that Mary Glover arrived at the *scientific certainty* of how to be well herself and how to heal others.

Mrs. Eddy makes it clear that Christian Science came to mankind from God; that she was simply the "transparency for Truth." (See S&H 295:19-24). We have seen that from before birth God was preparing Mary for her divine mission—to share with mankind the *Science* that lay behind Jesus' work and that lay behind her healing. Mary Baker Eddy's history is a holy one, but her task was by no means easy. *Mary began where Jesus left off.* How was she to teach frail mortals from this spiritual height?

"Start where you stand" is the beginning of the road to accomplishment. Mary made that beginning.

In the fall of 1866, Mary Baker Glover found her first student. It was at Mrs. Clark's boarding house that Mrs. Glover met Hiram S. Crafts. Mrs. Glover, by this time, had proved by many cases of healing that all causation is infinite Mind. Hiram learned quickly, and wanted to become a healer. After the Crafts returned home, Mrs. Crafts asked Mrs. Glover to come to them and help Hiram establish a practice.

Mrs. Glover moved in with Hiram Crafts and his wife in order to teach him Christian Science healing. She instructed Hiram from manuscripts that she wrote. His success in healing was so phenomenal that in April, 1867, they moved to a larger town, Taunton, Massachusetts, where Hiram Crafts advertised in the Taunton newspaper:

"To the Sick, Dr. H.S. Crafts. Would say unhesitatingly, *I can cure you*, and I have never failed to cure Consumption, Catarrh, Scrofula, Dyspepsia, and Rheumatism with many other forms of disease and weakness, in which I am especially successful...."

Then appeared testimonials of wonderful healings, such as that of Mrs. Abigail Raymond, who was healed of an internal abscess that threatened to destroy her life. "Dr." Crafts was an apt pupil, and with Mrs. Glover's help he

was healing all manner of diseases. He had good success, of course, with Mary doing the metaphysical work needed.

In July of 1867 Mary Glover healed her sister Martha's daughter, Ellen, of a severe case of enteritis that threatened to take Ellen's life. Ellen accompanied her aunt Mary back to Taunton. But it was the wrong time to come. Mrs. Hiram Craft's latent jealousy had burst into the open during Mrs. Glover's absence, and had made life so miserable for Hiram, that he gave up his practice and with his wife moved back to East Taunton. Ellen, seeing the kind of company her aunt Mary was involved with, was revolted. She became hostile toward her aunt and decided her mother and family were right in rejecting Mary. So the break between Mary and her family became permanent.

In the face of Mrs. Craft's resentment of her, Mrs. Glover saw it was time to move on. Though her grand beginning with her first student lay in ruins, she had learned important lessons. The sick were healed with her Christ Science only as the Truth of being first cast out error or sin in the thought of both the physician and the patient. Turning to God (the one divine Mind) was the only way to do this.

Mary Glover lived for one purpose only—to bring her revelation of reality to a world sunk in materialism. Many bitter experiences lay in her path, but she persevered even though she knew that if Jesus "had not taken a student and taught the unseen verities of God, he would not have been crucified." *Mary Baker Eddy would hang on the cross for forty-four years in order to teach mankind its oneness with infinite good.*

While staying with the Crafts Mary Baker Glover had begun work on a class-book that would become the center for teaching Christian Science. It was later called *"The Science of Man,"* and was eventually incorporated into the third edition of Science and Health as the chapter "Recapitulation."

Mrs. Glover's next important move was to the Websters

where, in 1867 and 1868, she continued seeking a thorough understanding of the Principle and rules of the divine Science that had healed her. Here she had time to write the beginnings of what would become Science and Health.

The Websters witnessed many healings performed by Mary Glover. Years later when Mrs. Glover was publishing the first edition of Science and Health a student asked her why she wrote Science and Health. In response, Mary told her of the following occasion.

One day a telegram arrived at the Websters for Mrs. Mary B. Glover (as Mrs. Eddy was then calling herself). It said, "Mrs. Gale is very sick. Please come..." The telegram summoned her to the bedside of a lady who was dying of consumption.

Three or four doctors were present when she arrived— fine men who had expended all their medical knowledge in trying to save this lady from death. When they had found there was no hope for her recovery, they had decided to test "that woman" (Mary Baker Glover) as they had heard of someone who had been cured by her. At their suggestion the lady's husband had sent for her.

When Mrs. Glover arrived at Mrs. Gale's home, the doctors informed her there was no hope; the patient was dying of pneumonia. Mary entered the room. The patient was propped up with many pillows and could not speak. Our Leader saw that what Mrs. Gale needed was an arousal and quickly pulled all the pillows away from behind her. As she fell backwards, the patient said, "Oh, you have killed me," but Mrs. Glover told her that she could get up and that she would help her to dress. (Mrs. Eddy, like Jesus, healed instantaneously by knowing the truth, just as a mathematicion "heals" 2x2=5.) The lady was instantaneously well, healed on the spot. Mrs. Glover asked the doctors to leave the room while she helped Mrs. Gale dress, after which they rejoined the doctors and Mr. Gale in the sitting room.

When Clara Shannon, in later years, asked Mrs. Eddy what had prompted her to write Science and Health, Mrs. Eddy told Clara of this healing, and added "One of the doctors, an old experienced physician, witnessed this, and he said, "How did you do it, what did you do? Mrs. Glover said, "I can't tell you, it was God," and he said, "Why don't you write it in a book, publish it, and give it to the world?"

When Mary Baker Glover returned home she opened her Bible, and her eyes fell on the words "Thus speaketh the Lord God of Israel, saying, Write thee all the words that I have spoken unto thee in a book" (Jeremiah 30.2).

Mrs. Glover Takes Two Students

Mary Glover still longed to teach others how to heal; her months with Hiram Crafts had shown her that others *could* be taught how to heal as Jesus had healed. Early in 1870 Mary Glover took two students, Sarah Bagley and Richard Kennedy.

Because Mrs. Glover had as yet no textbook she used the Socratic method for teaching. Later her early talks were systematized; the dissertations were dignified into the form of lectures which her early students declared to have been illuminating and inspirational beyond price.

These dissertations as well as her writings, we learn, were beginning to unseal the fountains of her inspiration. She had arrived at a clear standpoint, and could now wrap in words the spiritual concepts which had before been elusive and intangible. From this standpoint she lifted her eyes to a far horizon—the work now before her was the work of promulgation, *how to make it known, how to spread it abroad*.

By the spring of 1870 Mary Baker Glover had completed the manuscript entitled "*The Science of Man*." This booklet contained the fundamental principles of Chris-

tian Science, but she knew it was premature. "I did not venture upon its publication until later, having learned that the merits of Christian Science must be proven before a work on this subject could be profitably published" (*Ret.* p. 35).

Although Mary Glover had patiently labored four successive years, carefully and earnestly writing and rewriting the truth that was growing in her understanding, only to set it aside, she knew it was a necessary step. She understood that the unfolding of revelation was a steady growth. She could not have had her great discovery in 1866 had she not been prepared for it by long application to spiritual inquiry. Neither could she have written Science and Health had she not labored long and with perfect submission to imperative spiritual guidance.

All is Already Within Our Consciousness

No one learns anything from a book, whether it is the Bible or a book on arithmetic. Everything in the arithmetic book or the Bible or in any subject, is *already* within our consciousness—"the kingdom of God within you." It is only as we desire to learn, have a hunger to learn, that a book helps us to step by step learn the subject. So it was with Mary Baker Eddy as she tells us in *Retrospection and Introspection*.

In *Ret.*, p. 31, Mary Baker Eddy tells us, "From my earliest childhood I was impelled by a hunger and thirst after divine things,—a desire for something higher and better than matter, and apart from it,—to seek diligently for the knowledge of God as the one great and ever-present relief from human woe."

In *The Christian Science Journal*, June, 1887, Mrs. Eddy wrote, "As long ago as 1844 I was convinced that mortal mind produced all disease, and that the various medical systems were in no proper sense Scientific. In 1862, when I

first visited Mr. Quimby, I was proclaiming—to druggists, spiritualists, and mesmerists—that Science must govern all healing." And in *Ret.* p. 31, Mrs. Eddy tells us, "The first spontaneous motion of Truth and Love, acting through Christian Science on my roused consciousness, banished at once and forever *the fundamental error of faith in things material;* for this trust is the unseen sin, the unknown foe,— the heart's untamed desire which breaketh the divine commandments."

"The Christian Scientist is alone with his own being and the reality of things" just as the mathematician is alone with the multiplication table. (See *'01,* p. 20:8.) But, if he thinks 2x2=5 is something "out there," other than his own misperception, his own ignorance, he can't heal a single mistake in math. All we ever need is to get understanding; then, as the Bible says, "...by [his] stripes ye were healed...seek ye first the kingdom of God," then "all these things shall be added unto you." (I Pet. 2:24 and Matt. 6:33)

Classes Are Started

In Lynn Mrs. Eddy started classes with those she had drawn to her through healing. They were shoe factory workers, their hands stained with the leather dye and tools of the day's occupation, their narrow lives cramped mentally and physically. As they listened to the words of revelation that Mary Glover poured on them, they must have found their hearts stirred within them. Like the early Christians they found the Word confirmed by healing power, for they were able to perform cures with the truths they had learned. Courage from on high must have impelled this little band of mental pioneers as they went forth to solve the problems of life through the spiritual instruction Mary Glover gave them.

For Mrs. Glover the ability to heal came from far more

than an intellectual understanding of metaphysical concepts. It was rather whether material sense or spiritual sense governed the practitioner. Without the *spiritual aspect, the love,* the healing practice turned into a mesmeric exercise of one mind controlling another. This is why she stressed to her students the need for *greater goodness and purity* in their thought and lives. Before Mrs. Eddy wrote the words in Science and Health, *she lived the words, and proved them for all time.*

The healings at this time were many. For Mary Glover, her discovery of divine Science, which had come as a revelation from God, was a "pearl of great price." Scientific Christian healing was a lifework. It was not simply a way to earn a living, but rather a *total commitment was essential to success in this healing work. You cannot think of the physical condition, but must think only the fact that God, your own real Mind, "the kingdom of God within" you as your own consciousness, is all. You have to shut out what the physicians have said, and shut out everything else from the material side.*

Mary said that she spoke sharply sometimes because the thought must *move.* To follow Mrs. Glover, any student would have to cross swords with the world's beliefs in matter as a reality. Today the honest earnest student knows he can only follow Christ as far as he follows his Leader, Mary Baker Eddy, who brought the Second Coming of the Christ.

Richard Kennedy was one who did not. When he had entered the scene in June of 1870, he at first seemed to be a promising student. Sadly, he proved unfaithful; he became a mesmerist. Richard Kennedy's faithlessness was a blow to Mary Glover. His erring, disobedient ways—manipulating his patients—caused Mrs. Glover great distress. In the end, however, *it was a great blessing*, for it led her to deeply penetrate into the evils of animal magnetism and mesmerism. It again proved her statement, "The very cir-

cumstance which your suffering sense deems wrathful and afflictive, Love can make an angel entertained unawares" (S&H 574:27).

It was necessary that Mrs. Eddy go "to the bottom of mental action [which] reveals the theodicy which indicates the rightness of all divine action, as the emanation of divine Mind, and the consequent wrongness of the opposite so-called action,—evil, occultism, necromancy, mesmerism, hypnotism" (S&H p. 104). **By delving into the ways of mesmerism and animal magnetism in light of the life of the Master she would gain the understanding that man— Mind's idea or image—** cannot be used by evil as an agent, or a victim, because man, in reality, is forever governed by the one Mind, God, the kingdom of God within your consciousness, which is your real true Mind and "cannot be tempted with evil, neither...tempteth [God, infinite good] any man" (James 1:13). She would realize that the infinity of good as Mind, your real Mind, implies the unreality of evil mentality.

Mrs. Eddy about 1871, when teaching her first classes in Lynn, Mass.

This spiritual truth would prove of invaluable assistance to her all through the years to come, enabling her in great measure to defend the expansion of her work against division and divergence. She later said, "If students do not learn to handle animal magnetism [error of any kind, and

the belief of life, substance and intelligence in matter], Christian Science will do very little good in the world."

How She Came To Write Science & Health

Above all, the conflict with Richard Kennedy was a blessing in disguise because *it fixed in Mary Glover the purpose to begin writing a textbook.*

Mary Baker Glover recalled that after she had earnestly asked God what her next step should be, she opened her Bible and her eyes fell on the verse: "Now go, write it before them in a table, and note it in a book, that it may be for the time to come for ever and ever" (Isaiah 30:8). From 1866 to 1872 Mary had intensely studied the Bible. She had healed the sick through prayer alone, and had taught others how to heal every manner of sin and disease. In 1872 she suspended teaching in order to devote her full time to finishing Science and Health.

Between 1872 and 1875 Mary Glover was busy writing the textbook that would explain the Science that through divine revelation she had discovered in 1866. In the preface of her first edition of Science and Health Mrs. Eddy wrote: "We propose to settle the question of 'What is Truth?' on the ground of proof. Let that method of healing the sick and establishing Christianity, be adopted, that is found to give the most health, and make the best Christians...."

Her method of healing, which demonstrated the reality of the divine Science that had been revealed to her by God, the infinite good that was her own divine Mind, "the kingdom of God within" her consciousness, did "give the most health, and did make the best Christians...." Why? Because it treated the whole man, transforming human character while it healed the body.

The First Edition of Science and Health

In the spring of 1874 Mrs. Glover was living in a board-ing-house at Number 9 Broad Street. She had moved many times and now needed absolute peace and seclusion in or-der to add those important finishing touches that would bring her book, Science and Health, together, to unify it and complete it. She did not have this peace and quiet here at No. 9 Broad Street.

Leaning at the window she breathed a silent prayer for a resting place. Lifting her eyes, she saw across the way a little frame house with a sign affixed stating it was for sale. Contemplating it, she resolved to own it. With her own home she felt her work would go forward more pro-gressively.

The house at No. 8 Broad Street—Mr. Eddy is in the window

Mary had some modest resources, saved from tuition payments, which she had guarded in case she had to pub-lish her own book. On March 31st, 1874, the property at No. 8 Broad Street was deeded to Mary Baker Glover. It was to be the first home of Christian Science; there she would com-

plete her book. Because of limited means she had to rent out much of the house, reserving the front parlor for a classroom. On the attic floor she reserved a small bedroom lighted only by a skylight in the sloping roof. In this unheated garret chamber she was able to finish her Science and Health manuscript, the work of nearly nine years.

In the fall of 1874 Mary Baker Glover gave the manuscript of her book into the hands of a printer. A fund had been subscribed to by some of the students to ensure its publication. Mrs. Glover had done everything necessary. Then half way through there was a halt in its printing.

In *Retrospection*, p.37 and 38, Mrs. Eddy tells us, "My reluctance to give the public, in my first edition of Science and Health, the chapter on Animal Magnetism, and the divine purpose that this should be done, may have an interest for the reader, and will be seen in the following circumstances. I had finished that edition as far as that chapter, when the printer informed me that he could not go on with my work....

"After months had passed, I yielded to a constant conviction that I must insert in my last chapter a partial history of what I had already observed of mental malpractice. Accordingly, I set to work, contrary to my inclination, to fulfill this painful task, and finished my copy for the book....My printer resumed his work at the same time, finished printing the copy he had on hand, and started for Lynn to see me. [At the same time] I started for Boston with my finished copy. We met at the Eastern depot in Lynn, and were both surprised....Not a word had passed between us, audibly or mentally, while this went on."

Science & Health came out on October 30, 1875 in an edition of one thousand. It was a stout volume bound in green cloth. Though Mrs. Eddy would many times revise this book, the essential statements in her last edition are the same as in the original volume. Her revision was always for improvement of expression, not to change the content of her

message, although, to bring it closer to what people of her day could accept, she hid those vital truths they were not ready for. On page 37 of *Retrospection* she states,

"Science and Health, containing the *complete* statement of Christian Science...was published in 1875."

The landmark 50th edition of Science and Health came in early 1891. By September it had reached sixty-two editions. "The book had been written under the severest hardships. It was revised painstakingly in the midst of the multitudinous duties of a leader. It has been plagiarized and pirated from, vilified and burlesqued, but it will stand."

It still stands today. To date over 9,000,000 copies of this remarkable book have been sold. "Science and Health is the textbook of Christian Science. Whoever learns the letter of this book, must also gain its spiritual significance, in order to demonstrate Christian Science."

Whether teaching or lecturing, *healing* was at the heart of all Mary Glover's efforts. Concerning her teaching, she wrote a prospective student in 1876, "...If I do not make pupils capable of healing I will refund the money to them." To Mrs. Glover, the purpose of teaching was to produce students who could heal through Christian prayer alone.

In 1901 Calvin Frye wrote in his diary concerning a healing in which the patient was supposed to die. After Mrs. Eddy cured him she said, "I knew that if he died he would awake to find he had not that disease and I wanted to awake him to it *before he died*" (Frye's Diary, Oct. 9, 1901).

Mary Baker Glover wanted to awaken all mankind to the divine truth of their being. This was certainly behind her writing of Science and Health, the Second Coming of the Christ, the "Comforter" Jesus promised and prophesied. Mary Baker Glover knew it was part of her divine mission to see that the message in Science and Health reached all who "hunger and thirst after righteousness." Therefore one of Mary Glover's primary concerns was getting Science and Health into the hands of the public.

She appointed one of her students, Daniel Spofford, as publisher, to be responsible for the sale of the book. She wrote him, "What you most need is Love, *meekness* and *charity*, or patience with everybody....These things would increase your success."

In March of 1876 Mary Glover met Asa Gilbert Eddy, who came to her for healing of heart disease. He quickly became a Christian Science practitioner, being the first to announce himself to the public as a Christian Scientist. To a pupil, Mrs. Eddy wrote: "....Last spring Dr. Eddy came to me a hopeless invalid. I saw him then for the first time, and but twice. When his health was so improved he next came to join my class....In four weeks after he came to study he was in practice doing well, worked up an excellent reputation for healing and at length won my affections on the ground alone of his great goodness and strength of character."

The need to protect her "child," the newborn "cause of truth," was something Mrs. Eddy was keenly alert to because the materialistic thought of the entire world openly resisted this holy "cause" to the point of trying to destroy it. One such case occurred when Mary Baker Eddy's husband, Dr. Eddy, was falsely charged with being a party to a conspiracy to murder Daniel Spofford. This malicious lie was exposed and dismissed; and in March, 1879, Mrs. Eddy wrote a friend that "The cause is prospering again, rising up slowly from the awful blow of malice and falsehoods dealt it last autumn...."

Materialism's attempt to ruin the cause of Truth had failed utterly, and Mrs. Eddy was not slowed down by it, but courageously, under divine direction, led the holy Cause forward.

Students Turn Against Their Teacher

Such events should not surprise us. Isaiah 54:15-17 had prophesied, "Behold they shall surely gather together, but not

by me: whosoever shall gather together against thee shall fall for thy sake. Behold, I have created the smith that bloweth the coals in the fire, and that bringeth forth an instrument for his work; and I have created the waster to destroy."

This case was but one example. The five years after the publishing of Science and Health saw the conflict of personalities as people did "gather together against" Mrs. Eddy—important helpers turning against her and perpetrating much evil, robbing her of funds so that she could not properly publish the second edition of Science and Health. (Picture 4 of *Christ and Christmas* shows this time of Mrs. Eddy's life.)

But Isaiah's prophecy continues with a promise of deliverance, "No weapon that is formed against thee shall prosper; and every tongue that shall rise against thee in judgment thou shalt condemn. This is the heritage of the servants of the Lord, and their righteousness is of me."

Once again the prophecy held. The conflict of Mrs. Eddy's materially-minded, unscientific students cleared the atmosphere. Neither disaffection among her students nor aggression from without conquered her steadfast confidence and trust in divine direction. At the end of a path of seeming defeat Mrs. Eddy always saw a widening horizon.

However dire the circumstances Mrs. Eddy faced, she invariable found them to be blessings in disguise. For instance, it was because of setbacks like the ones mentioned here that Mary was led to investigate "the metaphysical mystery of error" (*Mis.* 223:1). Mrs. Eddy knew evil to be an illusion, hypnotic suggestion only; but she also knew that unless its true nature was specifically uncovered, thought could be influenced unconsciously. Her next edition of Science and Health therefore expanded the original sixteen pages on this subject into a forty-six page chapter entitled "Demonology."

Always aware of divine support, Mary Baker Eddy

went forward. Because of the tremendous amount of work now involved, Mrs. Eddy at this time organized the Christian Science Association, to help carry the load.

A bitter blow came to Mary with the death of her beloved husband, Dr. Asa Gilbert Eddy, on June 3, 1882. Mrs. Eddy retired to a student's home in Vermont to regain her peace and to find healing. The healing came.

On returning home Mrs. Eddy wrote in her Bible: "Aug. 6th, 1882...opened to Isaiah 54." One of the comforting verses she read there was, "thou...shalt not remember the reproach of thy widowhood any more." Soon she was able to tell a student, "The ship of Science is again walking the wave, rising above the billows, bidding defiance to the flood-gates of error, for God [her own right Mind, "the kingdom of God within" her consciousness] is at the helm."

The Christian Science field was now to see a great outreach. In 1882, following her return from her retreat in Vermont after Dr. Eddy's death, Mrs. Eddy delivered an address on Christian healing in the Methodist temple in Barton. This was a subject ever in her heart.

The *Christian Science Journal* appeared in April, 1883. Mrs. Eddy served as editor and wrote much of the *Journal's* contents. Mrs. Eddy's work was hard and arduous, seven days a week, with little leisure. She rested solely in the love for the work, and the love for God (infinite good).

Christian Science was now knocking loudly at people's thinking. Newspapers and churches were raising questions regarding this new denomination. Mrs. Eddy issued two pamphlets: "Historical Sketch of Metaphysical Healing" and "Defense of Christian Science."

After much revision "Historical Sketch of Metaphysical Healing would be published in 1891 as the book *Retrospection and Introspection;* and later "Defense of Christian Science" would be issued as *No and Yes.*

Besides her publishing, writing, preaching, Mrs. Eddy also gave classes, and in 1884 she even made her first trip

to Chicago, where she lectured on: "Whom do men say that I am?" She told a student afterwards, "I went in May to Chicago at the imperative call of people there and my own sense of the need. This great work had been started, but my students needed me to give it a right foundation and impulse in that city of ceaseless enterprise. So I went, and in three weeks taught a class of 25 pupils, lectured in Music Hall to a *full* house, got 20 subscriptions for my *Journal*, sold about thirty copies of Science and Health...."

Second Visit to Chicago

In 1888 Mary Baker Eddy made a second visit to Chicago. On this visit Mrs. Eddy spoke extemporaneously, for she had not been told she would be the principle speaker. She spoke on "Science and the Senses." *The Boston Evening Traveller* described what happened at the end of the address:

"When she had finished, the scenes that followed will long be remembered by those who saw them. The people were in the presence of the woman whose book had healed them, and they knew it. Up came the crowds to her side, begging for one hand-clasp, one look, one memorial of her, whose name was a power and a sacred thing in their homes. Those whom she had never seen before—invalids raised up by her book, Science and Health; each attempted to hurriedly tell the wonderful story. A mother who failed to get near held high her babe to look on her helper. Others touched the dress of their benefactor, not so much as asking for more. An aged woman, trembling with palsy at Mrs. Eddy feet, cried, 'Help, help!' and the cry was answered. Many such people were known to go away healed."

Other healings that day involved rheumatism, paralysis, diabetes. One in particular was noted by several people. A woman in the front row had come in with great difficulty on crutches. At the conclusion of the talk she rose

and spoke to Mrs. Eddy, who leaned over the platform to reply. Immediately the woman laid down her crutches and walked out free." Mrs. Eddy healed her just as a mathematician would heal 2x2=5.

If we weren't all so buried in the senses, if we could all learn the lesson of love, we would all be doing this same kind of healing today.

Loving Rebukes: a Call to Awaken

While Mrs. Eddy was in Chicago a number of her students met, back in Boston, and rebelled against her. Even so, Mrs. Eddy continued to love them. Love was the only way Mrs. Eddy knew to respond to hate, or to settle disagreements. She knew that "the arrow that doth wound the dove darts not from those who watch and love, [for] Love alone is Life; and life most sweet, as heart to heart speaks kindly when we meet and part."

Mary Baker Eddy did not turn away from her students when they failed her. Like Jesus in the Garden of Gethsemane, she returned again and again to lovingly urge them to wake up. She reproved, rebuked, exhorted with a boundless love. Like Jesus on the cross she proffered forgiveness in place of judgment, "for they know not what they do."

Now, after this students' rebellion, Mrs. Eddy again saw the great need of teaching her students how to guard against the influence of animal magnetism—the belief that mind is in matter and is both evil and good, that evil is as real as good, and more powerful.

Mrs. Eddy was separated from most theologians of her day, because she knew that in order to heal as Jesus did, one needs to believe and understand that God [infinite good, your own real Mind, "the kingdom of God within" your consciousness] does not know evil, and therefore one must treat evil as an illusion of the carnal Mind, as merely

59

hypnotic suggestion. The problem of animal magnetism is not one of overcoming a real power, but of not being influenced by the false suggestion that matter or brain, or human methods have power.

Mrs. Eddy considered teaching the handling of animal magnetism most important today. She wanted it thoroughly understood "that human will is not Christian Science, and he [the Christian Scientist] must defend himself from the influence of human will. He feels morally obligated to open the eyes of his students that they may perceive the nature and methods of error of every sort, especially any subtle degree of evil, deceived and deceiving" (S&H 451:20). "Uncover error, and it turns the lie upon you," she tells us, but we must *continue* to uncover it so it can be seen that it is illusion only, hypnotic suggestion, for it has no power when seen correctly.

It was Mary Baker Eddy's correct seeing—seeing with the eyes of Love—that enabled her to heal continuously. She "saw the love of God encircling the universe and man;" and this love so permeated her consciousness that she healed with Christ-like compassion everyone who turned to her for healing.

"Christianity, with the crown of Love upon her brow, must be [our] queen of life" (S&H 451:6). Then we will demonstrate the nothingness of sickness and sin. Our lives will reveal the omnipotence of divine good, and healing will follow.

The Love that crowned Mary Baker Eddy's life work transcended any sense of self. Meekness was one of the great qualities of the Leader of Christian Science, and one she especially valued, for it is essential in the healing practice. Mrs. Eddy's meekness, along with her unselfed love, purity, honesty, fearlessness, wisdom, and her absolute faith in God were her foundation stones as she brought the Second Coming of the Christ, the "Comforter" Jesus promised.

It was because Mrs. Eddy *lived* what she taught, and because she "let this Mind be in [her], which was also in Christ Jesus" that she was able to perform so many thousands of healings and taught her students to heal. It was because she constantly launched out deeper and anchored herself to God [to her own real divine Mind, "the kingdom of God within" her consciousness], that she could instantly heal the errors presented to her.

Mrs. Eddy warned that we are inconsistent if we fail to *do* as we *say*. She was instant and loving both in her rebuke of the wrong method and in her explanation of the right way to heal because she knew that only so far as the purity of the divine Mind was reflected in the students' minds, only to that degree would they succeed in healing. "When will the Spirit of Truth and Love prevail throughout the ranks of those who profess to be Christian Scientists?" she pleaded. The harvest has not yet come, but the way to the accomplishment of all good is marked by three milestones: self-knowledge, humility, love.

"The Onward March"

In November, 1888, Mrs. Eddy wrote a student, "We are gaining in the onward march slowly, but surely, through the clouds of selfishness out into the light of universal Love. God speed the dawn. Our cause has had a great propulsion from my late large class. Over fifty members have gone into our C. S. Association since the stampede out of it."

As always, Mary saw the future prophetically. When discouragement assailed her, spiritual vision showed her the path ahead. She had learned to *walk over*, not through, troubled waters of mortal strife. She utterly trusted the Truth which had delivered her from frailty and suffering. Thus was Mrs. Eddy led, by foresight and wisdom, to guide the initial stages of a movement destined to be world-wide, and to unfold forever.

In March 1892 Mrs. Eddy wrote in the *Journal*: "If our Church is organized, it is to meet the demand, 'suffer it to be so now.' The real Christian compact is love for another. This bond is wholly spiritual and inviolate. Our prosperity and progress rest on the love felt and expressed for each other by its members."

Because Mrs. Eddy saw that more of the spirit than of the letter was required to reach the Christ-stage of healing instantly, and to encourage this spirit she spent much of 1893 working with James Gilman, an artist from Vermont, to illustrate a poem she had written early in the year. *This poem, and the pictures illustrating it, she said, were her life story*.

In June of 1899 Mrs. Eddy traveled to Boston to address the Annual Meeting of The Mother Church. Because of the large numbers attending that year, the meeting was held in Tremont Temple. Mrs. Eddy told her students that the special demand of the hour was the "fulfillment of divine Love in our lives...." She went on to say, "Divine Love has strengthened the hand and encouraged the heart of every member....Divine Love hath opened the gate Beautiful to us, where we may see God and live....Divine Love will also rebuke and destroy disease, and destroy the belief of life in matter....Divine Love is our only physician, and never loses a case. It binds up the broken-hearted; heals the poor body, whose whole head is sick and whose heart is faint...."

As always when Mrs. Eddy spoke there were healings, wonderful healings, many of which are preserved in the archives of the Mother Church. Mary Baker Eddy taught and demonstrated dominion over all evil. She taught lasting spiritual peace. The divine revelation of Christian Science had come from infinity, it moved through infinity, and the Leader moved with it.

Hear again the triumphant promise of Isaiah 54, "For thou shalt break forth on the right hand and on the left;

and thy seed shall inherit the Gentiles, and make the desolate cities to be inhabited. Fear not; for thou shalt not be ashamed: neither be thou confounded; for thou shalt not be put to shame."

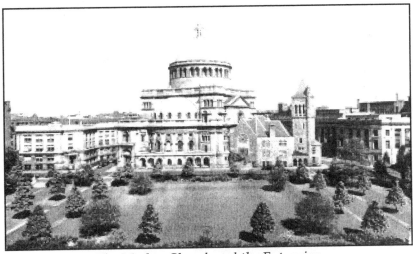

The Mother Church and the Extension

How true this prophecy was can be seen from what occurred at the time of the dedication of the Extension to the little Mother Church in 1906, a short sixty years after her great discovery of evil's unreality and infinite good's allness, fulfilling Jesus' promise and prophecy of the "Comforter," the Second Coming of the Christ. Thousands of Christian Scientists poured into Boston. "The press of the world was staggered at this sign of so great a vitality in so new a religion." Of this occasion, Sibyl Wilbur wrote:

> The Christian Scientists who had come to Boston to see The Mother Church [Extension] dedicated, remained to attend the Wednesday evening meeting at which testimonies of Christian Science healing were given. The great temple was crowded from floor to dome, and overflow meetings were held in the original Mother Church and in *four*

public halls. Many who were not Christian Scientists were amazed listeners to the outpouring of testimonies from every part of the great auditorium. Men and women arose in their places on the floor of the church, and in first and second balconies. As each arose he called the name of his city and waited his turn to tell of the miracle of health and virtue wrought in his or her life as a result of the study of Christian Science. The names of the cities called up the near and the far of the civilized world—Liverpool, Galveston, St. Petersburg, San Francisco, Paris, New York, Atlanta, and Portland. There were colored people as well as white in that audience; there were French, German, and Scandinavian; there were army officers from Great Britain, and members of the British nobility, Americans of great wealth, jurists, former doctors and clergymen, teachers, clerks, day laborers.

It was like a jubilation of any army with banners. And not only with the vanquishment of cancers, consumption, broken limbs, malignant diseases, and paralysis did these votaries of Christian Science testify, but of poverty overcome, victory gained over drunkenness, morphine, and immoral lives. It was a triumphant assertion of health and power of spiritual living. (*The Life of Mary Baker Eddy*, Sibyl Wilbur, p. 342).

S. P. Bancroft, who had studied with Mrs. Eddy in 1870, and who was present when Bronson Alcott visited her little group in 1876, wrote to Mrs. Eddy at this time of dedication:

My dear Teacher, Of the many thousands who attended the dedicatory services at the Christian Science church last Sunday it is doubtful if there was one so deeply impressed with the grandeur and magnitude of your work as was the writer,

whom you will recall as a member of your first class in Lynn, Mass., nearly forty years ago. When you told us that the truth you expounded was the little leaven that should leaven the whole lump, we thought this might be true in some far distant day beyond our mortal vision. It was above conception that in less than forty years a new system of faith and worship, as well as of healing, should number its adherents by the hundreds of thousands, and its tenets be accepted wholly or in part by nearly every religious and scientific body in the civilized world...

Seated in the gallery of that magnificent temple, which has been reared by you, gazing across that sea of heads, listening again to your words explaining the Scriptures, my mind carried back to that first public meeting in the little hall on Market Street, Lynn, where you preached to a handful of people....As I heard the sonorous tones of the powerful organ [in this grand amphitheater] and the mighty chorus of five thousand voices, I thought of the little melodeon on which my wife played, and of my own feeble attempts to lead the singing.

Possibly you may remember the words of my uncle, the good old deacon of the First Congregational Church in Lynn, when told that I had studied with you. "My boy, you will be ruined for life; it is the work of the devil." He only expressed the thought of all Christian (?) people at that time. What a change in the Christian world! "The stone which the builders rejected" has become the corner-stone of this wonderful temple of "wisdom, Truth, and Love...." (*My.* pp.58-60).

Part II

Atonement and Eucharist:
the story of the Second Coming of the Christ as Revelation

Mary Baker Eddy tells us that "Atonement and Eucharist," Chapter II of Science and Health, is *her* life story as well as that of Jesus. Nearly 2000 years ago Jesus said, "I am a man who has told you the truth."

What did he tell us was the truth?

He said, "The kingdom of God is within you," meaning it is your own Mind, the Mind that is Love and knows only infinite good.

Jesus also said, "I have yet many things to say unto you, but ye cannot bear them now." Two thousand years ago people were just coming out of mythology, and were too ignorant to understand Jesus' meaning—that the kingdom of God is your own real Mind. But Jesus promised and prophesied that the "Comforter" would come in the Second Coming of the Christ, and would "tell you all things and be with you forever." This Comforter, this second coming of the Christ, is the Christian Science brought to us by Mary Baker Eddy, who can never be separated from her revelation.

We have seen how Isaiah 54 prophesied this momentous event. However, although we find Mary Baker Eddy *prophesied* in Scripture, she has told us that we find *her* only in her writings. Those who look for her elsewhere lose her instead of find her.

Let's see how the chapter "Atonement and Eucharist" heralds forth Mary Baker Eddy's life and teaching as well as that of Jesus. In the pages that follow all quotes, unless

otherwise noted, are drawn from "Atonement and Eucharist," pages 18-55 in the current (1910) edition of Science and Health.

At-one-ment Must Be By Example

"Atonement and Eucharist" begins with an overtone of Mind, which shows that "At-one-ment" must be *by example.* Since "the kingdom of God is within you," our own real Mind must be Love; it must be the infinite good we call God. Mrs. Eddy, like Jesus, taught and demonstrated this oneness with Mind, the kingdom of God within our consciousness. For this we owe them both endless homage.

Mrs. Eddy's work, like that of Jesus, was both individual and collective. Its purpose was to bless all mankind. Mrs. Eddy, like Jesus, acted boldly, against the accredited evidence of the senses, against Pharisaical creeds and practices, against Old Theology. Jesus and Mary Baker Eddy refuted all opponents with their healing power. In Mary Baker Eddy's case, by the year 1906 it was estimated that two millions cases had been healed by Mrs. Eddy and her students. Even the prestigious Mayo Medical establishment was sending their incurable patients to Christian Science practitioners, and they were healed.

Archivists tell us that in the archives of the Mother Church 21,000 letters and articles by Mary Baker Eddy are to be found, as well as records of hundreds of her healings that have never been put into book form. Of these healings, Mrs. Eddy wrote, "Now as then, signs and wonders are in the metaphysical healing of physical disease; but these signs are only to demonstrate its divine origin,—to attest the reality of the higher mission of the Christ-power to take away the sins of the world" (S&H 150:12).

Mrs. Eddy tells us, "It was Christ's purpose to reconcile man to God"—to make all mankind aware that "the

kingdom of God within you" is your real Mind. This was Mary Baker Eddy's purpose as well. She wanted to awaken us to the spiritual facts of being, to "our present ownership of all good," to a full understanding of the truth that enabled Jesus to say, "When ye stand praying, believe that you already have what you are asking for."

Before Mrs. Eddy's time people thought that God was a man like we seem to be. Why? Because the Bible said that "God made man in His own image and likeness." Therefore people thought because we seem to be matter bodies God must be a man having a matter body. Mrs. Eddy's inspired teaching changed all that.

For nearly forty years Mrs. Eddy worked to perfect her definition of God—"the kingdom of God within" your consciousness, your true Mind. In Science and Health, p. xii: 20, Mrs. Eddy writes, "Until June, 1907, she [herself] had never read this book through consecutively in order to elucidate her idealism." It was in that reading in 1907 that she first saw that God, the kingdom of God within your consciousness, was correctly defined by *seven* instead of eight synonyms as she had previously defined God, infinite good. "Being" had been the eighth synonym. But she now saw that "Mind, Spirit, Soul, Principle, Life, Truth, and Love" were our "being."

Mary Baker Eddy's definition of God marks the only time in human history that God has been defined.

Why was it so important to define God?

Because God is our own real Mind. As Jesus said, "The kingdom of God is within you," so it would have to be your true consciousness, your true Mind.

To a student Mrs. Eddy wrote: "To know there is but *one* God [infinite good, your own real Mind, "the kingdom of God within you" as your true consciousness] one Cause, one effect, one Mind, heals instantly. Have but One God, and your reflection of Him does the healing [since "Principle and its idea is *ONE*"].

"Love is the only and all of attainments in spiritual growth. Without it, healing is not done and cannot be, either morally or physically. Every advanced step will show you this until the victory is won and you possess no other consciousness but *Love* divine."

Jesus and Mrs. Eddy Spoke the Whole Truth

After taking up the tone of Mind, the chapter Atonement and Eucharist next takes up a tone of Spirit (S&H 19:12). Jesus and Mrs. Eddy both brought a sword to material beliefs. They did not hesitate to speak the whole truth. What does Mrs. Eddy say here that will help us understand atonement for sin and aid its efficacy? She says, "Every pang of repentance and suffering, every effort for reform, every good thought and deed, will help us understand Jesus' atonement for sin, and aid its efficacy." She spoke from personal experience; her own spiritual understanding, as we have seen, was won through patient seeking and suffering.

Jesus and Mrs. Eddy bore our infirmities; they knew the error of mortal belief, *and with their stripes—the rejection of error—we are healed.* "Despised and rejected of men, returning blessing for cursing, Jesus [and Mary Baker Eddy] taught mortals the opposite of themselves, even the nature of God [infinite good]."

Jesus and Mrs. Eddy urged the commandment, "Thou shalt have no other gods before me," meaning we must acknowledge the kingdom of God that is within us as our real and only Mind. This means, as Mrs. Eddy explains, "Thou shalt have no belief of Life as mortal; thou shalt not know evil, for there is one Life,—even God"—the infinite good that is "the kingdom of God within" your consciousness.

When error felt the power of Truth, hatred and vengeance awaited Jesus and Mary Baker Eddy. Yet they

"swerved not, well knowing that to obey the divine order and trust God [infinite good], saves retracing and traversing anew the path from sin to holiness."

Mrs. Eddy quickly learned that "material belief is slow to acknowledge what the spiritual fact implies. The truth is the centre of all religion. It commands sure entrance into the realm of Love"—our true Mind, "the kingdom of God within" our consciousness. Therefore "let us put aside material self and sense, and seek the divine Principle and Science of all healing" (S&H 20:30).

We must constantly turn away from material sense, and look toward the imperishable things of Spirit, meaning of true substance, understanding, reality. "Be not weary in well doing." Mrs. Eddy encourages us, "If your endeavors are beset by fearful odds, and you receive no present reward, go not back to error, nor become a sluggard in the race" (S&H 22:14). Because we are so sound asleep in the Adam dream that has hypnotized us to think we live in a matter body, "wisdom and Love may require many sacrifices of self to save us from sin."

"The efficacy of the crucifixion lay in the practical affection and goodness it demonstrated for mankind. The truth had been lived among men; but until they saw that it enabled their Master to triumph over the grave, his own disciples could not admit such an event to be possible." Here let us add that human theories are inadequate to interpret the divine Principle involved in this divine event, which Mrs. Eddy speaks of as "his mighty, crowning, unparalleled, and triumphant exit from the flesh" (S&H 117:21).

Jesus and Mary Baker Eddy worked for our guidance, that we might demonstrate this power as they did and understand its divine Principle. Mrs. Eddy designed the Mother Church so that healing would permeate all of its activities. She constantly wanted her students to broaden their avenues for blessing the people. She said, "Learn to

forget what you should not remember *viz.* self, and live for the good you do."

We must "go and do likewise," else we are not improving the great blessing which Jesus and Mary Baker Eddy worked and suffered to bestow upon us. Mrs. Eddy writes, "The divinity of the Christ was made manifest in the humanity of Jesus" (S&H 25:31).

We know Mrs. Eddy is also speaking of her experience when she writes, "While we adore Jesus and the heart overflows with gratitude for all he did for mortals,—treading alone his loving pathway...in speechless agony exploring the way for us, yet [neither Mrs. Eddy nor] Jesus spares us one individual experience, if we follow [their] commands faithfully; and all have the cup of sorrowful effort to drink in proportion to their demonstration of love, till all are redeemed through divine Love..." Their mission was to reveal the Science of celestial being, to prove what infinite good, "the kingdom of God within" your consciousness, your own true Mind, is and does for man. Man is this true Mind's reflection; therefore "man" is always spiritual and perfect. Christian Science reveals "the omnipresence of present perfection."

Jesus' and Mary Baker Eddy's teaching and practice involved such a sacrifice as makes us admit its Principle to be Love. They "proved by their deeds that Christian Science destroys sickness, sin, and death." They taught and practiced the divine Principle of all real being. We must follow their example, and work out the harmony of Life and Love. As we do, we will find that "the I—the Life, substance and intelligence of the universe—is not in matter to be destroyed." Jesus and Mrs. Eddy "laid the axe of Science at the root of material knowledge that it might be ready to cut down the false doctrine of pantheism,—that God, or Life, is in or of matter."

Mrs. Eddy, like Jesus, found that many of her students stood in her way. "If the Master had not taken a

student and taught the unseen verities of God, he would not have been [thrown into the cauldron of hate; he would not have been] crucified" (S&H 28:4). Mrs. Eddy had the same experience. At the end, it was her own students in the highest echelon that caused her "mental murder"—something her enemies had never been able to accomplish.

At one time Mrs. Eddy said, "My students are doing more for, and against Christian Science than any others can do. They are the *greatest sinners on earth when they injure it;* and doing more good than any others when they do the best they know how" (A Carpenter item).

Oh, how much Mrs. Eddy wished that all Christian Scientists were awake and demonstrating Love and intelligence as they should. In June, 1901, Mrs. Eddy wrote a student: "Wisdom is one third of Christian Science, the other two-thirds is *Love.*"

In a meeting with her students in February of 1885 Mrs. Eddy told them:

The grand secret of your success is in your Christianity. Just in proportion as mortal sense is hushed [in the mind of the practitioner], just in that proportion will healing be done.

Some say "We are doing all we can." Stop the utterance. *Do more.* God is making the extreme trial an occasion for your good. Such moments are the most glorious of all experiences because God's hand is stretched out over them.

We have God [infinite good] on our side to meet *all* questions, and I have never found an hour when He [infinite good] would not deliver me.

"The determination to hold Spirit in the grasp of matter is the persecutor of Truth and Love," Mrs. Eddy says in Atonement and Eucharist. By understanding more of

72

the Principle of the deathless Christ, we are enabled to heal the sick and to triumph over sin. This understanding will come as we persevere in our study of Mary Baker Eddy's teaching.

"Our churches spring up spontaneously from the soil of healing," Mrs. Eddy wrote a student, "But I know that a healer needs all her time to do her best in caring for patients. It is an absorbing subject to lift the mind above pain, disease, and death and when I practiced I could not attend to aught else."

Mrs. Eddy learned from the Bible how to wear Love's "wedding garment." What is the "wedding garment" of divine Love?

The "wedding garment," Mrs. Eddy explained to a student, "is first the desire above all else to be Christ-like, to be tender, merciful, forgetting self and caring for others' salvation. To be temperate, pure, whereby appetite and passions cease to claim your attention and you are not discouraged to wait on God. To wait for the *tests* of your sincere longing to be good, and seek, through daily prayer for Divine teaching. If you continue to ask you will receive,—provided you comply with what you must do for yourself in order to be thus blessed....Be of good cheer, you cannot *seek* without *finding*."

Mrs. Eddy's desire above all else was to heal as Jesus did.

She wrote to her students, the Millers, "Today it is a marvel to me that God chose me for this mission, and that my life-work was the theme of ancient prophecy and I the scribe of His infinite way of salvation! O may he keep me at the feet of Christ, cleansing the human understanding and bathing it with my tears; wiping it with the hairs of my head, the shreds of my understanding that God "numbered" to make men wise unto salvation."

But in the beginning, with her as it was with Jesus, "neither the origin, the character, nor the work of [Mary Baker Eddy] was generally understood, not a single com-

ponent part of [her] nature did the material world measure aright." They did not see the purity of her thought. "To suppose that persecution for righteousness' sake belongs to the past, and that Christianity today is at peace with the world because it is honored by sects and societies, is to misunderstand the very nature of religion. Error repeats itself," she wrote.

Surely Mrs. Eddy found that the "trials encountered by prophet, disciple, and apostle, 'of whom the world was not worthy,' await, in some form, every pioneer of truth" (S&H 28:29).

How do we finally "have the crown of rejoicing"? Mrs. Eddy answers, "Christian experience bids us work more earnestly in times of persecution because then our labor is more needed." "Great is the reward of self-sacrifice, though we may never receive it in this world."

Born of a Woman

Mrs. Eddy tells us that the Virgin-mother conceived the idea that God—infinite good, the kingdom of God within our consciousness as our real Mind—is the only author of man. She "gave to her ideal the name of Jesus— that is Joshua, or Saviour" (S&H 29:18).

"The illumination of the [Virgin] Mary's spiritual sense put to silence material law and its order of generation, and brought forth her child by the revelation of Truth, demonstrating God, Mind, ["the kingdom of God within" our consciousness] as the Father of men. [Our Mind, our consciousness, is the only creator. Therefore man is image or idea.] The Holy Ghost [divine Science] or divine Spirit, overshadowed the pure sense of the Virgin-mother with the full recognition that being is Spirit. The Christ [the reflection of God, Mind, "the kingdom of God within you," within your consciousness] dwelt forever an idea in the bosom of God, the divine Principle of

74

the man, Jesus, and woman perceived this spiritual idea, though at first faintly developed." The Virgin Mary glimpsed that man is an idea, manifested by her Mind, by "the kingdom of God within [her consciousness]." It was this recognition that "overshadowed the pure sense of the Virgin-mother with the full recognition that being is Spirit."

Therefore, Mrs. Eddy states, "Jesus was the offspring of "Mary's self-conscious communion with God [her own real Mind, "the kingdom of God within" her consciousness]. Hence he could give a more spiritual idea of life than other men, and could demonstrate the Science of Love,...his divine Principle," meaning the Mind that was the kingdom of God "within his consciousness."

Because he was born of a woman Mrs. Eddy said, Jesus' advent in the flesh partook partly of Mary's earthly condition. Had his origin and birth been wholly apart from mortal usage, Jesus would not have been appreciable to mortal mind as "the way." Only after nearly two thousand years since the time of Jesus, do we have Mary Baker Eddy, born of *two* parents, fulfilling the scriptural promise of Jesus to send "another Comforter," the Second Coming of the Christ, and fulfilling also the promise of Isaiah's 54th chapter.

No Ties of the Flesh

Why was Mary Baker Eddy chosen for this holy task? Perhaps because she alone was worthy. Mrs. Eddy tells us (S&H 31:1), "Pride and fear are unfit to bear the standard of Truth, and God will never place it in such hands." Mrs. Eddy certainly knew neither pride nor fear, and all her life she sought after the spiritual as men seek for buried treasure.

Perhaps even more important, Mary Baker Eddy, like Jesus "acknowledged no ties of the flesh." Because Jesus knew that man is the reflection of our true and real divine Mind, of "the kingdom of God" within our consciousness,

he was fully aware that the belief in a fleshly mortal was merely hypnotic suggestion, illusion only, and would disappear when the light of truth dawned on human consciousness. Therefore, as Mrs. Eddy tells us, "Jesus acknowledged no ties of the flesh." He, like Mary Baker Eddy, recognized Spirit, Mind, as the only creator, and therefore as the "Father" of all.

"Referring to the materiality of the age, Jesus said: 'The hour cometh, and now is, when the true worshippers shall worship the Father [Mind, the kingdom of God within your consciousness] in spirit and in truth.' He also saw the persecution that would attend the Science of Spirit, and said, 'They shall put you out of the synagogues; yea, the time cometh, that whoso killeth you will think that he doeth God service; and these things will they do because they have not known thee.'" "They have not known" the truth about the kingdom of God, infinite good, within their consciousness, which is the only creator.

Like Jesus, Mary Baker Eddy understood that "All is infinite Mind and its infinite manifestation." Jesus and Mary Baker Eddy both taught that human birth is the first death. In the Gospels Jesus said, "Blessed are the wombs that never bare." This angered the high priests, and caused Jesus' crucifixion. Mrs. Eddy, too, angered many when she instructed that bringing a child into the world was murder. Jesus and Mrs. Eddy both knew that human birth pulls the wool over our eyes, and causes us to "see through a glass darkly."

The illusion of birth subjects us to the illusion of death. In notes from *Divinity Course and General Collectanea* (p. 14), compiled by Richard Oakes, we find the following:

In a booklet entitled *Fragments of a Lost Gospel,* published by the Oxford University Press, giving account of the sayings of Jesus that are regarded as authentic by scholars, we find the following: "When Salome asked when those things about which she questioned should be made known, the Lord said,

'When ye trample upon the garment of shame, when the two become one and the male with the female, neither male nor female.' The meaning being that Christ's kingdom on earth would not be manifested until man had returned to that state of innocence in which sexual ideas and relations had no place. [This is why Jesus loved little children—they were innocent of sexual notions and relationships].

When Salome asked how long death would prevail, the Lord said, "So long as ye women bear children, for I have come to destroy the works of the female" (Logia of Jesus, *Christian Science Journal*, Vol. 25). Jesus was asked, "When shall the dominion of death cease?" Jesus saith, "As long as (material) birth continues, for I am come to destroy the works of birth." (See Matt. 5:17 and S&H 69).

Is it not true that many so-called Christians secretly feel "Jesus blasphemeth" when he taught in Luke, "Blessed are the wombs that never bare," and when he told Salome: "Death will never cease until ye women cease your childbearing"?

When Laura Sargent asked Mrs. Eddy, "Mother, what do you mean by 'sin, sin, sin'?" Mrs. Eddy answered, "I mean the connubial relationship." When someone wrote, asking Mrs. Eddy to congratulate them over the birth of a Christian Science baby, Mrs. Eddy read the letter aloud to her household; "then with apparent indignation uttered: 'A Christian Science baby! A crime! Just as much a crime as murder would be!'"(Carpenter items).

How many so-called Christian Scientists would, like the high priests of old, say "within themselves," "this [woman] blasphemeth"? In Science and Health we read, "The earthly price of spirituality in a material age and the great moral distance between Christianity and sensualism precludes Christian Science from finding favor with the worldly minded" (p.

36:14). This is why Scripture warns us "the remnant shall be few and very feeble." How many today have the courage to step forward and defend Mary Baker Eddy in her teaching on this subject? Or to defend her when her God-dictated *Manual* is disobeyed and voided by human and materially-minded seekers for temporal power—who persuaded those who "want a king to rule over them," that Mary Baker Eddy and her *Manual* estoppels can't rule from the grave?

Mary Baker Eddy's teaching of man as never born and never dying is basic to learning our immortality, and our oneness with the infinite good we call God, namely, "the kingdom of God [of infinite good] within" our consciousness, our own real divine Mind. "It is the spiritualization of thought and Christianization of daily life [Mrs. Eddy has 50 references to "daily"], in contrast with the results of the ghastly farce of material existence; it is chastity and purity in contrast with the downward tendencies and earthward gravitation of sensualism and impurity, which really attest the divine operation of Christian Science. The triumphs of Christian Science are recorded in the destruction of error and evil, from which are propagated the dismal beliefs of sin, sickness, death" (S&H, p. 272:19).

Again, Mrs. Eddy writes: "The broadcast powers of evil so conspicuous today show themselves in the materialism and sensualism of the age, struggling against the advancing spiritual era. Beholding the world's lack of Christianity, and the powerlessness of vows to make home happy, the human mind will at length demand a higher affection" (S&H 65:13). "The false claims of error continue the delusion until the goal of goodness is assiduously earned and won" (S&H 233:13).

Mary Baker Eddy's purity and spiritual understanding fitted her to teach the Truth. Through the "Comforter," the Second Coming of the Christ, promised and prophesied by Jesus, every human being is destined to learn his oneness with his divine Principle, Love.

"The Cup of Our Lord"

As the Wayshower and Witness to the Truth, Mary Baker Eddy, like Jesus, found that her path led through suffering. Again in Atonement and Eucharist (Science and Health, page 32) we read of "the cup of our Lord." Here Mrs. Eddy writes, "The cup shows forth his bitter experience,—the cup which he prayed might pass from him, though he bowed in holy submission to the divine decree."

Jesus' last sad supper that he ate with his disciples was a mournful occasion taken at the close of day with shadows fast falling around. "This supper closed forever Jesus' ritualism or concessions to matter." For the truth Jesus had taught he "was about to suffer violence and drain to the dregs his cup of sorrow....With the great glory of an everlasting victory overshadowing him, he gave thanks and said, 'Drink ye all of it.'"

"When the human element in him struggled with the divine, our great Teacher said:....'Let not the flesh, but the Spirit, be represented in me.' This is the new understanding of spiritual Love. It gives all for Christ, or Truth." Mrs. Eddy too, like Jesus, took up the cross and left all for the Christ-principle. For the Christ-principle she gave up family and friends, endured the world's taunts and slander and the betrayal of trusted students and finally, like Jesus, knowingly allowed herself to be given into the hands of her enemies.

Mrs. Eddy's final sacrifice came when she left her beloved home in Concord, N.H., to return to Boston in 1908. The move from Boston to Concord, at the dawn of the 1890's had been a significant and welcome crossroad in Mrs. Eddy's life. In Pleasant View, her new quiet home, more isolated from society, she devoted herself to writing and study, first bringing out the 50th edition of Science and Health.

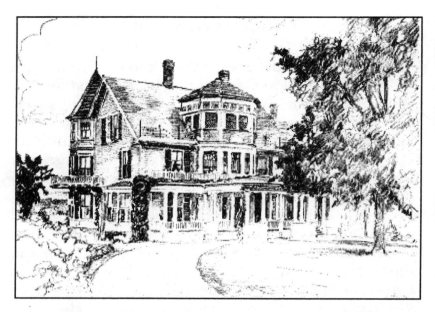

Mrs. Eddy's beloved "Pleasant View" in Concord, N.H.

Mary Baker Eddy once told a dear student that if she ever left Pleasant View it would be to be delivered up to her enemies, yet on January 26, 1908 she left Pleasant View. Why?

In order to bless all mankind.

As early as 1878 Mrs. Eddy had publicly declared an interest in having a newspaper at her disposal "to right the wrongs and answer the untruths" (S&H, second edition 1878, p. 166), but she could not oversee such an undertaking from Pleasant View.

Thus it was that, impelled by divine Love, she left the home she so dearly loved and moved to Chestnut, a suburb of Boston, to help establish a daily newspaper, the *Christian Science Monitor,* which she hoped would have a healing effect on the world. And, as she had forseen, two years later she was mentally murdered by her own power-seeking students.

Under the heading of "Millennial glory," we read: "If all who ever partook of the sacrament had *really* commemorated the sufferings of Jesus and drunk of his cup, they would have revolutionized the world [and would have brought in the millennium]."

The Joyful Meeting on the Shore of the Galilean Sea

"In the bright morning hours at the joyful meeting on the shore of the Galilean Sea" (S&H 34:31), the disciples discerned Christ, Truth, anew and "were enabled to rise somewhat from mortal sensuousness, or the *burial of mind in matter*, into newness of life as Spirit." Mrs. Eddy teaches us how to overcome all error. She writes that "our baptism is a purification from all error. [It certainly was for her.] Our church is built on the divine Principle, Love. We can unite with this church only as we are new-born of Spirit, as we reach the Life which is Truth and the Truth which is Life by bringing forth the fruits of Love" as Mrs. Eddy surely did.

It was so important to Mary Baker Eddy that Christian Science express Love in practical ways. Her last talk to the workers in her beloved Pleasant View home concerned the importance of healing: "Give all your time to healing. Perfect yourself in this." This meant, "Physician, heal thyself"—the practitioner is always the patient who must heal himself of believing any error presented to him is true. "Error comes to [the practitioner] for life, and [the practitioner] gives it the only life it has," said Mrs. Eddy.

Nothing was more important to Mrs. Eddy than that Christian Scientists devoted themselves to the healing practice—healing themselves of the belief that error, sin sickness, inharmony of any kind, is anything but illusion, hypnotism. For more than forty years Mrs. Eddy had devoted her life entirely to fulfilling Jesus' prophecy and promise to send another "Comforter" who would teach

81

mankind to heal as he had healed. She would bring the Second Coming of the Christ that would teach all humanity that our own Mind is God—is "the kingdom of God within" our consciousness, that would be aware of "the omnipresence of present perfection."

"Without the proof of healing, there is no real Christian Science. When we lean on God [our real, true Mind, "the kingdom of God within" our consciousness] and deny that which is ungod-like, always affirming the perfection and omnipresence of the one perfect Principle [that is our real Mind], we will experience healing. The crown of divine Love comes or follows in the unselfed living for others."

Answering the question of how to heal quickly, Mrs. Eddy said to her last class, "Just be Love, be it; be nothing but Love."

"The design of Love is to reform the sinner....Divine Science reveals the necessity of sufficient suffering, either before or after death, to quench the love of sin....Jesus endured the shame, that he might pour his dear-bought bounty into barren lives. What was his earthly reward? He was forsaken by all save John, the beloved disciple, and a few women who bowed in silent woe beneath the shadow of his cross."

Mrs. Eddy was speaking of her own experience when she wrote, "The earthly price of spirituality in a material age and the great moral distance between Christianity and sensualism precludes Christian Science from finding favor with the worldly-minded....Martyrs are the human links which connect one stage with another in the history of religion. They are earth's luminaries, which serve to cleanse and rarefy the atmosphere of material sense and to permeate humanity with purer ideals" (S&H 36:14 to 37:12).

Too many assume that Jesus' commandments were intended only for a particular period and for a select number of followers. "This teaching," Mrs. Eddy says, "is even

more pernicious than the old doctrine of foreordination,—the election of a few to be saved, while the rest are damned." This was what the young Mary Baker stood against so stoutly in her childhood. She firmly believed that Jesus' words were still true: "These signs shall follow them that believe;...they shall lay hands on the sick, and they shall recover."

Mary understood that the word *hands* is used metaphorically, as in the text, "The right hand of the Lord is exalted." She saw the significance of the fact that while Jesus was addressing his disciples, yet he did not say, "These signs shall follow *you*," but "These signs shall follow *them*." She understood that this meant not just his disciples but all *"them that believe"* in all time to come.

The cause needs healers more than it needs teachers. Mrs. Eddy wrote to the Editor of the Journal: "I started this great work and *woke the people* by demonstration, not by words, but by works. Our periodicals must have more testimonials....The sinner and the sick healed are our best witnesses." Wherever Mrs. Eddy lectured, or spoke in sermons, wonderful healings followed.

All that error threw at Mary Baker Eddy—disease, insanity, death, legal attacks that threatened everything she had worked to establish—error in every form, was treated as an occasion to heal, just an opportunity to show the world that God is an ever-present help in trouble.

Mind, not matter, is our Life, and we can rejoice in knowing that Mind never dies. Sin and a false sense of life is all that dies. Immortality and blessedness never die, hence we should banish the false sense; it is not real.

When the editor of the *Minneapolis Daily News* asked for a statement of what Christian Science could do for universal fellowship, Mrs. Eddy replied:

Christian Science can and does produce universal fellowship as a sequence of divine Love. It explains Love, it lives Love, it demonstrates Love. The

human material so-called senses do not perceive this fact until they are controlled by divine Love, hence the Scripture: "Be still and know that I am God." [This means, "know that I am Mind, Spirit, Soul, Principle, Life, Truth, Love."] (*My.* 275:3.)

To a student she wrote: "Faith in and the spiritual understanding of the allness of divine Love, heals. Work and wait, watch and pray, till you know the allness of God [infinite good, your own right Mind, "the kingdom of God within" your consciousness] and in that understanding you will gain the desired result, the 'secret place,' then you can abide under the assurance spiritual of his support." Healing the sick and the sinner with truth, demonstrates what we affirm of Christian Science, and nothing can substitute this demonstration.

Let us all, as Christian Scientists, address ourselves to becoming better healers. Watch, pray, labor and have faith. Know that you can be what God, your real, true Mind, "the kingdom of God within" your consciousness, demands you to be and *now are*.

Her Healing Ability Remained Undiminished

Mrs. Eddy's desire to be Christ-like was constant. Her healing ability remained constant too. Because Mrs. Eddy found Calvin Frye of great help to her, it seemed error wanted to deprive her of that help. She raised Mr. Frye from death several times, because she needed him in her daily work for the world. George Kinter, a worker in Mrs. Eddy's home, tells of one of the times that Mrs. Eddy raised Calvin after he had been dead for some time. Mr. Kinter says Mrs. Eddy called him late one night in February, 1905, and asked him to find out why Mr. Frye had not answered her call.

When Mr. Kinter entered Calvin's bedroom, he found him slumped in a chair. He had passed on. He

was as cold and rigid as stone; he had no pulse. When Kinter reported this to Mrs. Eddy she went at once to Calvin's side and began treatment—denying the error and declaring the truth. Mr. Kinter says, and other members of the household also attest, that these denials of error and declarations of truth were uttered with such dominion and eloquence—*for a full hour*—as they had never heard before.

Mr. Kinter says that our beloved Leader called Calvin Frye with the following words:

"Calvin, wake up and be the man God made! You are not dead and you know it! Calvin, all is Life! How often have you proved there is no death. [Mrs. Eddy had raised Calvin from death several times before.] Calvin, all is Life! Life! Undying Life. Say, 'God is my Life'....Declare: 'I can help myself'....Rouse yourself. Shake off this nightmare of false, human belief and of fear. Don't let error mesmerize you into a state of believing Satan's lies about man made in God's image and likeness! Your lifework is not done. I need you. Our great blessed Cause needs you."

"Life is as deathless as God Himself for Life is God. Calvin, there is no death, for the Christian. Christ Jesus has abolished death, and this treatment is not reversed by error." (*Mary Baker Eddy: Christian Healer,* Yvonne von Fettweis and Robert Warneck, p. 200-1)

Slowly, after about an hour, Calvin moved. Then he spoke in low tones, just as he had done on two other occasions when Mrs. Eddy brought him back. He said, "Don't call me back. Let me go. I am so tired." But Mrs. Eddy needed Calvin Frye, and she answered him that she would persist in calling him back, for "You have not been away. You have only been dreaming. And now that you have

awakened out of the dream, you are not tired, and you do not concede any claims of the material senses [because God, infinite good is your own Mind]." (See *ibid.* p.201)

Kinter says that in another half hour "Calvin Frye had completely recovered." The rest of the night, he said, was peaceful, and in the morning Calvin resumed his regular duties in helping Mrs. Eddy.

Did Mrs. Eddy limit her healing ability to men and women? No. She said, "Heal the animals as well as mankind. When I was in [the continual healing] practice I healed them and found them responsive to Truth in every instance."

Mary Baker Eddy, like Jesus, mapped out the path for others. Like Jesus, Mrs. Eddy unveiled the Christ, the spiritual idea of divine Love. Both Jesus and Mrs. Eddy taught that "the material senses shut out Truth and its healing power" (S&H 38:31). Meekly, they both "met the mockery of [their] unrecognized grandeur. Such indignities as [they both] received, [their] followers will endure until Christianity's last triumph."

Both Jesus and Mary Baker Eddy have won eternal honors. As before stated, "Human theories are inadequate to interpret the divine Principle involved...in Jesus' mighty, crowning, unparalleled, and triumphant exit from the flesh" (S&H ll7:19). The time will come when Mary Baker Eddy will have won the esteem she deserves for bringing us the understanding of that Principle.

Mrs. Eddy knew that if we, as the practitioner, remove error from our thought error will not appear in effect in the patient. Old theology is always preparing for a future-world salvation. "The educated belief that Soul (true identity) is in the body, causes mortals to regard death as a friend....[but] Jesus overcame death and the grave instead of yielding to them. He was the way..."—he saw the total unreality of matter, saw it as illusion, hypnotic suggestion.

Mary Baker Eddy knew, like Paul, that "*Now* is the accepted time...*NOW* is the day of salvation." Jesus and Mrs.

Eddy taught that *now* is the time in which to experience that salvation by knowing and demonstrating the Truth they brought. She taught that *NOW* is the time for material pains and pleasures to pass away, for both are unreal.

Mary Baker Eddy had also learned that the advance beyond matter must come through the sorrows and afflictions of the righteous as well as through their joys and triumphs. Like Jesus and Mrs. Eddy we too must depart from material sense into the spiritual sense of being.

"Jesus foresaw the reception Christian Science would have before it was understood," but Jesus, knowing the power of Mind over matter "met and mastered on the basis of Christian Science, all the claims of medicine, surgery, and hygiene." Mrs. Eddy did likewise, and taught us how to do so. The key, she told us, is love.

This is what dominates through all Mary Baker Eddy's teaching—the great need for loving one another.

To a student she wrote: "You must love *all*, even if they persecute you, you must love all. But you must love especially the brethren. You must meet with them, cheer them in their labors, point the way of love to them and show them it, by loving first, and waiting patiently for them to be in this great step by your side, loving each other and walking together. This is what the world must see before we can convince the world of the truths of Christian Science."

In writing to another student, Mrs. Eddy told him, "The healing will grow more easy and be more immediate as you realize that God, good [your true Mind, "the kingdom of God within" your consciousness] is *all* and is *Love*. You must gain Love, and lose the false sense called love. [It is all in letting go of the wrong point of view.] You must *feel* the Love that *never faileth*,—that perfect sense of divine Love that makes healing no longer power but grace. Then you will have the Love that casts out fear, and when fear is gone doubt is gone and your work is done. Why? Because it never was *undone*." (A Carpenter item.)

87

Mary Baker Eddy's Chestnut Hill residence.

In her 1896 address to her church in Boston, The First Church of Christ, Scientist, Mrs. Eddy directed thought away from the persecution of Jesus to his demonstration of divine, infinite Love, forgiving his enemies. She pointed out that this was what enabled him to overcome the cross and the grave. We all must learn to forgive.

Jesus, knowing the kingdom of God was his own divine consciousness, could demonstrate the power of Spirit to overrule mortal, material sense. He "vanquished every material obstacle, every law of matter....[he] fully and finally demonstrated divine Science in his victory over death and the grave....[his] persecutors had failed to hide immortal Truth and Love in a sepulchre." The same can be said of the truth Mary Baker Eddy discovered and taught.

When Jesus presented the same body after his death by crucifixion, he "glorified the supremacy of Mind over matter" (S&H 45:31). Mary Baker Eddy likewise "glorified the supremacy of Mind over matter" when she explained Jesus' demonstration, in the Second Coming of the Christ, fulfilling Jesus' prophecy and promise concerning the "Comforter" that would "abide with you forever."

Of this "Comforter"—the Second Coming of the Christ, which Mary Baker Eddy brought—Jesus said, "the Comforter, which is the Holy Ghost [divine Science] whom the Father [Mind, infinite good] will send in my name, he shall teach you all things, and bring all things to your remembrance, whatsoever I have said unto you" (John 14:16). This prophecy Mary Baker Eddy fulfilled.

Through all Mary Baker Eddy suffered she received the Holy Ghost, or divine Science. It came after a life of suffering, as Isaiah, chapter 54, had foretold. Her life, in founding Christian Science, after her great discovery that "all is infinite Mind and its infinite manifestation," was like that of Jesus, "filled with pangs of neglect [as] the staves of bigoted ignorance smote [her] sorely."

Mrs. Eddy, like Jesus, suffered from the fear that her

great discovery—divine Science—would be misunderstood and lost to the centuries, as was Jesus' great teaching a few hundred years after his crucifixion and ascension. Mrs. Eddy describes this fear that assailed both her and Jesus when she says "the burden of that hour was terrible beyond human conception. The distrust of mortal minds, disbelieving the purpose of his mission, was a million times sharper than the thorns which pierced his side. [This was equally true of Mary Baker Eddy's burden.] The real cross which Jesus [and Mary Baker Eddy] bore up the hill of grief, was the world's hatred of Truth and Love. Not the spear nor the material cross wrung from [Jesus'] faithful lips the plaintive cry, *'Eloi, Eloi, lama Sabachthani?'* [My God, my God, why hast thou forsaken me?] It was [as in the case of Mary Baker Eddy too] the possible loss of something more important than human life that moved Jesus [and Mrs. Eddy]—the possible misapprehension of the sublimest influence of [their] careers. This dread added the drop of gall to the cup of Jesus [and of Mary Baker Eddy, whom Jesus said would explain everything that he had demonstrated.]"

Mrs. Eddy's mighty works, her toils, privations, sacrifices, her divine patience, sublime courage, and unrequited affection, caused her to see clearly what Jesus endured. She writes of Jesus: "Remembering the sweat of agony which fell in holy benediction on the grass of Gethsemane, shall the humblest or mightiest disciple murmur when he drinks from the same cup, and think, or even wish, to escape the exalting ordeal of sin's revenge on its destroyer" (S&H 48:10).

Yet how few disciples remain steadfast, even as the Wayshower suffers all for them! Where, at the crucifixion, were the seventy whom Jesus had sent forth, and who had come back saying, "Even the devils are subject unto us through thy name"?

Jesus had been forsaken. His healing demonstration of the nothingness of matter and the allness of God, infi-

nite good, the "kingdom of God within" was misunderstood. The world's understanding of the *Science* behind his marvelous demonstration would have to wait almost two thousand years, until Mary Baker Eddy, through her pure Christ Mind, discovered the Christ Science and brought the Second Coming of the Christ, the "Comforter" Jesus had promised and prophesied.

This "holy Ghost or divine Science" was the "Spirit of truth," of which Jesus said, "When he, the Spirit of truth, is come he will guide you into all truth: for he shall not speak of himself; but whatsoever he shall hear, that shall he speak: and he will shew you things to come. He shall glorify me: for he shall receive of mine, and shall shew it unto you....that the world may know that thou [infinite good] hast sent me."

Yes, nearly two thousand years later this prophecy and promise of Jesus, which had already been foretold in Isaiah, chapter 54, would be fulfilled. This would be Mary Baker Eddy's divine work on earth. She would fulfill Jesus' prophecy to bring forth the "Comforter." The first advent was ushered in with healing. The Second Coming of the Christ would be ushered in with millions of healings.

With the advent of Mary Baker Eddy came a mighty blessing for the human race. Through her the divine Spirit that centuries ago identified and filled Jesus has today "...spoken through the inspired Word and will speak through it in every age and clime..." (S&H 46:9).

This blessing, this "Comforter," is not always welcomed today, any more than Jesus and his message were welcomed in his time. "Perhaps the early Christian era did Jesus no more injustice than the later centuries have bestowed upon the healing Christ and spiritual idea of being. Now that the gospel of healing is again preached by the wayside, does not the pulpit sometimes scorn it?" (S&H 55:6).

Nevertheless, as Mary Baker Eddy tells us at the end of Chapter II, *Atonement and Eucharist*, "Truth's immortal idea *IS* sweeping down the centuries, gathering beneath

91

its wings the sick and sinning. My weary hope tries to realize that happy day, when man shall recognize the Science of Christ and love his neighbor as himself,—when he shall realize God's omnipotence [infinite good's, "the kingdom of God within" his own consciousness, as his own Mind] and realize the healing power of the divine Love in what it has done and is doing for mankind." The promises will be fulfilled as "mankind awakens to its present ownership of all good" (*My.* 356:1).

Part III

CHRIST AND CHRISTMAS

In several places Mrs. Eddy tells us that her book, *Christ and Christmas*, is her life story, and that in *Christ and Christmas* the star of Bethlehem is really the "STAR OF BOSTON," though it was too early to say this to the general public at her time. *Christ and Christmas* is about Mary Baker Eddy, the Wayshower who brought the Second Coming of the Christ in fulfillment of Jesus' prophecy to send the "Comforter" to reveal all that Jesus, 2000 years ago, was not able to tell the people of his time, as they were just coming out of mythology.

There can be no doubt that the poem and pictures in *Christ and Christmas* reveal the high points and deep significance of Mary Baker Eddy's life.

Irving C. Tomlinson writes regarding *Christ & Christmas*:

> Mr. James F. Gilman, the illustrator of this inspired poem (whom I visited at Mrs. Eddy's request) has told us in his memoirs that Mrs. Eddy once said to him: "Do you know what you have done? You have portrayed to the world *what I am as God's messenger to this age*."

> In seeking the lessons to be learned from the illustrations of *Christ and Christmas* we must remember that our beloved Leader has given us important data which should be kept in thought. She describes *Christ and Christmas* as "hopelessly original" (*Mis.* 371:28). Of vital interest are her words in *Miscellaneous Writings* which tell us that the il-

93

lustrations 'refer not to personality ["Those who look for me in person...lose me..."], but present the type and shadow of Truth's appearing in the womanhood as well as in the manhood of God, our divine Father and Mother'" (*Mis.* 33:8). Tomlinson adds, "These notes on *Christ and Christmas* had the approval of our Leader, Mary Baker Eddy."

Nothing in *Christ and Christmas* lulls us to sleep; it is front burner stuff all the way. To the spiritually-minded reader every page of the book's incredible insights have a healing effect, for they show how Science and Health is transforming the thinking of the world, just as education transformed mankind's thought about the earth's flatness. Mrs. Orgain writes: "The message of *Christ and Christmas* is expanding with every approach, always revealing the wonderfully balanced view which is the result of the manhood and womanhood of God operating in unity."

Sources

The information we will look at in Part III will come primarily from two sources. The first source is Alice Orgain's insightful book, *Angelic Overtures of Mary Baker Eddy's Christ and Christmas*, quoted above. Mrs. Orgain explores how *Christ and Christmas* depicts the spiritual history of the life of Mary Baker Eddy in coincidence with the unfoldment of Science and Health. The first picture, she says, covers Mrs. Eddy's experience previous to her discovery of Christian Science; the second and third pictures cover her nine years of teaching and practice before she established a church, and so forth.

Alice Orgain's book shows "not only the spiritual life of Mary Baker Eddy in coincidence with the unfoldment of Science and Health, but the limits of each phase of institutional church as it progresses to its prophesied complete-

ness, as illustrated in the pictures of Christ and Christmas and as outlined in the poem and its Glossary."

The second source for Part III is an inspired and thoughtful analysis entitled *An Explanation of the Illustrated poem, Christ and Christmas, with remarks by Judge Septimus J. Hanna and James F. Gilman.* This manuscript, which has been in print for many years, is believed to be based on notes Judge Hanna made on at least one occasion when he was present while Mrs. Eddy instructed the artist, James Gilman. Unfortunately no one seems to know who the author of this piece is, nor have I succeeded in tracking down the Hanna notes on which it is based. In the discussion that follows I credit it to Judge Hanna cautiously, with a "?".

In this book we will alternately shine the light first on Alice Orgain and then on the interpretation based on Judge Hanna's notes. Important spiritual observations by John Pawlik will also be included as appropriate.

Alice Orgain's *Angelic Overtures* is well over a thousand pages in length. It therefore seems best to take from it only those remarks most applicable to the ideas under consideration. Note-taking from Alice Orgain's 1070-page book is complicated by the fact that Mrs. Orgain's marvelous insight into Mary Baker Eddy's life made her want to pack everything into one sentence, or one might say into one suitcase, even if it sometimes meant leaving a sock or a bootstrap hanging outside.

More frequent use of periods would certainly have enhanced what this great, spiritually-minded author brought to light. Where punctuation is concerned, many, like Mrs. Orgain, have never met the most beautiful mark of all. It is called the *"period,"* a dot all writers should love. The correct use of the period would surely give tired readers, or even *alert* ones, a break.

In the following discussion of *Christ and Christmas,* the reader is urged to remember that where ideas are drawn from Alice Orgain's prolific spiritual explanations,

much of the wording is also hers. I have only paraphrased lightly to simplify the text, and added the blessed *period* here and there. The language and concepts remain complex, with much for the spiritually-minded reader to assimilate and understand for himself.

The second source, *An Explanation of the Illustrated Poem, Christ and Christmas, with remarks by Judge Septimus J. Hanna and James F. Gilman,* is much shorter than Mrs. Orgain's 1070 pages and the language is more succinct. Therefore it is quoted directly, with comments by this author inserted as needed for clarity. The same is true of the quotes from John Pawlik, a good friend of this author.

In the book *Christ and Christmas* each of the eleven pictures is paired with one or two stanzas of Mrs. Eddy's poem. The *GLOSSARY* of *Christ and Christmas* also gives Scriptural texts that are the basis of the sentiments in the verses corresponding to each picture. To aid discussion of each picture, we will start each section with the picture itself, and its title and number, followed by its portion of the poem and its scriptural basis.

Sub-sections labeled "Alice Orgain," "Hanna?" and "John Pawlik" will follow in that order, with occasional comments by the author offered for clarification of the picture under consideration.

Both the Alice Orgain book and the analysis based on Hanna's notes explore the symbolic content of the pictures in *Christ and Christmas* in detail. The reader should note that these illustrations were much clearer in the early editions. Much in them has become obscured by poor rendering of the pictures. Thus some observations refer to elements which are now impossible to see.

Symbolism in *Christ & Christmas*

Before we look in detail at each picture, the reader may find the following brief summary of symbolism used in

Christ and Christmas interesting. It is quoted from a three paged typewritten carbon copy which bears the penned notation, "To Mrs. Orgain — JEJ 5 April, 1949." It is thought these notes were sent to Mrs. Orgain by Joseph E. Johnson after he read her book, *Angelic Overtures*, published in 1941.

JOSEPH E. JOHNSON'S NOTES:

Christ and Christmas: An interpretation by Judge Hanna, who was present [possibly more than once] when Mrs. Eddy gave instructions to the artist.

The pictures are the objects of the references on pages 115 and 116 of Science and Health:

Black in each picture is "first degree," depravity, lines 21-24.

Gray is "second degree," evil beliefs disappearing, lines 26, 27.

White is "third degree," understanding, lines 2, 3, 4-10, (p. 116).

First Picture: Black, gross materiality, error, unreality, Star of Bethlehem (which was really the "Star of Boston" but it was too early [for Mrs. Eddy] to say this). The star is the Christ idea - Truth appearing to the world to destroy error.

2nd Picture: Death of the First Degree - note the ugly coffin. The black robe on Jesus' shoulders represents the cross. Note woman in gray, in prayer. Note the man, [in] black [background,] Pharisaical belief, showing astonishment. Note the woman in the coffin, eyes opening, showing spiritual discernment.

3rd Picture: Quill of pen touched by divine Light; candle is half-burned showing Mrs. Eddy's life was half-spent when she discovered Christian Science. Clock on wall shows time is behind her. The animated serpent [old theology], First Degree, would bite the heel of Truth - Divine Light coming through the window (there must be an opening).

4th Picture Where is the star? The tree is grotesque. Artist did not wish to paint this picture, no beauty in Christmas tree which exists only to celebrate the birth and death of the human Jesus and this belief is responsible for human birth, [mortal, material] beliefs.

5th Picture: One Shepherd and one fold; twelve sheep, two figures blending into one, represents spiritual individualism [white robed purity uniting "in one person masculine wisdom and feminine love, spiritual understanding and perpetual peace]. The angel knows "Thy kingdom *is come*; Thou art *ever-present*."] — "Watch and Pray." River represents Euphrates ["Divine Science encompassing the universe and man" (S&H 585:14)], prophecy of the Mother Church is in background; light gray — note black steeple, First Degree, [despotic ecclesiastical] thought, old theology.

6th Picture: Old belief leaving the bed; medicine is behind him. Curtains, FIRST DEGREE, are drawn back, and light coming through brings the theological thought in matter to state of prayer. Note picture on wall, "Breaking through the clouds of darkness" etc. The Woman's robe reaches base of bed and represents understanding, symbolizing her thought reaching the foundation of sickness as merely error, hypnotic suggestion, illusion, ignorance of divine being.

7th Picture: No barriers of age to Truth.

8th Picture: [Mary Baker Eddy took an hour each night to know the truth for the world.]

9th Picture: Circle represents world. Note that Jesus has laid off the robe, showing dominion. Take Christian Science to the world, and in that light creation is shown anew.

10th Picture: Child thought sees or perceives Truth. Woman [Science] knocking at the door of mortal mind.

11th Picture: Foreground is FIRST DEGREE, — [then] following the path of light up to the right way, leads beside "still waters" and "green pastures." The cross, smaller one,

represents demonstrations; birds represent God's winged thoughts. Note white dove coming from heaven with thought messages nearest the cross. Left side of picture reached same destination, but the way is rugged.

Again, the mission of *Christ and Christmas* is to lift Christianity into Science.

The notes quoted above agree to a marked degree with the symbols identified in the longer manuscript, *An Explanation of the Illustrated Poem, Christ and Christmas, with remarks by Judge Septimus J. Hanna and James F. Gilman,* which strongly suggests that both sources accurately reflect the content of Hanna's notes.

As we will see, Mrs. Orgain, as well as the unknown author of *An Explanation,* and John Pawlik add some valuable insights to the understanding of these symbols.

After each picture we thought you might like a little laugh, so the following brief jollies represent notices that have been seen on church bulletin boards. They were submitted to us by one of our email subscribers.

> The Rev. Merriwether spoke briefly,
> much to the delight of the audience.

STAR OF BETHLEHEM
Picture Number 1

Fast circling on, from zone to zone,
Bright, blest, afar, —
O'er the grim night of chaos shone
One lone, brave star.

Scriptural basis:
I am the root and offspring of David,
and the bright and morning star. —Christ Jesus

ALICE ORGAIN:

The lines of the poem for the first picture says: "Fast circling on, from zone to zone, Bright, blest, afar, — O'er the grim night of chaos shone One lone, brave star."

The Scriptural basis for this first picture, as shown in Glossary, is: "I am [both] the *root* and *offspring* of David, and the bright and morning star." This statement encompasses not only the first picture, but the full gamut of all the succeeding pictures, inasmuch as it is the last promise in the Bible and embraces both the genesis and apocalypse of being as "root" and "offspring." [As *root*, the kingdom

100

of God is within you. And *offspring* is this kingdom's — our Mind's — image or idea.]

In view of the all-embracing range of the Scriptural basis of this first picture, the full signification of the title of the book, *Christ and Christmas,* should be readily seen in this first picture as the *re-dedicating* of Christmas, typing Jesus' first appearing, to the "Christ" of Jesus' "*Second* appearing." Thus the "Star of Bethlehem," the title of this first picture, as indicating the birthplace of the *personal* Jesus in his first appearing to the human consciousness, must be *rededicated* to the "*star of Boston,*" indicating the birth place of the *impersonal* Jesus in his "second appearing" as Truth. And Mary Baker Eddy herself dedicates the "star of Bethlehem" to "the star of Boston", saying: "*The star of Bethlehem is the star of Boston*...that looketh down on the long night of human beliefs, to pierce the darkness and melt into dawn" (*Mis.* 320:23).

The head of the woman in the upper right-hand corner of this first picture is prayerfully bowed over a dark mass that might be identified with "the long night of human beliefs" upon which Mrs. Eddy in her article "Christmas" represents "the star of Bethlehem," as "the star of Boston," to be shining. The ascending cloud outline of "the Holy Family" (of Joseph, Mary, and the babe Jesus) is placed directly under the star.

Mrs. Eddy's mission under the light of "the star of Boston" was her re-discernment of the same "infant idea" of the Christ which Mary brought forth through her "self conscious communion with God" (S&H 29:32). Mrs. Eddy in *Science* presents "The Holy Family" in quality "as Life, represented by the Father; as Truth, represented by the Son; as Love, represented by the Mother" (S&H 569:1). This enables each individual to impersonally and progressively incorporate "The Holy Family" in quality as Life, Truth, and Love into his own consciousness. "At present we know not what we are, but certainly we shall be Love, Life, and

Truth, when we understand them" (2nd ed. S&H p. 19. Also in first edition.).

In this picture "The Holy Family" as an ascending idea turns its back on the human consciousness, in line with Christianity's "Get thee behind me, Satan." The cloud-formed head of the woman, in the right side of the picture, typifying Science, prayerfully *faces* its problem—the more subtle forms of the human consciousness such as "lust and hypocrisy"—until it overcomes their resistance. This illustrates the difference between Christianity (which rose above error), typed by Jesus in his first coming, and Science (which demands the facing and scientific overcoming of error by each individual consciousness), typed by Jesus' second coming, under the light of the "star of Boston."

"Dedication" means "*de*, down, + *dico*, declare," — a call from above to a mission, or purpose, larger than one's consciousness can comprehend, but which one inspirationally accepts. The first step in ascending Church is *dedication* to Love's plan.

The initial step of dedication could be generalized in this first picture as being the first illumination of the heavenly light of Christian Science to which one inspirationally *dedicates* himself. However, *Christ and Christmas* must *first* specifically identify this *dedicatory* call as the unfolding Word in Mrs. Eddy's consciousness, for *Christ and Christmas* "must be a new revelation of the God-anointed mission of our Leader" (January 1894 *C. S. Journal*, p. 467).

Thus this picture identifies the *dedicatory* call to the mission of the revelation of Womanhood through Mrs. Eddy's consciousness. In *Retrospection and Introspection*, on pages eight and nine, Mrs. Eddy records the divine call to dedicate herself to the fulfillment of her great mission. As a little child at the age of eight she heard repeatedly over a period of time a voice calling three successive times, "Mary," "Mary," "Mary." She records the confusion and distress it brought into her life until her mother (after the call to her

102

was heard by another little child — her cousin) interpreted it to her as a call similar to that which came to little Samuel and suggested she answer in the words of Samuel. The call came, and after replying, "Speak, Lord; for Thy servant heareth" (I Sam. 3:9), her child-consciousness never heard the call again, for she had accepted in her life the dedication it demanded of her.

Hence this first picture presents a panoramic preview of the fullness of the revelation and founding of Christian Science that Mrs. Eddy as a little child had inspirationally accepted, and which held her unsparingly to the fulfillment of each "jot" and "tittle" of the Law "till all...[was] fulfilled" (Matt. 5:18). The vast ultimate of Mrs. Eddy's dedication of herself in this picture is typed by the woman's bowed head, crowned with the head of man, the latter symbolizing the ultimate lifting up of manhood by womanhood from Christianity to Science.

HANNA?:

It would appear that we could not understand these pictures in *Christ and Christmas* because no key has been given — that is, none that is generally known. This is not entirely true. Judge Hanna was present [probably more than once] when Mrs. Eddy gave instructions to Mr. Gilman the artist; and Judge Hanna wrote down and preserved for us what she said. James Gilman also wrote in his diary about his experience [working] with Mrs. Eddy while...he illustrated [*Christ and Christmas*]. The real key, however, to any figure in *Christ and Christmas* is Mrs. Eddy's other writings. She explains the symbols used in *Christ and Christmas* throughout her writings. We must seek them out.

The first Biblical quote in *Christ and Christmas* is a statement of the Master's stating that he is the bright and morning star. The last quote in *Christ and Christmas* also deals with this same morning star.

The selection of this Biblical verse (above) with Mrs. Eddy's poetry gives us a clear indication of this picture's meaning. It is a picture of "one lone, brave star." So, the next [assumption might be] that this "lone, brave star" is Christ Jesus; but this is not the case. This picture, like the Master's parables, relates to the human and divine coincidence. It represents the light of the Christ, the absolute, divine [Science] appearing; but it also has direct reference to the relative or human experience [of both Jesus and Mary Baker Eddy].

The picture is titled: "Star of Bethlehem." In its first appearing this star, this Christ, was definitely represented in human experience as the Master, Christ Jesus.

Mrs. Eddy has hidden the import of this picture; it is a veiled message. She tells us in *Miscellaneous Writings:* "The star of Bethlehem is the star of Boston" (p. 320:23). The world was not ready at the turn of the previous century to have this picture entitled: "The star of Boston." That would have led to controversy and speculation. But, we can understand it to be so now in the light of a fuller understanding of Mrs. Eddy's place in Bible prophecy. The star is Mary Baker Eddy in its relative, human appearing — the transparency through which the divine, absolute Christ, Truth, appears to this age. This picture represents the dual appearing of the Woman, as generic man and as Mary Baker Eddy. Thus the two phases of the woman in the Apocalypse are represented in this picture, but both as one star, "the star of Boston."

Throughout Mrs. Eddy's life, the phrase, "Lone as a solitary star," appealed to her as an apt description of her fate. It first appeared in the early poems to Colonel Glover, and did not make its exit until forty-six years later in a letter to her son, the second George Glover. In a letter to George Glover in April of 1898, she says, after pointing out that her life was "as pure as that of angels," that she was "alone in the world, more alone than a solitary star." One

definition of the word *star* is: "A person of brilliant qualities standing pre-eminently among his fellows."

The very important margin note in Science and Health, p. 511:12 reads, "Darkness scattered." The darkness is indeed being scattered in this first picture of *Christ and Christmas*. Mrs. Eddy says, "At the present time this Bethlehem star looks down upon the long night of materialism, — material religion, material medicine, a material world; and it shines as of yore, though it 'shineth in darkness; and the darkness comprehended it not.' But the day will dawn and the daystar will appear, lighting the gloom, guiding the steps of progress from molecule and mortals outward and upward in the scale of being" *(Miscellany* 110). This is not "the pale star" that shone to the "prophet shepherds;" this is the "guiding star of *being*" (S&H vii) [the Second Coming of the Christ, the Comforter, prophesied and promised by Jesus.]

In *Miscellaneous Writings*, Mrs. Eddy says, "The nineteenth century prophets repeat, 'Unto us a son is given.' The shepherds shout, 'We behold the appearing of the star!' — and the pure in heart clap their hands" (p. 168).

The first degree is black; mortal, depravity. This depravity, represented by the myriad physical evil beliefs in this picture, is pierced by the light of Truth, represented in this picture by the second appearing of Truth as Mary Baker Eddy. This light of Truth, *through her*, appears to destroy the physical and all that physical beliefs bring. "The mortal mind through which Truth appears most vividly is that one which has lost much materiality — much error — in order to become a better transparency for Truth. Then, like a cloud melting into thin vapor, it no longer hides the sun" (S&H 295). Notice the clouds of sense breaking up in this picture, darkness being scattered, "melting into thin vapor" from the light of Truth. "So Christian Science can be seen only as the clouds of corporeal sense roll away" (S&H 548:10).

The seven-pointed star represents the seven synonyms for God, given to us by Mary Baker Eddy through her

man-child named Christian Science, and this again identifies the star more closely with her.

The large black cloud on the left, Judge Hanna tells us, is the dragon. The dragon is the type of error associated with the latter days; and as Jesus was not in the latter days, this picture depicts the life of Mary Baker Eddy. Jesus said the "Comforter" would lead into all truth. In other words, the "Comforter" will reveal the method of destroying the dragon that blocks the light of divine Science from the view of mankind.

"RED DRAGON: Error; fear; inflammation; sensuality; subtlety; animal magnetism; envy; revenge". (S&H 593).

"The great red-dragon symbolizes a lie, — the belief that substance, life, and intelligence can be material. This dragon stands for the sum total of human error. . . This malicious animal instinct of which the dragon is the type, incites mortals to kill morally and physically even their fellow-mortals, and worse still, to charge the innocent with the crime. This last infirmity of sin will sink its perpetrator into a night without a star" (S&H 563:8).

The seven points, seven synonyms, dismember the organization of the dragon. The two large clouds on the right, we are told, represent...two-faced... ecclesiastical despotism... Here once again this picture identifies the Second Advent, the life and light of Mary Baker Eddy, *uncovering* the two-faced nature of [ecclesiasticism]. [In S&H and Prose Works Mrs. Eddy has 32 references showing the necessity of uncovering error. She says he who sees evil and does not uncover it, will be punished.] Speaking of this [dragon] in Science and Health she writes, "The serpentine form stands for subtlety [theological beliefs], winding its way amidst all evil, but doing this in the name of good. Its sting is spoken of by Paul, when he refers to 'spiritual wickedness in high places.'" (S&H 563:27)

Just beneath the star and a bit to the left is the Virgin Mary and the babe Jesus in her arms. They are facing

106

the light of Christian Science; and this divine Science, revealed through the woman, is in turn revealing them [revealing the virgin Mary and the babe] in their proper light. Only Christian Science has explained the virgin birth, the purity of the Virgin Mary, and the words and work of the Master. The small shadow above the Virgin Mary's head is Joseph. These figures again point out that this [picture number 1] is indeed the Second Advent, and not the First, for Mrs. Eddy clearly shows through Science and Health the mission of the Virgin Mary, Jesus and Joseph. She alone has revealed them in their right place in prophecy and their niche in history. Mary Baker Eddy says, "No person can take the individual place of the Virgin Mary. No person can compass or fulfill the individual mission of Jesus of Nazareth. No person can take the place of the author of Science and Health, the Discoverer and Founder of Christian Science. Each individual must fill his own niche in time and eternity. The *second* appearing of Jesus is, unquestionably, the spiritual advent of the advancing idea of God, *as in Christian Science*" (*Retrospection and Introspection*, p. 70). This picture represents the light of divine Science appearing through the "one lone, brave star," bringing the Christ to earth, and breaking up material beliefs and piercing spiritual wickedness in high places. "There is neither growth, maturity, nor decay in Soul [true identity]. These changes are the mutations of material sense, the varying clouds of mortal belief, which hide the truth of being" (S&H 310:31).

Only through an understanding of Mary Baker Eddy's life and light, can we understand the Christianity that Jesus taught. Primitive Christianity had its "pale star" which has now, through a long night, become full-orbed as the day-star of divine Science. Mrs. Eddy makes this clear when she says, "So shone the pale star to the prophet-shepherds; yet it traversed the night, and came where, in cradled ob-

107

scurity, lay the Bethlehem babe, the human herald of Christ, Truth, who would make plain to benighted understanding the way of salvation through Christ Jesus, till across a night of error should dawn the morning beams and shine the guiding star of being" (S&H vii). [The "guiding star of being" is Christian Science.]

This light of divine Science that has come through the woman, fast circles the five zones of earth (mortality), represented by the twelve tribes of Israel with all mortals, running the spectrum of thought from Dan to Joseph. The movement is fast, it is bright, it blesses afar, and its influence is piercing and thorough. "Behold, I come quickly..." (Revelation).

"While Christian Science, engaging the attention of philosopher and sage, is circling the globe, only the earnest, honest investigator sees through the mist of mortal strife this daystar, and whither it *guides*"(*Message for 1902*, 1:20).

Because the serpent [old theology] has been dismembered by the Second Advent, the two-faced nature of [ecclesiasticism] is uncovered. Malicious animal magnetism and [ecclesiasticism] have been in league to block the light from piercing the gloom, but to no avail. "Let us watch, work, and pray that . . . this light be not hid, but radiate and glow into noontide glory" (S&H 367:21).

The dragon is lust and hypocrisy, and represents the two-fold resistance accepted and expressed through mortal mind to the two phased mission of the woman in the Apocalypse (generic man) and Mary Baker Eddy (the absolute and the relative). The main exponent of this dragon-thought is [ecclesiasticism], *which strives to separate Mary Baker Eddy from her revelation.* [Mrs. Eddy said old theology was her worst enemy.]

The understanding of Mary Baker Eddy's life and light breaks up the dragon thought. This [first] picture indicates this is accomplished when she is recognized as the star of

Boston, the second witness, as distinguished from the star of Bethlehem, the first witness, Christ Jesus. *If her place is not recognized, the dragon remains active* [because there is nothing to resist it]. Two-faced malicious animal magnetism [ecclesiasticism], is uncovered and destroyed when the light of her place shines forth.

"In the Apocalypse, when nearing its doom, this evil increases and becomes the great red dragon, swollen with sin, inflamed with war against spirituality and ripe for destruction. It is full of lust and hate, loathing the brightness of divine glory" (S&H 565:1). As she says, "...it is cast out by Christ, Truth, the spiritual idea, and so proved to be powerless."

Jesus, Mary and Joseph are seen correctly in the light of Truth because of Mary Baker Eddy and the light she gives to the Bible. Remember, without her [without Mrs. Eddy's holy mission and explanation] none of the above is possible, and the Bible remains a closed Book.

This Christ-light, brought by Mary Baker Eddy, enables us to fully express the "transitional qualities" of the "second degree." It enables us to destroy the "first degree" named mortality and depravity. It demands that we accept our divine nature as given in the "third degree." The closer we approach the star, the understanding of the inseparability of Mary Baker Eddy and Christian Science, the more we see what she has done for us, the more we enter into the light, the more we find the clouds of sense broken up and dissolved. She reveals the way from chaos to spiritual understanding.

The picture is rectangular denoting that there is a lot of the human to be worked out. *It is her place that must be seen and appreciated before the human can be worked out.*

Malicious animal magnetism accomplishes its work in the black thought of mortality, the first degree. Its power lessens as we get into the light and recognize the second witness. *Unless this is done the world will again slip into the*

dark ages, and Christian Science will be lost for another two thou-
sand years.

"This polar star, fixed in the heavens of divine Science, shall be the sign of his appearing who 'healeth all our diseases'; it hath traversed [the] night, wading through darkness and gloom, on to glory. It doth meet the antagonism of error; addressing to dull ears and undisciplined beliefs words of Truth and Life.

"The star of Bethlehem is the star of Boston, high in the zenith of Truth's domain, that looketh down on the long night of human beliefs, to pierce the darkness and melt into dawn.

"The star of Bethlehem is the light of all ages; is the light of Love, to-day christening religion undefiled, divine Science; giving to it a new name, and the white stone in token of purity and permanence" (*Mis.* 320).

In Revelation, we read, "He that hath an ear, let him hear what the Spirit saith unto the churches; To him that overcometh will I give to eat of the hidden manna, [the leaven hidden from the foundation of the world] and will give him a white stone, and in the stone a new name written, which no man knoweth saving he that receiveth it" (Rev. 2:17). Thus Christian Science will be understood as inseparable from our precious Leader, Mary Baker Eddy, and this recognition shall destroy the domain and dominion of mortal mind.

In Science and Health, she says, "In divine Science, which is the seal of Deity and has the impress of heaven, God is revealed as infinite light. In the eternal Mind, no night is there" (S&H 511:11).

JOHN PAWLIK:

In the study of this first illustration, Mrs. Eddy's words shine forth: "The star of Bethlehem is the light of all ages; is the light of Love,...divine Science" (*Mis.* 320:27). Here we see that the only light and all the light, is from the star.

Without this star of Bethlehem — without the revelation of Mary Baker Eddy — there is nothing but chaos; nothing but darkness without one ray of light. All spiritual understanding, all true healing of sickness and sin, all true consciousness, all Science of being, is found in the light of the star of Bethlehem.

Our Leader also says: "The star of Bethlehem is the star of Boston" (*Mis.* 320:23). Why Boston? [Boston is a symbol for Mary Baker Eddy's teaching, the "Comforter" promised and prophesied by Jesus,—the Second Coming of the Christ. "The star of Boston looks down on the long night of human beliefs to pierce the darkness and melt into dawn" *Mis.* 320]. Because Boston is headquarters for Christian Science: is the home of the spiritual Mother Church and of The Christian Science Publishing Society. From this shines forth the light that is meant to heal the world. To all those reflecting the light [gaining spiritual understanding] comes the promise of Christ Jesus: "He that overcometh, and keepeth my works unto the end, to him will I give power over the nations [over all mortal mind thinking]: and I will give him the morning star" (Rev. 2:25-28).

The outreach committee has enlisted
25 visitors to make calls on people
who are not afflicted with any church.

CHRIST HEALING
Picture Number two

In tender mercy, Spirit sped
A loyal ray
To rouse the living, wake the dead,
And point the Way —

The Christ-idea, God anoints —
Of Truth and Life;
The Way in Science He appoints,
That stills all strife.

Scriptural basis:
*Verily, verily, I say unto you, The hour is coming, and
now is, when the dead shall hear the voice of the Son of
God: and they that hear shall live.* — Christ Jesus

*The people that walked in darkness have seen a great light;
they that dwell in the land of the shadow of death,
upon them hath the light shined.* — Isaiah

"The people that walked in darkness have seen a great light." They have seen that love for one another is the great need. We must waken out of the Adam dream, and see that our true and real Mind is Love — is "the kingdom of God within" us as our divine consciousness that sees only "the omnipresence of present perfection."

The artist, James Gilman, speaking of what he had gained from his association with Mrs. Eddy, which was infinitely above anything money could buy, said, "Mrs. Eddy reflects the Love and Truth of Perfect Goodness in such a way that it becomes plain that Love and Goodness and Goodness and Love is the only thing worth living for. The sense of it gives us freedom from all lesser interests, and makes us know it is completely within the reach of each of us when we are ready with self-surrender for its sake. 'The way in the flesh is the suffering that leads out of the flesh'" (*Recollections of Mary Baker Eddy,* James Gilman, and *Un.* p.11).

"To really understand all that is in *Christ and Christmas* we must have on the *wedding garment,*" (Judge Hanna told a student). Those that spontaneously and unconsciously reveal that they love the spiritual realization of divine Love and Truth more than they love anything else, I judge to be the ones Mary Baker Eddy credits with having on the wedding garment. There is one great encouragement; "wedding garments" are not beyond the reach of any who earnestly desire them and live for their possession.

The women in this picture have on the "wedding garment." In this second picture we see that woman is the first to understand and to welcome the Science of being. ["Woman" means man or woman who is putting on the Christ selfhood.] The mortal in the background with his hand uplifted in protest stands for mortals' antagonism to the "Christ healing" revealed through Mary Baker Eddy. He stands for old theology. His hand upraised in protest shows his cards; protesting full force against what Mary

Baker Eddy was to bring as the "Comforter," revealed in the Second Coming of the Christ. But Mary Baker Eddy's great revelation shines on as "O'er the grim night of chaos shone One lone brave star." Note that there is no dark robe on "woman." Mary Baker Eddy's great revelation is teaching us all what Jesus demonstrated.

ALICE ORGAIN:

The Scriptural basis given in the "Glossary" of *Christ and Christmas,* for the two stanzas of the poem corresponding to this second picture are:

"Verily, verily, I say unto you, The hour is coming, and now is, when the dead [*'those buried in dogmas'* (*Mis.* 168:9)] shall *hear* the voice of the Son of God: and they that *hear* shall live." — Christ Jesus.

"The people that walked in darkness have *seen* a great light: they that dwell in the land of the shadow of death ['individuals *buried above-ground* in material sense' (*My.* 110:4)] upon them hath the light shined." — Isaiah.

Note that in the bracketed interpolations, Mrs. Eddy's interpretations of "death" have been used. It will be seen that Mrs. Eddy makes "death" and "burial" the same thing. Thus "death" is burial (submergence) in dogma (static Christianity). In other words, one is dead when buried in dogma. Mrs. Eddy's fuller texts read as follows: "...how the dead, those buried in dogmas...are raised" (*Mis.* 169:9, 10); and "Divine metaphysics is not to be scoffed at...it is the divine nature of God, [your true identity as Mind, Spirit, Soul, Principle, Life, Truth, Love] which belongs not to a dispensation now ended, but is ever present...raising the dead — resurrecting individuals buried above-ground in material sense" (*My.* 109:23-24).

These interpretations of "death" are particularly applicable to the second picture, in which theological dogma, typed by the man in dark clothing standing behind Jesus, has cast its shadow of "death" upon the girl in the coffin in

its endeavor to submerge or bury the consciousness of dawning Womanhood [Christhood].

Mrs. Eddy, up to her last revision of Science and Health in 1910, chose a *New Testament* Scriptural "basis" for this picture: "The people which *sat* in darkness saw a great light; and to them that *sat* in the region and shadow of death light is sprung up." [In 1910 she replaced it with the *Old Testament* verse used now.]

Doubtless Mrs. Eddy felt that those Christians who had "*sat* down on the right hand of God" with Jesus were too much "asleep" in Jesus to hear the voice of his "second appearing," which awakens woman to her mission, as typed by the girl in the coffin. Therefore, she made this change in wording, from "*sat* " as used in the New Testament verse, to "*walked*" as used in the *original* text of this verse in the Old Testament. The former, "sat," is a passive state of mind, the latter, "walked," is an actively progressive state of mind. Only those who are walking in darkness feel its limitation, and struggle for the advancing light of life. Thus they alone can rise to the call of the "second appearing."

At first glance one might think this second picture shows the raising of Jairus' daughter by Jesus, but Jairus' daughter died while Jesus was on the way to heal her; and therefore she could not yet have been placed in a coffin. Furthermore there were no coffins in Jairus' time, and the girl is in modern attire, as is her mother. Also Jesus was alone with Jairus' daughter when he raised her from the dead, having put her mother and father and his disciples out of the room — the Bible stating, "And he put them all out, and took her by the hand and called, saying, Maid, arise." (Luke 8:54)

We must regard the literal raising of Jairus' daughter at the age of twelve as a prototype of the more figurative experience in Mrs. Eddy's life at the same age, when she rose above creeds and dogmas at the time of joining the Congregational Church, recorded by Mrs. Eddy as follows:

115

"At the age of twelve I was admitted to the Congregational (Trinitarian) Church....Before this step was taken, the doctrine of unconditional election, or predestination, greatly troubled me....So perturbed was I by the thoughts aroused by this erroneous doctrine, that the family doctor was summoned, and pronounced me stricken with fever. My father's relentless theology emphasized belief in a final judgment-day, in the danger of endless punishment, and in a Jehovah merciless towards unbelievers; and of these things he now spoke, hoping to win me from dreaded heresy. My mother, as she bathed my burning temples, bade me lean on God's love. [Doing so, Mary was comforted and healed.]

[When questioned by the pastor]...I stoutly maintained that I was willing to trust God and take my chance of spiritual safety with my brothers and sisters — not one of whom had then made any profession of religion — even if my creedal doubts left me outside the doors [of church]....To the astonishment of many, the good clergyman's heart also melted, and he received me into their communion, and my protest along with me" (*Ret.* pp. 13-15).

The raising of Mrs. Eddy by "the Christ-idea" from among those "buried in dogmas" was of larger portent than the mere bursting of the creedal bonds of one church. It was rather a bursting of the bonds of Christianity itself. "Christianity reveals God as an ever-present Truth and Love...raising the dead; a divine good that gives life to the religion buried in materiality, that resurrects men from a material sense of Truth and Love, to their spiritual understanding and demonstration" (*Historical Sketch of Metaphysical Healing* p. 13).

All elements involved in Mary Baker's first healing (as just presented from *Retrospection and Introspection*) were present in her second "Christ Healing" [after her fall on the ice in Lynn, on February 4, 1866] — for in her second experience her old theological pastor "came to bid her good-

116

bye before proceeding to his morning service, as there was no probability that she would be alive at its close" (*Pul.* 34:8-10), thus casting the dark mantle of old theological dogma over the healing "Christ-idea" in her own consciousness. Immediately after her pastor left, she was forced to request the retirement, from her bedchamber, of the little group awaiting her "death" — an exact repetition of Jesus' necessity in raising Jairus' daughter to "put them all out" of the room before he could effect his "Christ-Healing" purpose. Mrs. Eddy [first as the child Mary Baker and then as the invalid Mrs. Patterson] was forced to triumphantly rise above old theological dogma in both instances.

This second picture represents Science rising above Old Theology. Mrs. Eddy's healing at age twelve is the basic or foundational one portrayed — her second healing being its spiritual superstructure.

The *consecration* of Mrs. Eddy's life in deep devotion to the Principle of these two "Christ Healings" is her second identification in this picture, *consecration* being the next footstep beyond *dedication*.

Jesus as "the Christ-idea" in the consciousness of woman raises up woman to fulfill *Life's anointing and Truth's appointing in Christian Science*. The "loyal ray" that "Spirit sped...to rouse the living, wake the dead" in her own consciousness was Mrs. Eddy's anointing. Her first healing forced her to humanly embrace the divine life of Jesus in his first appearing before she could rise through the purity of her own human life in her second healing to the divine appointing of Truth in Jesus' "second appearing" "without sin"[humanity] "unto salvation" [as a redemptive idea] (Heb. 9:28).

HANNA?:

The Christ-idea is motivated by Spirit alone. The healing work rouses the living, wakes the dead, and points the right Way. Heeding the words of the Master, we live and

cannot die. God [our own true Mind — "the kingdom of God within you"] anoints the Christ-idea that is understood because it is His [your own real Mind's] own. Through this understanding, we have Science that stills all strife. Mankind sees the great light of Truth because Mary Baker Eddy overcame its sting, and gave us this precious Science. The Way is now pointed out.

The prophecy in Genesis 3:15 explains why the "strife" has been stilled. Mrs. Eddy says of this prophecy, "The serpent [old theology], material sense, will bite the heal of the woman, — will struggle to destroy the spiritual idea of Love; and woman, this idea, will bruise the head of lust. The spiritual idea has given the understanding a foothold in Christian Science" (S&H 534:26).

The serpent, malicious animal magnetism, attempted once again to make woman fall and be destroyed. But, the serpent destroyed itself in this instance, for the fall in Lynn, Massachusetts, signaled the destruction of all error, and this too through the woman. Prophecy was being fulfilled.

This second picture illustrates the period in Mrs. Eddy's life when she fell in Lynn, Massachusetts. Once we understand correctly the position and place of the "Star of Boston," we are ready to understand what happened in the "Bethlehem of Massachusetts." Naturally the picture following the star would relate to her healing in 1866. Her babe [the "Comforter"—the Second Coming of the Christ] was conceived at the moment of this healing, and her work for humanity began. She says, "St. Paul writes: 'For to be carnally minded is death; but to be spiritually minded is life and peace.' This knowledge came to me in an hour of great need; and I give it to you as death-bed testimony to the daystar that dawned on the night of material sense" (*Miscellaneous Writings* 24:2).

Mrs. Eddy's great love for the Master opened her consciousness to this healing. She saw clearly that, following his commands faithfully, we live and cannot die. It was

118

the child-like purity of her consciousness that enabled her to witness this "Christ Healing." The healing Christ was understood sufficiently to heal her, but as yet the Science of this healing had not been revealed, thus the picture is titled "Christ Healing." You will notice in a later picture the title "Christian Science Healing."

The woman that is standing represents the expression of womanhood; that was Mrs. Eddy's own sense of womanhood at the time of her healing. The same can be said for the man [Jesus]. He represents the manhood of her own thinking at that time. The great love for Jesus that Mrs. Eddy entertained, is indicated by the personal touch. Notice his hand touching hers as she is lifting herself up through enlarged understanding.

The poem attached to this picture amply describes Mrs. Eddy's healing and its results. The first four lines speak of a "loyal ray." Who is the "loyal ray"? The second four lines speak of divine Science, or Christian Science. This healing experience brought forth the "loyal ray" — the Christ-idea or Christian Science. Again we have the coincidence of the human and divine, the relative and the absolute.

The star as a symbol is needed, though the light of Truth, the Christ, is seen and felt. Mrs. Eddy says, "It is most fitting that Christian Scientists memorize the nativity of Jesus. To him who brought a great light to all ages, and named his burdens light, homage is indeed due, — but is bankrupt. I never looked on my ideal of the face of the Nazarene Prophet; but the one illustrating my poem approximates it" *(Mis. 374).*

The picture is oblong because there is much human to be worked out as in the previous picture. *Forty-five years of hard work lay ahead.* Mrs. Eddy, in retrospect, realized this about that moment of healing in her experience.

Animal magnetism attempted to make the fall fatal, but notice the inside of the coffin is white — the third degree. It was seen by Mrs. Eddy that death is an illusion, a

119

sham, and that she was always in the arms of her precious Father-Mother [— that she always had the kingdom of God within her consciousness as her very own Mind].

The name plate [on top of the coffin] signifies that material belief names all things and this leads to death. The woman standing in this picture describes the unfoldment of Mrs. Eddy's human consciousness at that time. Her own sense of womanhood stood in awe and rapture at what was taking place; it is a face of anticipation. Ecclesiasticism, aggressive mental suggestion, working through her own sense of manhood, argues, "Who do you think you are? This cannot be so!" However, womanhood lifted up that doubting manhood. You will notice that womanhood is nearer the light of divine Science than manhood. Notice that the robe the Master wears is the same robe of false manhood. False manhood named Pharisaical beliefs, old theology, ecclesiastical despotism, *materia medica*, caused the crucifixion of the Master, and will attempt to destroy the Christ-idea in any age. This black robe that the Master wore, represents the cross, the cross of false manhood that he bore and we all must bear. Notice it is off his shoulders in the picture "Christian Unity" [picture nine], because the sense of false manhood has been dissolved, and true manhood has been lifted up by womanhood through Mary Baker Eddy.

Mrs. Eddy is being lifted out of the sense of death through a greater awareness and understanding of the Master's work. Remember, the first thing that she saw was that she could not die. The eyes of the woman in the coffin are opening, showing spiritual discernment beginning to open up. From that moment of healing, her spiritual discernment could not be darkened.

The Master is looking away from the body. He is the center of the picture; he is the center of her life work. She never forgot Jesus; we must not forget her. His robe is seamless and white just like the inside of the coffin and

womanhood's dress. The black represents the Master's cross, false manhood, the first degree; in it all is the belief of death, the Adam dream. He, the ideal man, overcame the claims of false manhood; and she, the ideal woman, revealed true womanhood, generic man [the Christ, as your real being.]

As no figure touches the ground, or matter, this shows these figures represent types of thought rather than persons. This picture is the subjective experience of Mary Baker Eddy at the time of her healing in 1866. You will also notice that the coffin, *death, has no foundation, it is but a false belief.*

Jesus' left hand, held up, is a sign of authority, the theology of Jesus, overcoming the arguments of the serpent, named Old Theology, *materia medica* and false science. The hand of false manhood is false authority, or Old Theology, trying to halt the advancing idea of what it can comprehend little or nothing. Jesus' hand is over his head into the realm of revelation, Spirit; false manhood's hand is below the seat of reason, the head, into the reaction of mortal mind opinion. Mrs. Eddy's right hand [in the casket] is inactive, signifying unused power; her left is active and reaching. Jesus' ear is covered signifying that the Christ-idea hears no false claims. He is not looking at, nor listening to, the claims of evil, but is handling them with the consciousness of the Christ.

The "Low Self-Esteem Support Group" will meet Thursday at 7 to 8:30 p.m. Please use the back door.

SEEKING AND FINDING
Picture Number 3

What the Beloved knew and taught
Science repeats,
Through understanding clearly sought,
With fierce heart beats;

Scriptural basis:
*But seek ye first the kingdom of God
and His righteousness.and all these things
shall be added unto you.* —Christ Jesus

ALICE ORGAIN:
The first picture in Christ and Christmas covered Mrs. Eddy's spiritual experience previous to her discovery of Christian Science. The second picture and this third picture cover Mrs. Eddy's nine years of teaching and practice before she established a church.

The poem at the juncture of pictures two and three culminates in the statement, "What the Beloved [Jesus] knew and taught, Science repeats." (This statement animated the first edition of Science and Health, in which Mrs. Eddy denounced *church* on the basis of Jesus' example. Despite this, her students disobediently started a church which lasted a year, ending in rebellion.)

Jesus is never mentioned again in the poem, except once negatively, the Christ taking the place of Jesus from the third picture to the end of the poem. *The Christ is Woman*, whereas the "Christ-idea" in the verse of the poem corresponding to the second picture refers to Christianity (S&H 577:15-17). *Hence Christ and Christmas was accepted by Mrs. Eddy as outlining her own mission* (*Christian Science Journal*, January 1894) *as distinguished from that of Jesus, or Christianity.*

The Scriptural basis given by Mrs. Eddy for this third picture and the corresponding stanza of the poem, demands the *seeking* of "the kingdom of God, and his righteousness." This text shows the great distance between the third picture as the *Christianity*, or manhood, of Science, that presents God's kingdom as a heavenly goal "without" oneself, and the *inner* consciousness of *Science*, wherein "Love...seeketh not her own" (S&H 538:1). Love has no need to seek "her own," for she has it as an indissoluble manifestation of which she can never be deprived. "Divine Love [your own right Mind — "the kingdom of God within you"] cannot be deprived of its manifestation, or object" (S&H 304:10). As Mrs. Eddy's last addition to her spiritual interpretation of the Lord's prayer declares, "Thy kingdom is come; thou art ever present [to us on earth]."

Jesus said, "The foxes have holes, and the birds of the air have nests, but the Son of man hath not where to lay his head" (Matt. 8:20). This is the inevitable result of laying one's treasures in heaven as Jesus did and advised others to do. This Christian attitude of mind is illustrated in this third picture by the bare surroundings, by the black gar-

ments of the woman, by the serpent (old theology) which hisses behind her, by the clock of time indicating "mortal measurements" (S&H 595:17), and by the candlelight signifying that it is night.

No one can doubt that this third picture is intended to represent Mrs. Eddy writing the first edition of Science and Health in her attic skylight room at Lynn, Massachusetts. Mrs. Eddy says that she was but a scribe when writing this edition: "I should blush to write of Science and Health with key to the Scriptures as I have, were it of human origin, and were I, apart from God ["the kingdom of God within" me, as my own real Mind], its author. But...I was only a scribe echoing the harmonies of heaven in divine metaphysics" (*My.* 115:4).

The poverty of Mrs. Eddy's surroundings, as shown in this picture, proves that "echoing...harmonies of heaven in divine metaphysics" is devastating to earth consciousness. "Pilgrim on earth, thy home is heaven" (S&H 254:31). The higher divine metaphysics lifts thought above earthly manifestation, the more of a desert becomes its earthly surroundings. Then "...the material transformed with the ideal, disappears, and man is clothed and fed spiritually" (S&H 442:22).

"Intelligence" (metaphysics) is the indispensable step leading from earth to heaven, an inescapable phase of Christian Science through which consciousness must pass.

Mrs. Eddy says in connection with her writing of Science and Health, "I could not write these notes after sunset. All thought in the line of Scriptural interpretation would leave me until the rising of the sun. Then the influx of divine interpretation would pour in upon my spiritual sense" (*My.* 114:18).

The woman in this third picture is not writing in the light of day but is thinking in the candlelight of reason ("divine metaphysics"). This dual position — taking no thought for her revelation [which pours in] after "the rising of the sun," but reasoning in the candlelight of night — is the

struggle between womanhood and the manhood qualities in her consciousness, which resulted in "understanding, dearly sought, with fierce heart beats..."

Mrs. Eddy realized that she must share her discovery with others, and sought a "letter" medium of conveying it to them. Both the woman's daytime revelation and her nighttime quest are wholly objective and, therefore, "without" herself; for Mrs. Eddy says of her daytime experience, "...the influx of divine interpretation would pour *in* upon [rather than pour out from] my spiritual sense as gloriously as the sunlight on the material senses." And in her nighttime quest she seeks reason from the Bible, typing manhood, as a foundation for her inspirational daytime illumination typing Womanhood.

Mrs. Eddy's "seeking" was to the end of "finding" a way to present her revelation to others. And this involved an analysis beyond her own need. Her daylight revelation corresponded to the "irradiance of Life" in her own consciousness; and her nighttime quest was her endeavor to adapt her daytime revelation for presentation to the beclouded consciousness of her own followers in their limited conception of scientific Christianity.

Manhood & Womanhood Qualities

While the *symbol* of woman represents a higher idea than the *symbol* of man, the distinction between manhood and womanhood, as used in this book *pertains only to qualities which are accessible to each and both*, rather than to sex, which separates man and woman, contrary to Mrs. Eddy's statement that the "union of the masculine and feminine *qualities* constitute completeness [in one consciousness]" (S&H 57:4). Many men express more balanced feminine qualities than some women and vice versa.

The woman in this picture wears the dark shadow-clothes of human reason. (Everyone who touches the Bible

is clothed in black.) Here Mrs. Eddy reasons as the man-angel consciousness — light in front, problem behind (533:27; 534:5-7). The Bible was direct revelation to Mrs. Eddy, and it had to be wedded to the reason of the Western mentality. Reason and the Bible must be wed, and they are wed through the direct revelation Mrs. Eddy received from divine Mind.

The serpent [old theology] coiled behind the woman's chair recalls the dragon of Revelation. Mrs. Eddy defines serpent as "corporeal sense" (S&H 533:31). She justifies placing the serpent *behind* the woman in this picture (despite the objections of her artist) by quoting a portion of Revelation from Rotherham's translation, "'And the serpent [old theology] cast out of his mouth *behind* the woman, water as a river, that he might cause her to be river-borne'" (*Mis.* 373:9).

The warfare for the demonstrable purification of the human sense of man after he had been theoretically declared to be pure and holy was the inevitable conflict pictured in Revelation. [Mrs. Eddy's interpretation of the Lord's Prayer states, "Thy kingdom is come. Thou art ever present."]

"The twelfth chapter of the Apocalypse typifies the divine method of warfare in Science" (S&H 568:5). This warfare was occasioned by the fact that the wilderness-woman must needs prepare the soil of human consciousness for the reception of the divine revelation of the God-crowned Woman as against the resistance of Old Theology, for it was thus prophesied; hence the "fierce heart-beats." The water which the serpent, the dragon, old theology, cast out of his mouth *behind* the woman in Revelation's twelfth chapter, was his always-taunting demand for more and more purification, [whereas Science and Truth reveals man's *present* perfection].

The woman handles the serpent by seeing the divine origin of man. Mrs. Eddy's womanhood says, "Man is as per-

fect now, and henceforth, and forever, as when the stars first sang together, and creation joined in the grand chorus of harmonious being" (*Mis.* 188:3). Man's past is written in God.

The time on the clock behind the woman, five minutes past midnight, indicates the passing of the material conception of the twelve tribes as matter — Ezekiel's valley of the shadow of death, "dry bones." In this picture Mrs. Eddy revives the dry, dead bones into active, living ideas, while corporeal sense (the serpent) hisses behind her.

HANNA?:

What the First witness, Christ Jesus, knew and taught, the Second witness repeats through "dearly sought" understanding. She sought God's kingdom first and His righteousness, and all was added unto her. At this point in her life she had given up everything for God.

The meaning of this picture is not hidden. The woman with the leaven that had been hidden from the foundation of the world, is now revealed.

This picture reveals her as the Revelator of Truth to this age.

We come now to the next event in her life that has meaning to Christian Scientists, namely: "For three years after my discovery, I sought the solution of this problem of Mind-healing, searched the Scriptures and read little else, kept aloof from society, and devoted time and energies to discovering a positive rule" (S&H 109:11-15). She is seeking and finding. The Bible is an open Book to the Second witness.

Her right hand is under the table and is a symbol of unused power — the power to be revealed in Science and Health. Her quill is partly light and partly shadow showing that the Truth has not yet been completely revealed. Mrs. Eddy's life was half spent when her healing came in 1866. The candle is half spent in this picture, she is past the center of her life. The clock therefore is at 12:05 which is also equivalent to Revelation twelve, verse five: "And she

brought forth a man child, who was to rule all nations with a rod of iron: and her child was caught up unto God [infinite ever-present good], and to his throne." This prophecy is being fulfilled in this picture. Mrs. Eddy says, "This immaculate idea, represented first by man and, according to the Revelator, last by woman, will baptize with fire; and the fiery baptism will burn up the chaff of error with the fervent heat of Truth and Love, melting and purifying even the gold of human character. After the stars sang together and all was primeval harmony, the material lie made war upon the spiritual idea; but this only impelled the idea to rise to the zenith of demonstration, destroying sin, sickness, and death, and to be caught up unto God, — to be found in its divine Principle" (S&H 565:18).

"TIME: Mortal measurements; limits, in which are summed up all human acts, thoughts, beliefs, opinions, knowledge; matter; error; that which begins before and continues after, what is termed death, until the mortal disappears and spiritual perfection appears" (S&H 595:17).

In Science and Health we read, "You are bringing out your own ideal. This ideal is either temporal or eternal. Either Spirit or matter is your model. If you try to have two models, then you practically have none. Like a pendulum in a clock, you will be thrown back and forth, striking the ribs of matter and swinging between the real and unreal" (p. 360:15).

As we read in the book of Revelation, "There shall be time no longer." The woman has revealed this as absolute Truth. [There is no time to 2x2=4; it is omnipresent. So is the truth about your true being.]

We are told by Mrs. Eddy that she could write only by day. Day is symbolic of the woman. Night is the time of false manhood.

Mrs. Eddy consented to model for this picture. The artist sketched the main lines of her face and figure with the hand resting against the head.

Mrs. Eddy is sitting on a chair that is quite dark, as is her clothing. This darkness must be overcome by her, before mankind can see its way through this same type of darkness. There are only two of the three rails showing on the back of the chair; the mortal and human degrees have been experienced, the divine understanding of the third degree is yet to come. She alone had been prepared by the grace of God to reveal this divine understanding of the third degree to tired humanity. She is the transparency through which it comes.

This third picture shows the attic room where the star of the Christ idea shone so brightly in 1875. The serpent [old theology] is malicious animal magnetism seeking to devour the child [the great revelation in Science and Health] before it is born. Notice that she is still unaware of evil's claims at this time. But she is seeking that uncovering. The serpent is behind her waiting to strike and poison. But the talking, lying serpent is now being uncovered by her. Notice the forked tongue [of the serpent], again symbolizing the two-faced nature of ecclesiasticism. You will remember that Mrs. Eddy could not finish Science and Health until the chapter on "Animal Magnetism" had been included. It was this chapter that uncovered the nature of the serpent, [alternately named the "dragon." Mrs. Eddy has many references in her writings saying that evil is unreal].

Clearly identifying herself with the Woman in the Apocalypse, chapter twelve, Mrs. Eddy says, "I insisted upon placing the serpent behind the woman in the picture 'Seeking and Finding.' My artist at the easel objected, as he often did, to my sense of Soul's expression through the brush; but, as usual, he finally yielded. A few days afterward, the following from Rotherham's translation of the New Testament was handed to me, — I had never before seen it: And the serpent cast out of his mouth, *behind* the woman, water as a river, that he might cause her to be river-borne'" (Mis. 373:3). *When she is understood as the*

129

woman of prophecy, the serpent [old theology] *is destroyed, broken up and dissolved. It has no power when she is seen correctly.* Malicious animal magnetism cannot combat a searching thought that is finding its proof.

Mrs. Eddy knew that [ecclesiasticism] claims that the farther away in time we are separated from her, the more it could submerge her in the past until finally she would be vaguely referred to, or entirely forgotten. That is why the serpent and time are behind her. The serpent utilizes time to accomplish its evil purposes. Once she was forgotten, we would use her precious books, bask in the privileges of the Cause, and say we are Christian Scientists with never a thought of her. We would give testimonies on Wednesday evening without a mention of her. We would write for the periodicals never mentioning her or giving gratitude for her. [This happens far too frequently. This is what Isaiah's "small and feeble" remnant are working day and night to remedy.] *A right apprehension and acknowledgment of her will maintain our Cause and further the interests of the one divinity.* In *Miscellaneous Writings,* we read "Christian Science is my only ideal, and the individual and his ideal can never be severed. If either is misunderstood or maligned, it eclipses the other with the shadow cast by this error" (p 105:21).

"SERPENT *(ophis,* in Greek; *nacash,* in Hebrew). Subtlety; a lie; the opposite of Truth, named error; the first statement of mythology and idolatry; the belief in more than one God; animal magnetism; the first lie of limitation; finity; the first claim that there is an opposite of Spirit, or good, termed matter, or evil; the first delusion that error exists as fact; the first claim that sin, sickness, and death are the realities of life. The first audible claim that God was not omnipotent and that there was another power, named *evil,* which was as real and eternal as God, good" (S&H 594).

Revelation xii: 4. "And his tail drew the third part of the stars of heaven, and did cast them to the earth: and the

130

dragon stood before the woman which was ready to be delivered, for to devour her child as soon as it was born."

"The serpentine form stands for subtlety, winding its way amidst all evil, but doing this in the name of good. Its sting is spoken of by Paul, when he refers to 'spiritual wickedness in high places.' It is the animal instinct in mortals, which would impel them to devour each other and cast out devils through Beelzebub" (S&H 563).

"The serpent [old theology] is perpetually close upon the heel of harmony" (ibid. 564). Why is the serpent close upon the heel of harmony? Because it is seeking to bite the heel of the woman. She, however, bruises its head — destroys it.

The loose leaves to the left of the Bible are Science and Health yet to be, as yet incomplete. Notice the candle and candlestick. In Mark, chapter 4, we read, "And he said unto them, Is a candle brought to be put under a bushel, or under a bed? And not to be set on a candlestick? For there is nothing hid, which shall not be manifested; neither was any thing kept secret, but that it should come abroad." Indeed, that which was "secret" from the foundation of the world was to be revealed. The snuffer near the candlestick's glimmer of light is ready to snuff out human opinion (the second degree): *human* goodness, and *human* wisdom. She is reaching for the *divine* light. Notice the light emanating from her head; it is the inner Christ light beginning to shine forth, showing that she is indeed getting *divine* inspiration as opposed to *human* wisdom.

The ear is uncovered, and she is deep in thought listening for her Father-Mother's heavenly voice. To "uncover the ear" is to whisper or tell a secret to one. (See I Samuel 9:15.) Again this is the secret hidden from the foundation of the world. The white frills at the collar of the throat and sleeves show purity of action, and denote clarity of thinking. She tells us that the Bible was her textbook, and that is shown in this picture; it is illuminated by the Christ. Malicious animal magnetism [hypnotic suggestion] has diffi-

culty in poisoning this type of clear thinking and acting. Her hand is in the inner Christ glow, symbolizing reason reaching out to inspiration. She says, "...I won my way to absolute conclusions through divine revelation, reason, and demonstration" (S&H 109).

JOHN PAWLIK:

The symbols before us are a woman seated at a table, with open Bible; the star of Bethlehem shining through the skylight, falling full upon the woman and the open Bible on the table; a clock at the midnight hour; a candle almost burned out; and behind the woman a serpent.

The revelation of the Bible is plain to the woman through the light of Truth. The window pane is less opaque, showing that light comes through a receptive thought. The candle stands for old theology flickering out. The Bible is in the full light of Science. The serpent, animal magnetism (S&H 594:4), is in the dark. In the light, there is no serpent. When one abides in the light of Truth he is never harmed by animal magnetism. In the light of the woman's revelation the serpent is harmless. The clock points to Revelation 12:5: the "man child," Christian Science breaks the belief of time. Time is behind the woman. [In Science, there is no time factor; 2X2=4 is always, everywhere.] Time, "mortal measurements" (S&H 595:17), is put behind the seeker of the light of being.

As with the woman, so with us, Truth must be sought earnestly and persistently. "...seek ye first the kingdom of God, and his righteousness; and all these things shall be added unto you" (Matt. 6.33).

The clock signifies midnight labors; the pen and ink equal the written word. The candle equals human doctrines.

Ushers will eat latecomers.

CHRISTMAS EVE
Picture Number 4

Thus Christ, eternal and divine,
To celebrate
As Truth demands, — this living Vine
Ye demonstrate.

For heaven's CHRISTUS, earthly Eves,
By Adam bid,
Make merriment on Christmas eves,
O'er babe and crib.

Scriptural basis:
The tabret, and pipe and wine, are in their feasts:
but they regard not the work of the Lord,
neither consider the operation of His hands. — Isaiah

Man that is born of a woman
is of few days, and full of trouble. — Job

Since you, dear reader, are Mind, Spirit, Soul — in other words, since you are Principle — you are destined to express only Life, Truth and Love. Each individual has both the masculine and feminine qualities. Every picture of *Christ and Christmas* shows this.

This fourth picture, "Christmas Eve" with its crowded, artificial setting and frenetic festivity, presents a marked contrast to the next, the fifth picture, "Christmas Morn," where two angels as one divine being float in serene rapture over a quiet landscape at sunrise.

While picture five presents the dawning Truth, this fourth picture depicts the mortal seeming — the illusion, or what hypnotism *suggests* is real. It shows the errors Mrs. Eddy came to free us from. Note the aged, the infants, the cripples, the invalid in a wheel chair. Note the artificial light; the focus on *getting*, rather than giving.

The birth of the Christ in our consciousness does *not* take place as "earthly Eves by Adam bid make merriment on Christmas Eve o'er babe and crib." Even in the midst of their celebration, the revelers find, "Man that is born of a woman is of few days and full of trouble." "The tabret and pipe and wine are in their feasts..." and yet each one longs for the glorious annunciation — the invitation of the Christian Science hymn, "O rest beside the weary road, and hear the angels sing....For lo the days are hast'ning on...[when] the whole world [will] send back the song which now the angels sing."

ALICE ORGAIN:
The first Scriptural "basis" of this portion of the poem describes the formal commemoration of Jesus' birth without spiritual quickening. In this picture the tree is lopped off at the top and so points to nothing, neither is there the symbolic star in the tree top, to signify a higher conception than the emotional pleasure of those present suggests. Above all, there is no light of star, typing a spiritual source

of life, shining from without. Those participating in this commemoration — with the exception of the woman in the wheel chair [which could represent Mrs. Eddy at the time when her students turned against her] and the man in the extreme left, with his back turned on the festivities — fail to see "the operation of His, God's, hands." They fail to see the spiritual idea behind the symbols of "the work of the Lord." They fail to see the Christ as the "living Vine," which must be *lived* rather than commemorated.

Dead rites, offered in place of this "living Vine," have shut out (invalidated) the Christ as the Spirit of Womanhood, and rejected the form of true manhood, "typed" by the woman in an invalid's chair and by the man standing behind the tree. This "typical" woman and man are clothed in the black "sackcloth" of duality and rejection, as prophesied of the "two witnesses" in Revelation 11:3.

Mrs. Eddy defines these "two witness" as "Christ Jesus and Christian Science" (*My.* 347:1) —The Christ in its first and second appearing. The Christ's first appearing witnesses to the manhood of God. The Christ's "second appearing" — "the spiritual advent of the advancing idea of God, as in Christian Science"(*Ret.* 70:20) — witnesses to the womanhood of God.

The witness of manhood, to human sense, is that of self-denial, cross-bearing, persecution "for righteousness' sake," suffering, and crucifixion, — epitomized in Jesus' mission. It's method was declared by Jesus as "Get thee behind me, Satan" (Matt. 16:23). The witness of womanhood is of the forever allness of good and the perfection of man. Its method is that of facing and redeeming all human problems by spiritually discerning their underlying realities. It declares of even humanhood, "The more I understand *true humanhood*, the more I see it to be sinless, — as ignorant of sin as is the perfect Maker" (*Un.* 49:8).

The invalid woman in this picture is not only detached from her surroundings, but from her manhood as well.

135

This picture corresponds to the second edition of Science and Health, [just as picture three corresponded to the first edition.]

In the first edition of Science and Health Mrs. Eddy had revealed the manhood of her own consciousness as separated from her womanhood. In this fourth picture she seeks to recover her initial vision of Womanhood in order to preserve her distinctive mission, which static Christianity, her students' lack of understanding, unwittingly seeks to slay.

Despite Mrs. Eddy's denunciation of church in the first edition of Science and Health, she had heard the cry of her followers, "Nay; but a king [a church] shall reign over us" (I Sam. 12:12). Hearing their need, in 1876 Mrs. Eddy and six of her students formed the Christian Scientist Association (later called the Massachusetts Metaphysical College Association) upon which to base a church, and in 1879, with twenty-six of her students, she formed, in Lynn, Massachusetts, the first (sustained) organization of the Christian Science Church "to *commemorate* the word and works of Jesus, which should reinstate primitive Christianity and its lost element of healing" (*Manual* p.17).

Mrs. Eddy was forced to found the first organization of church upon the Christian outer commemoration of "the word and works" of Jesus in his first coming, because her student's lives were not yet attuned to his "second appearing...as in Christian Science," which demanded an inner consciousness of Truth. But because it was founded on this outer commemoration, the more Mrs. Eddy, in her preaching and teaching, poured into it the treasures of Truth and Love of Jesus' "second appearing," the darker the "church" grew, and the more its actions reflected only commemoration rather than demonstration of the "living Vine," or "Christ-idea."

This fourth picture makes "Christ" the subject of its first corresponding verse, and makes "mortal thought" the

subject of its second verse, thus showing the conflict between Mrs. Eddy's thought and that of the first organization of the Boston church, established and founded on Jesus. The confusion on the face of the woman in the wheel chair, and her detachment from the festivities, illustrate this conflict between the "Christ" in the first verse of the poem accompanying this picture, and the commemoration of the birth of Jesus in the second verse.

During the writing of the second edition the male element tried to wrest Science and Health from Mrs. Eddy, and take credit for it. Here, in this picture and the events it references, we see the conflict of personalities. Man and woman, in reality, are one; each has *ALL* the divine qualities. Therefore they cannot remain two without forever warring.

At this period the struggle between Mrs. Eddy and the men in her cause was so great as to seemingly almost wreck the Movement. One student stole the entire proceeds from the first edition of Science and Health, leaving Mrs. Eddy no funds to release her new revision of Science and Health, then at the press. Another plagiarized over thirty pages of Science and Health, forcing a lawsuit to establish Mrs. Eddy's copyright. Another man, also her student, brought a lawsuit against her for all his personal services in the interest of the Movement.

Another man started a conspiracy involving men students, which resulted in the arrest of Mrs. Eddy's husband, Dr. Eddy, who was accused of murdering a student, while the man who was the alleged victim was in hiding to insure the success of the conspiracy.

As men in the movement were trying to take credit for what Mrs. Eddy had discovered, a *Christian Science Journal* article, entitled "Our Place," thought to be by Mrs. Eddy, provided a thoughtful response:

I believe that God has given to every one a place, and in this harmonious creation there is no

137

void, — nothing left out, nothing lacking, — some may as well try to breathe without air, or think without mind, as to think we can rotate out of the divine order of being, or take any place other than our own. Others may try to usurp us; they may try to be like us; they may move earth, and apparently heaven, to gain our position; but when God has placed us there, we are there, and naught can move us out of this, our rightful inheritance.

If this were understood, many warfares would cease: envy and jealousy be exchanged for the peaceful gleams of joy and gratitude; and, mingling with the light of love, would bring man new health and happiness, — yea, Life immortal.

We never see the stars vieing [sic] for each other's places, nor the sun and moon at variance; nor have we seen a Paul take a Peter's place, or John the place of our Master, or *vice versa*. Each fills its own, her own, his own place, whether they have knowledge of it or not; and I, for one, would be content in the sweet consciousness that I have a place with Thee, eternal Love; and however grand or great, humble or small, I am of Thy creation; therefore thine. — Pioneer

(Based on S&H vii:22 [which reads: "Future ages must declare what the *pioneer* has accomplished."] I would say that "Pioneer" is the pen name in this case for Mary Baker Eddy — Schult).

Mrs. Eddy had found that when she revealed the manhood of her own consciousness in the first edition of Science and Health, thereby dividing her manhood from her womanhood, she had not succeeded in placing her own manhood in control over "church" consciousness. Instead she unwittingly had allowed the imperfect manhood of her "church's" consciousness to take over, a consciousness

which had no vision of womanhood, other than as under the mastery of man.

The mission of *Christ and Christmas* is to lift Christianity into Science. Woman [the Christ], alone, revealed the Principle [Love] by which evil could be ruled out of man's consciousness as unreal. "God never said that man would become better by learning to distinguish evil from good, — but the contrary, that by this knowledge, by man's first disobedience, came 'death into the world, and all our woe'" (*Un.* 14:27).

Ultimately Mrs. Eddy, like Jesus, was forced to ascend above earth (manhood) in order to escape the "ecclesiastical despotism" which had crucified Jesus. She heard a voice from heaven saying, "Come up hither" (Rev. 11:12), and the "two witnesses," the manhood and womanhood of her own consciousness, ascended together (as presented by the two angelic figures in the fifth picture) to the consciousness of "the temple of God [which] was open in heaven" (Rev. 11:19) as presented in the sixth picture.

HANNA?:

The cornerstone of the original Mother Church was laid in the evening and Mrs. Eddy tells us that this original edifice is the "cross." The extension had its corner stone laid in the morning and is a symbol of the crown. [It signifies the extension of Mary Baker Eddy's teaching into all the world, and its acceptance by all mankind.] Before the *original* edifice could be built in December of 1894, the followers of Mary Baker Eddy had to overcome their limited understanding of her as just another mortal.

The false concept they carried of Mrs. Eddy gave her the cross to bear. The building of the original Mother Church was an overcoming, in part, of the students' misunderstanding of their Leader. Only when Mrs. Eddy was recognized as having an equal mission with Christ Jesus, did the building work go forward, and this recognition

139

came when *Christ and Christmas* was published.

This fourth picture is the false picture of Mrs. Eddy — the one the world holds of her, and accordingly, there is no light, but darkness.

"Christmas Eve" would stop the correct understanding about the Revelator, and attempt to reverse the Revelator's mission by an improper recognition.

[But the work went forward. The church was dedicated. The following refers to the laying of the cornerstone of the original Mother Church:]

So with one hand upon the stone, our heads uncovered, and faces toward the western sky, where the clouds of the weary day were disappearing, we stood in silent communion with God. (May 21, 1894).

The sun which had been behind the clouds for three days, burst forth in brightness just at this moment and shone upon the corner stone.

— Ira O. Knapp

The first portion of the above poem of Mrs. Eddy's, demands that you demonstrate the Christ, Truth. This is the true celebration and birth of the Christ idea. Heaven's Christ-celebration is obscured and counterfeited by mortal man bidding mortal women to make merry on Christmas eves over mortal babies and the belief of procreation. This is the complete reversal of the true Christ-idea. This error is corrected in the picture "Christmas Morn," and is healed in the picture "Christian Science Healing."

Music and drink are in their ceremonies, but they regard not the Christ, nor consider the operation of God's being. As a result, they have a false concept of creation, and mortal man has his days full of trouble.

We are told in Genesis that the evening and the morning were the first day. Here we have the same order, "Christmas Eve" and then "Christmas Morn." "Christmas Eve"

shows what needs to be uncovered and handled, namely: all the beliefs of the carnal mind stemming from sexuality. The remedy for Eve's submissiveness to evil comes through the Woman prophesied, Mary Baker Eddy. In this picture we can clearly see what Mrs. Eddy had to meet from false manhood, the Adam thought, manipulating the false concept of womanhood, Eve. It continually confronted her, and would have stopped her work if it could.

"ADAM. Error; a falsity; the belief in 'original sin,' sickness, and death; evil; the opposite of good—of God and His creation;... a material belief, opposed to the one Mind, or Spirit; a so called finite mind, producing other minds, thus making 'gods many and lords many' (I Corinthians viii:5)... the usurper of Spirit's creation, called self-creative matter" (S&H 579).

"EVE. A beginning; mortality; that which does not last forever; a finite belief concerning life, substance, and intelligence in matter; error; the belief that the human race originated materially instead of spiritually, — that man started first from dust, second from a rib, and third from an egg" (*ibid*. 585).

"CHILDREN.... Sensual and mortal beliefs; counterfeits of creation, whose better originals are God's thoughts, not in embryo, but in maturity; material suppositions of life, substance, and intelligence, opposed to the Science of being" (*ibid*. 583).

These three definitions certainly blot out the Christ-idea of Christian Science healing. It will be of interest to realize that this picture represents all that must be handled before "Christmas Morn" can shine forth. Mrs. Eddy handled all of the errors in this picture. So must we, if we would be good Christian Scientists and good healers. This picture could be said to represent the first half of Mrs. Eddy's life, because that was the time in which she had to overcome the belief of procreation in her own experience. It was this belief that blocked Science from view.

Later, prior to the building of the original Mother Church, the followers of Mary Baker Eddy had to also overcome this false estimate of her.

The artist did not want to paint this picture because the big tree is grotesque. Notice it is not even finished; it is not complete. The origin of a Christmas tree is based in paganism, and has nothing to do with the Christ-idea. This picture celebrates the birth of the human Jesus. This belief of birth, Adam, Eve, and children, is responsible for human birth, manhood, womanhood, the belief of separation, old age, invalidism, distress, and death. There is no star of the Christ in this picture. There is only an artificial light — electricity. The Christ light of healing cannot find entrance into gross materiality and sensualism. Mrs. Eddy encountered and overcame these evils in her experience, and so must we. The rectangular shape of the picture again shows that much has to be worked out, "even the gold of human character."

Explaining this tree and the tree of knowledge of good and evil in Genesis 2:9, Mrs. Eddy says, "This opposite declaration, this statement that life issues from matter, contradicts the teaching of the first chapter, — namely, that all life is God. Belief is less than understanding. Belief involves theories of material hearing, sight, touch, taste, and smell, termed the five senses. The appetites and passions, sin, sickness, and death, follow in the train of this error of a belief in intelligent matter" (S&H 526:5).

She says this about Christmas, in *Miscellany* (p. 122:18), "Are we still searching diligently to find where the young child lies, and are we satisfied to know that our sense of Truth is not demoralized, finalized, cribbed or cradled, but has risen to grasp the spiritual idea unenvironed by materiality?"

Mrs. Eddy overcame the belief of a *human* mother's goodness, self-satisfaction, and a father's stern and pompous nature, self-righteousness. The children in this fourth picture are in varying degrees of spirituality as the colors

142

of black and white indicate. Notice that the smaller children are in white, and as the children get older (in material sense) their garments become darker. Many children symbolize the false mortal mind creation. You will notice, too, that the children are not given the Christ-idea, but tokens of the parent's material form of love.

Speaking again of the train in *Miscellany* we read, "Ignorance of self is the most stubborn belief to overcome, for apathy, dishonesty, sin, follow in its train" (p. 233). The dolls represent a small impersonation of the false concept. Speaking of **Christian Science**, Mrs. Eddy says, "It is the dear children's toy and strong tower" (*Miscellaneous Writings* 252).

Each of us must overcome these same errors if we would be good Christian Science practitioners; we must understand it is always a case of "physician, heal thyself," then the patient is also healed. [Error comes to the practitioner for life, and the practitioner gives it all the life it has.] Each of us must overcome the claim of animal magnetism that would keep humanity thinking of our Leader as basically a false type of man, rather than the type fulfilling Bible prophecy.

The *true* tree is for the healing of the nations, and not to be decorated with materialism. If we adorn this tree with materiality, false concepts of the Christ-idea, we lose the healing Christ.

The Book in the little boy's hand is closed. It was handed to him by the old man (Old Theology). The Bible is a closed Book to Old Theology, and Old Theology is a part of this material form of creation. It cannot heal because it is based upon procreation and original sin instigated by a suppressed free will. Old Theology tries to extend its influence to coming generations and to darken its understanding with a closed Bible. This Old Theology in Christmas Eve is being healed in the Picture No. 7 where the little girl is reading from Science and Health.

[A further interpretation could be:]

The old lady in the chair in the middle of the picture is mesmerized by the beliefs of old age. Mrs. Eddy overcame all these errors in order to direct the Church of Christ, Scientist. She destroyed the works of animal magnetism in order that "Christmas Morn" might come. A recognition [and understanding] of the woman God-crowned destroys all forms of evil.

Notice that without a window in the room there is no way for the light of Christian Science healing to enter. Mrs. Eddy is the transparency, the window through which the healing comes to humanity. Recognize this, and you will progress as a Christian Scientist.

When our Leader is improperly viewed we cannot perceive her revelation, and we do not heal the sick in Christian Science.

For those of you who have children
and don't know it, we have a
nursery downstairs.

CHRISTMAS MORN
Picture Number 5

Yet wherefore signalize the birth
Of him ne'er born?

What can rehearse the glorious worth
Of his high morn?

Scriptural basis:
Before Abraham was I am. — Christ Jesus

ALICE ORGAIN:

The fifth picture shows Mrs. Eddy's thought as two angels rising above institutional church. The manhood phase of the angels, representing Christianity, is still worshipping, and the womanhood phase, representing Science, is looking for a higher thought.

These figures of angels represent the mission of woman as typing Science, and the mission of man as typing Christianity. The woman as a type of "spiritual discernment" (sight, S&H 586:3) is looking beyond the ken of manhood in her own consciousness of Womanhood; while the man as a type of "spiritual understanding," or "spiritual perception" (hearing, S&H 585:2), is worshipping his spiritual perception of her mission, as embracing the full end of his own discernment.

Mrs. Eddy interprets only two senses in the "Glossary" of Science and Health — those of sight ("spiritual discernment") and hearing ("spiritual understanding"). She makes these two one in her definition of generic "Bride" — "*a* sense of Soul, which has spiritual bliss and enjoys but cannot suffer" (S&H 582:14). She interprets "bridegroom" only as "spiritual understanding" (S&H 582:17), synonymous with "ears," or hearing (S&H 585:1). Thus "Bride" (Word) prophesies the encompassment of hearing by sight, or of man by woman, in fulfillment of Jeremiah's prophecy, "A woman shall compass a man" (Jer 31:22).

"Spiritual Understanding and Spiritual Discernment are the two highest faculties of Spirit, corresponding to hearing and sight...Spiritual Understanding came to the Apostles in Tongues of Fire" (*Christian Science Journal*, June 1886, p. 61) A tongue of fire (light) rests upon the head of each angel in this picture, showing each has his separate impartation of revelation.

The two angels are conjoined in a unified mission as characterized by their blending forms, although their consciousnesses are entirely distinct, expressed as the sight of woman and the hearing of man. Mrs. Eddy, in her article on "Christ and Christmas" in *Miscellaneous Writings* on page 374, speaks of the composite angel in this fifth picture as "a woman," which shows that one phase of this angel types the manhood of Woman (Christianity) and the other phase types the womanhood of

Woman (Science) — both being phases of the same composite Woman.

Christ and Christmas Reveals
the Divine Mission of Our Leader

[Mrs. Orgain explains that] Judge Hanna in an article on *Christ and Christmas* (approved by Mrs. Eddy) stated that *Christ and Christmas* reveals *"the God anointed mission of our Leader" and that therefor a corresponding identity to Mrs. Eddy's mission must be found in each picture.* Here the female figure types Mrs. Eddy's consciousness as prophesying Womanhood as Bride or Word, symbolized by the book under her arm [not easily seen]. She looks beyond the embraced Word — the revelation of the manhood of her own consciousness in the first and second editions of Science and Health — into the revelation of Womanhood in the unreleased third edition of Science and Health as her own consciousness. The male figure types the manhood of her own consciousness. Worshipping Womanhood's past revelation of true manhood (in the first and second editions) he identifies the limit of manhood consciousness.

The womanhood of Woman is watchfully looking into a higher position than the book under her arm — her past revelation of manhood — has yet demanded. The "Glossary" to Science and Health (defining "Abel") links "Watchfulness" with "self-offering; surrendering to the creator the early fruits of experience." Mrs. Eddy is offering her past revelation, the closed book under her arm, to her higher revelation of Womanhood, which she was about to release in the third edition of Science and Health, still at the press, wherein "the female idea" embraces "the male idea" as the wedded consciousness of "two individual natures in one" (S&H 577:6).

The manhood of Woman, as illustrated in this picture, having reached the limit of his mission, offers "worship,"

which Mrs. Eddy associates with Cain's offering of the "fruits of the ground" (S&H 541:10), or earth's demonstration as the exclusive mission of manhood [Christianity].

The "two witnesses" ascend in response to the voice of heaven to a unified consciousness of woman's higher vision than the "fatherhood of God" could reveal through the manhood of Woman. "As Elias presented the idea of the fatherhood of God, which Jesus afterwards manifested, so the Revelator completed this figure with woman, typifying the spiritual idea of God's motherhood" (S&H 562:3). These angels' partly divided and partly blended forms are approaching Mrs. Eddy's definition of Bride as, "The Lamb's wife [which] presents the unity of male and female as no longer two wedded individuals, but as two individual natures in one" (S&H 577:4)

The stanza of the poem corresponding to picture five is: "Yet wherefore signalize the birth of him ne'er born?"

The Scriptural basis given by Mrs. Eddy for this stanza is: "Before Abraham was, I am." — Christ Jesus.

The Glossary verse given for this picture replaces Jesus with the Christ. Jesus said, "Before Abraham was, I am." The "I" in this statement of Jesus indicates that this picture illustrates the "birth" of the Christ idea of Jesus' second coming as Truth to the human consciousness, coming as the "Comforter," promised by Jesus, meaning the Second Coming of the Christ. The "I am" of each of us is forever. [This "I AM" is "the kingdom of God within our consciousness, and is our true Mind.]

Only the ascending angels in this picture can even measurably understand the meaning of this deep saying of Jesus, "Before Abraham was, I am." Certainly it is not given to the grave (beneath the angels), typing Christianity's entombment of Jesus, to know it; for Christianity follows Jesus only to the point of crucifixion. His resurrection and ascension are regarded as beyond Christianity's demonstration.

148

Nevertheless, the grave of Christianity's entombment of the Christ-idea, below the angels in this fifth picture, cracks at this renewed voice of the Christ through Christian Science, which antedates the birth of Jesus. Mrs. Eddy says "Christian Science is as old as God" (S&H 146). Neither "womb" (beginning), nor "tomb" (ending) claims power over the Christ. [See S&H 117:19]

Jesus, being born of "womb," was forced to triumph over the "tomb." Thus Christianity lies between these two points of conception.

Christian Science, on the other hand, starts in the human consciousness with resurrection and ascension (S&H 35:10-18), as typed by the angels in this picture. Therefore it knows nothing of either "womb" or "tomb."

The long and toilsome Christian "highway" (Isaiah 35:8) in this fifth picture, starting with the grave, knows nothing of this Scriptural text, "Before Abraham was, I am." It is equally certain that the institutional church to the left of the highway, with its toilsome processes to attain an ever and always-present goal (the perfection of man) knows little of the meaning of the statement, "Before Abraham was, I am."

HANNA?:

Early on the morn of July 16, 1904, the cornerstone of the extension to The Mother Church was laid at 8 o'clock. The corner stone for the original Mother Church had been laid in the evening. The extension was a fitting crown to the cross of the original Mother Church.

Mrs. Eddy writes, "The modest edifice of The Mother Church of Christ, Scientist, began with the cross; its excelsior extension is the crown.... Its crowning ultimate rises to a *mental* monument — [of which the extension building is a symbol. But this *mental* monument rises to] — *a superstructure high above the work of men's hands*, even the outcome of their hearts, giving to the material a spiritual significance — the speed, beauty, and achievements

149

of goodness. Methinks this church is the one edifice on earth which most prefigures self-abnegation, hope, faith; love catching a glimpse of glory" (*My.* 6).

As the sun dawns, the darkness disappears with great speed. To the artist of a picture of The Mother Church called *Dawn,* that Mrs. Eddy had in her library, she wrote, "Your picture of the Mother Church of Christ, Scientist, distinguishes the artist, points a history, and illuminates it." This was her reply to the artist's letter of July 27, 1907, in which he said; "I represent the Christ Science Church rising unharmed out of the smoke of contending factions, the struggle of creeds and all sort of 'isms' for supremacy." (See *Christian Science Sentinel,* Vol. X, p. 732.)

Mrs. Eddy never came closer to the extension than to drive one day in her carriage to a spot where she could see its great dome looming high against the blue sky, just as she depicted it in this picture of *Christ and Christmas.*

[Mr. Carpenter tells us that as Mrs. Eddy viewed the extension from her carriage it suddenly dawned on her what was in store for her Movement, as outlined in Revelation 13-20, and she became ill.]

Perhaps our Leader had seen the vision of the Extension many years prior to its building, and she was willing to see only what God revealed to her in vision — the crowning dome, [each one's awareness of "the omnipresence of present perfection"]. She had [evidently] seen it as early as 1893 when picture number five was drawn, [whereas the extension wasn't built until 1904.]

Our Leader was content to abide with the substance rather than the symbol. At the opening ceremonies, she was not present. She sat in her study many miles away in Concord, watching, working, and praying for humanity, [as we see her doing in picture 8].

She saw the dome [in Mind] and on April 8, 1906 she wrote, "I have faith in the givers and in the builders of this church edifice, — admiration for and faith in the grandeur

150

and sublimity of this superb superstructure, wherein all vanity of victory disappears and the glory of divinity appears in all its promise" (*Miscellany* 25).

On June 2, 1906, precisely eight days before the dedication, sufficient funds were on hand for its completion. It seated 5,012. This *symbolized* her crowning achievement in feeding humanity through spiritual means alone, just as Jesus fed the five thousand and the twelve disciples — a tender, mothering Shepherd feeding her children.

Years before, Mrs. Eddy wrote to a student, "Jesus no doubt supplied the literal loaf and fish to their sense so as to impress upon them at that period, the Christian era, the fact of his two-fold power, as the Way-shower, or mediator between the things of the flesh and those of Spirit. This was his mission on earth, declaratively and demonstrably from the beginning to the end.

"Not so is the Christ's appearing at this age. Rather is it now to show through Science and not the senses the power of Spirit and of Good, and to spiritualize all the meaning of the Christ, *to name Christ the idea and not the person of God*, and to impress, at this period, the Science of Spirit on the mind, through Truth, and the phenomena of Mind, and not matter: to voice God less in parable, and more in the facts of Being. This must be the true interpretation of the parable of the loaves and fishes, because Jesus could in no other way have made the way for the second appearing of Christ in Science."

The morning beams were beginning to dawn in the Movement. All that was portrayed in "Christmas Eve" was beginning to be overcome, and the light was shining forth with greater intensity and with a more brilliant magnitude than had been seen before.

We are asked two questions in this portion of the poem. Why should we mark the birth of the Christ idea as remarkable, as something eminent or notable? Secondly, what can repeat the glorious worth and value of

the risen Christ or the First Advent?

Considering the first question, we see that it must be answered in a positive manner. A recognition of the new-old birth of the Christ in our experience must come. We must acknowledge the channel through which it comes, else it has little relevance to our experience. The birth of the Christ must be recognized, even though we know that the Christ, as the spiritual idea of God, is never born in the flesh. The birth we speak of, is its appearance to humanity through the enlightened consciousness of a clear transparency.

Next, we ask ourselves what can possibly repeat, for the second time, the glorious worth or value of the risen Christ? We answer that only Christian Science can give utterance to this Christ idea, eclipsing the cross, the symbol of Christianity, with the crown, the symbol of Science. This is the Second Advent, the second witnessing, rehearsing, repeating, the first witnessing of the Christ.

Thus the two questions asked in this portion of the poem are answered through a recognition of the two witnesses. The birth must be recognized, and it can only be recognized, spiritually, through Christian Science. Christian Science reveals the two witnesses.

This "Christmas Morn" is the healing to "Christmas Eve." Mrs. Eddy wrote a letter in 1903 to some students, in which she said;

> May this dear Christmas season be to you a Christ risen, a morn, the break of day. There is nothing jubilant attached to the birth of a mortal that suffers and pays the penalty of his parents' misconception of man and of God's creation. But there is a joy unutterable in knowing that Christ had no birth, no death, and that we may find in Christ, in the true sense of being, life apart from birth, sorrow, sin; and death. O may your eyes not be holden, but may you discern spiritually what is our Redeemer."

The manhood and womanhood of God's appearing are clearly illustrated in this fifth picture. You will notice that [the angels'] seamless garment is one garment, but clothes both witnesses. It is the healing Christ, the babe of Christian Science healing. The path can be traveled only when we recognize the two witnesses. When this recognition comes, a new era will dawn. It will truly be a "blest Christmas Morn." These two angels represent Truth as revealed by His two witnesses.

In Revelation, we read: "And there was war in heaven: Michael and his angels fought against the dragon [old theology]; and the dragon fought, and his angels, and prevailed not; neither was their place found any more in heaven."

Explaining this, Mrs. Eddy says, "The Old Testament assigns to the angels, God's divine messages, different offices. Michael's characteristic is spiritual strength. He leads the host of heaven against the power of sin, Satan, and fights the Holy wars.

"Gabriel has the more quiet task of imparting a sense of the ever-presence of ministering Love.... The Gabriel of His presence has no contests. To infinite, ever-present Love, all is Love, and there is no error, no sin, sickness, nor death. Against Love, the dragon [old theology] warreth not long, for he is killed by the divine Principle. Truth and Love prevail against the dragon because the dragon cannot war with them. Thus endeth the conflict between the flesh and Spirit" (S&H 566-7). That is why this picture is oval, and nears the stage of complete perfection realized in "Christian Unity." Gabriel symbolizes the feminine idea of Love. Michael symbolizes the masculine idea of Truth. Thus, together these angels represent the risen Christ, as revealed through His two witnesses.

"My angels are exalted thoughts, appearing at the door of some sepulchre, in which human belief has buried its fondest earthly hopes. With white fingers they point upward to a new and glorified trust, to higher ideals of life

and its joys. Angels are God's [your true Mind's] representatives. These upward-soaring beings never lead towards self, sin, or materiality, but guide to the divine Principle of all good, whither every real individuality, image, or likeness of God [your true Mind], gathers" (S&H, 299). Who are His representatives who guide? His two witnesses.

As Mrs. Eddy's accomplishments begin to burst forth and her place is recognized, then will mankind receive the angelic message. She says, "The objects of time and sense disappear in the illumination of spiritual understanding, and Mind measures time according to the good that is unfolded. This unfolding is God's day [Mind's day, the day of "the kingdom of God within you"], and 'there shall be no night there'" (S&H 584).

The day of the seed of the Woman [woman means Christ] approaching its complete fulfillment, is glimpsed in this picture. This is why it is oval. It is nearing the completion or full recognition of the two witnesses given in "Christian Unity." The two angels and the dome are in the "FIRMAMENT: Spiritual understanding; the scientific line of demarcation between Truth and error, between Spirit and so-called matter" (ibid 586).

The followers of the masculine and feminine appearing of the Christ, Truth, are the *remnant*, who recognize these two witnesses, and who appear in this picture in the wake of their robes [where you can see the many faces in the original pictures.] They are partially in the human and partially in the divine.

The two witnesses guide this *remnant* towards the light and away from the attraction of animality, animal magnetism, represented by the very dark tree of the knowledge of good and evil, just below their train [no longer discernible].

Immediately following her explanation of angels on page 299 of Science and Health, Mrs. Eddy says, "Knowledge gained from material sense is figuratively represented in Scripture as a tree, bearing the fruits of sin, sickness, and death.

154

Ought we not then to judge the knowledge thus obtained to be untrue and dangerous, since 'the tree is known by its fruit'?"

There is an effort on the part of the "remnant" to escape sensuality in its many gravitational forms. When we gather ourselves into this garment of the Christ, we are lifted above materiality. However, the serpent [old theology] would attempt to seduce us earthward.

In Revelation, chapter 11, we read, "And I will give power unto my two witnesses, and they shall prophesy a thousand two hundred and threescore days, clothed in sackcloth. These are the two olive trees, and the two candlesticks standing before the God of the earth. . . [notice the candles on the heads of these figures in picture 5] And when they shall have finished their testimony, the beast that ascendeth out of the bottomless pit shall make war against them and shall overcome them [the two witnesses], and kill them. . . And they that dwell upon the earth shall rejoice over them, and make merry, and shall send gifts one to another; because these two prophets tormented them that dwelt on the earth. [This merry-making and gift-giving is portrayed in the previous picture "Christmas Eve."] And after three days and an half the spirit of life from God entered into them [into the two witnesses], and they stood upon their feet; and great fear fell upon them which saw them. . . And they ascended up to heaven in a cloud; and their enemies beheld them."

In this 5th picture, the witnesses have risen up. Notice that they have risen out of a sepulcher where the sensuous world [belief] thought it had buried them — in other words, kept them misunderstood, obscure, and unknown. They are risen up out of that sepulcher, and the rock of coldness and stubbornness to Truth's advanced appearing has been rolled away. They are raised up by their followers, a small remnant, who understand their place and mission. [You, the reader, now understand their place and mission.]

In *Miscellany*, Mrs. Eddy writes: "Are we still searching diligently to find where the young child lies, and are

we satisfied to know that our sense of Truth is not demoralized, finitized, cribbed, or cradled, but has risen to grasp the spiritual idea unenvironed by materiality? Can we say with the angels today: 'He is risen; he is not here; behold the place where they laid him'?" (ibid. p 122).

Science and Health states, "Christian Science is dawning upon a material age. The great spiritual facts of being, like rays of light, shine in the darkness, though the darkness, comprehending them not, may deny their reality" (p. 546). These rays, spiritual facts of being, are clearly shown in this picture, and are being witnessed by the two witnesses. Notice the rays coming from the dome of The Mother Church extension, which, at the time this illustration came out, was about thirteen years in [*the future*].

The river in this picture, Judge Hanna tells us, is Euphrates. On this side of the bridge, we have "A state of mortal thought, the only error of which is *limitation: finity*; the opposite of infinity" (S&H 585) The false concept of Euphrates is running along side the tree of the knowledge of good and evil, which is death and all the serpentine forms of error. One of the definitions of serpent serves to illustrate the point that the false sense of Euphrates is animal magnetism. "SERPENT: ...the first lie of *limitation, finity.*" (S&H 594)

[As we know, our Leader often uses a dual definition for many of the terms in the Glossary, whether applied from the standpoint of the human, or that of the divine. The definition for "Euphrates" contains one of these "dual" definitions. In this *"Explanation"* the erroneous concept is brought forth first. How does this relate to Mary Baker Eddy's life? When she is seen simply as a good mortal — from the standpoint of "limitation; finity; the opposite of infinity" — our understanding is darkened. Yet, when Mrs. Eddy is seen correctly in relation to her discovery and "Church" — as His infinite idea; how God sees her — then we will see "Divine Science encompassing the universe and man; the true idea of God; a type of the glory which is to come; metaphysics taking the place of physics; the reign of righteousness."]

On the other side of the bridge, by the water, are the twelve sheep, eleven white and one black. The tree of life is in the midst of the garden. These twelve sheep symbolize the twelve tribes of Israel (See "Glossary" in Science and Health for definitions of various tribes.). Mrs. Eddy speaking of these twelve tribes in Science and Health says, "The twelve tribes of Israel with all mortals, — *separated by belief from man's divine origin* and the true idea, — will through much tribulation yield to the activities of the divine Principle of man in the harmony of Science" (p. 562).

The tree of life in the midst of the garden, in the midst of pleasure in matter, is in the firmament, understanding. However, its fruit is too high for mortals. Mortals cannot receive the Truth unless they recognize the two witnesses, get into their train, and become their followers.

The one black sheep is "animal magnetism; so-called mortal mind controlling mortal mind; error, working out the designs of error; one belief preying upon another" (S&H 583). This is the evil we must destroy before the witnesses can be recognized and healing come to humanity.

Notice that the two witnesses are watching and praying that mankind might awake from its dream of pleasure in matter, and follow them faithfully — as these in their train have already done through vigorous strugglings with the serpent [old theology]. SHEEP is defined as: "Innocence; inoffensiveness; those who follow their leader" (S&H 594). There is one Shepherd and one fold. Mrs. Eddy, speaking of Christian Scientists, says, "Let them seek the lost sheep who having strayed from the true fold, have lost their great Shepherd and yearn to find living pastures and rest beside still waters."

In the definition of [the river] Euphrates, we read, "Divine Science encompassing the universe and man; the true idea of God; a type of the glory which is to come; metaphysics taking the place of physics; the reign of righteousness. The atmosphere of human belief before it accepts sin, sick-

ness or death." Once we cross the bridge over Euphrates into metaphysics, we immediately see the luxuriant growth to the right of the bridge, but then we have to prove it all. Ahead are the difficulties and obstructions that would destroy our vision of the dawn of the Day. The path becomes narrower as it flows on. At its start, it is sin, depravity, birth, age, false education, death, etc., but upon crossing the bridge [into metaphysics] it immediately becomes narrow.

The crossing into metaphysics is at first a sweet taste in our mouth, but the bitterness to digest it is to come. In Mrs. Eddy's definition of "Year" as a space of time, we have the wrong definition of Euphrates (limitation and finity). We also have this statement: "One moment of divine consciousness, or the spiritual understanding of Life and Love, is a foretaste of eternity. This exalted view, obtained and retained when the Science of being is understood, would bridge over with life discerned spiritually the interval of death [the sepulcher] and man would be in the full consciousness of his immortality and eternal harmony, where sin, sickness, and death are unknown." That is the bridge we cross over. The path in this picture shows the destination, and what is to be overcome before the destination is reached.

Notice that there are the letters C.S. in the middle of the picture. The path is Christian and the river is Science.

Mrs. Eddy says, "Christian Science is dawning upon a material age. The great spiritual facts of being, like rays of light, shine in the darkness, though the darkness, comprehending them not, may deny their reality" (S&H 546).

If we do not recognize Mrs. Eddy as the second witness and as the Woman God-crowned, we are being handled by [ecclesiastical despotism], which is attempting to separate the revelator from the revelation. Alert Christian Scientists must handle this unseen mental argument. Our Cause will not prosper until this specific hatred against our Leader is handled.

Handle those tempting arguments to turn away from your precious Leader, the silent enticing arguments of [old theology]. The "murky clouds" that pursue the Christ idea are thus broken up; and the rays of light, the great spiritual facts of being, shine forth to illumine the world on the Day of divine Science, the Day of the Woman [Science].

We are not interested in the high mass, but in the "high morn."

JOHN PAWLIK:

This fifth illustration foretells the time when Christian Science shall cover the earth. In contrast with "Christmas Eve," picture number four, this picture, number 5, "Christmas Morning," has no babes, no cribs, no aged, or invalids, no crippled, no false states of consciousness. [The Christ is incorporeal, spiritual, — yea, the divine image and likeness, dispelling the illusions of the senses; the Way, the Truth, and the Life.] The angels (the two witnesses, Christ Jesus and Christian Science) behold the earth mantled with Christian Science. The roadway — "The Christ [which] is...the Way, the Truth, and the Life" — forms the letter "C", while the river — "Divine Science" (S&H 585:16), "the course of Truth" (S&H 593:15-16) — shines forth the letter "S". The dome in the light is prophetic of the Mother Church extension, signifying the extension of Mary Baker Eddy's teaching into all the world [when she is seen correctly, thus the first part of the definition of "Euphrates" is realized].

The eighth-graders will be presenting Shakespeare's *Hamlet* in the church basement on Friday at 7 p.m. The congregation is invited to attend this tragedy.

CHRISTIAN SCIENCE HEALING
Picture Number 6

Christ was not crucified — that doom
Was Jesus' part;
For Sharon's rose must bud and bloom
In human heart.*

Forever present, bounteous, free,
Christ comes in gloom;
And aye, with grace towards you and me,
For health makes room.

* "God was manifest in the flesh." — St. Paul

Scriptural basis:
*If Christ be in you, the body is dead because of sin
but the Spirit [God-likeness] is life because of
righteousness.* — St. Paul

*But such as I have, give I thee: In the name of
Jesus Christ of Nazareth rise up and walk* — St. Peter

ALICE ORGAIN:

The stanzas accompanying this picture read:

"Christ was not crucified — that doom was Jesus' part; For Sharon's rose [meaning the Church of Christ] must bud and bloom in human heart. ("...God was manifest in the flesh." — Paul)

"Forever present, bounteous, free, Christ comes in gloom; And aye, with grace towards you and me, for health makes room."

The Scriptural texts given for these two stanzas indicate the striking contrast between them. A similar contrast is evident between the plane of consciousness of the man on the bed and the woman in the doorway on one hand, as typing the first stanza, and the woman in white as typing the second stanza.

This second stanza presents the woman in white in the foreground as typing the "Christ," which "comes in gloom; and aye, with grace towards you and me, for health makes room." She has done this by casting out the "gloom" of Christianity, represented by the woman dressed in dark hues, standing in the doorway, who represents institutional church, which has caused the man's seeming illness. The dark-clothed woman, typing the man-controlled spirit of the Christianity of Jesus' first coming, is still enshrouded in the sackcloth of its "commemorative" form, typing the crucifixion of its spirit.

Human womanhood, typed by the woman in grey, having failed to discern a higher light than *commemorative* Christianity as manhood (typed by the first organization of the Boston Church), feels the weight of static Christianity. Commemoration is but the "dead body" of a previously living idea. The first organization of the Boston Church commemorated the word and works of Jesus *before his crucifixion*, for Jesus neither taught nor healed after his crucifixion, merely explaining the Scriptures to two of his disciples on the walk to Emmaus (Luke 24:13, 15,27).

161

Beyond this, St. Paul declared, Christianity could not go. As the then highest evangel, he said, "For I determined not to know anything among you , save Jesus Christ, and him *crucified*" (I Cor. 2:2).

Christian Science is not thus limited. Mrs. Eddy says, "The second appearing of Jesus is, unquestionably, the spiritual advent of the *advancing* [not static] idea of God, as in Christian Science" (*Ret.* 70:20). Specifically refuting St. Paul's static bounds for Christianity, Mrs. Eddy says, "Christian Science says: I am determined not to know anything among you, save Jesus Christ, and him *glorified*" (S&H 200:27).

Thus while the blood of a crucified Savior in the first coming of Jesus gave color to "Sharon's rose" which bloomed in the suffering heart of Christianity, the "second appearing" of Jesus in Christian Science demanded its glorification as "the smile of God" (S&H 175:10).

Picture six signals the beginning of WOMAN'S mission, as set forth in the THIRD EDITION of Science and Health. The woman in white is healing the man, when she (in the words of the poem) "for health makes room." The Womanhood of God (having encompassed Jesus' teaching, the manhood of God) looks heaven-ward, and extends her hand to the patient. Woman's mission as separate from Man's mission really starts here.

This 6th picture represents Fatherhood embraced in Motherhood. It corresponds to the period when Mrs. Eddy put her whole revelation into Motherhood in the third edition of Science and Health, where God was consistently referred to as "She" and "Her."

The Star is the CHRIST. Christianity, the organized church, represented by the petitioning wife, is put out of the room, showing the symbol can be perverted unless intelligently upheld. This ejection of the woman in dark clothes also represents the end of the first organization of the Boston church, which Mrs. Eddy dissolved. The static

162

Christianity of the first organization of the Boston Church, which commemorated Jesus' first coming, had crucified the "Christ" of Jesus' "second appearing." Instead of the first Scriptural "basis" of this picture — "If Christ be in you, the body is dead because of sin" — it presented its reversal in a "body...dead" to the "second appearing" of Jesus as the Christ.

Inasmuch as the intent of *Christ and Christmas* is to reveal "the God-anointed mission of our Leader," it is necessary to figuratively *identify Mrs. Eddy in every picture.* Mrs. Eddy's subjective consciousness at this point is typed by the heavenly woman in white. Woman [standing for the Christ] was a heavenly idea. In the third edition of Science and Health, which this picture correlates, Mrs. Eddy said, "this earth and *heaven* are now and forever the male and *female* of spirit..." (S&H Vol. II, p. 120).

Composite Womanhood, in this third edition, goes beyond Mrs. Eddy's previous revelation of manhood in the first edition as an earthly idea, typing Christianity, upon which the First Organization of the Boston Church was founded.

Note that this picture is not called "*A* CHRISTIAN SCIENCE HEALING," but "CHRISTIAN SCIENCE HEALING." The Christ idea as the Principle of "Christian Science Healing" is typed by the resuscitation of the man on the bed at the heavenly demand of the woman in white for a *higher* Christianity than that which blooms in "human heart." Womanhood, embracing manhood, "makes room for health, with grace towards you and me." The *TRUE* sense of Woman [again, meaning the Christ] brings health to man.

The Woman's gown, the man's apparel and the bed linen in this sixth picture are all light greys, unlike their darker hued counterparts in picture two, while the woman's stole here is white in contrast to the black stole of Jesus in picture two. As noted before, shades of brightness stand for degrees of purification; black for first degree, gray for the second, white for the third or highest degree.

[A number of the images Alice Orgain found in this picture are no longer visible. There was the large head of a serpent, eating dust under the chair, his sinuous body winding down the left drape. The face of the lamb was apparent in the upper right behind him; other animal faces appeared in the upper left fold of the drape. A wolf could be plainly seen in the extreme lower right corner; a Leopard was nearby.

Were the twelve Apostles depicted on the overhang of the bedspread? Very distinct faces were visible. A man's profile (an ancient face) was evident over the "l" in "healing;" another man could be seen in a face over the "ia" in "Christian." There were animals and "men" the full length of the bed.]

The picture on the wall shows a new day dawning; medicine is seen behind the man in bed.

The light hued bed in picture six is in a reverse position to the black casket in picture two, but the girl in picture two, with one arm extended to the right hand of Jesus, is sitting in the same position as the man in this picture.

Here the man-patient is reaching toward the Womanhood of God, rather than to God's manhood, and, unlike picture two, the hands do not touch. The Scriptural message here (as given in the Glossary of *Christ and Christmas*.) is: "Such as I have give I thee; in the name of Jesus Christ of Nazareth, rise up and walk." Note that the WOMAN points to the ascended Jesus, not the crucified Jesus of the Bible, and that she is *not* holding a BIBLE. The patient finds that he does not need her help, since the *message* quickens him to his own completeness, whereas the woman in dark clothes (second degree, moral) (his wife in Christianity) had tried to *personally* complete him.

When Jesus "fully and finally demonstrated divine Science in his victory over the grave," *it was then that he rose into "WOMANHOOD,"* Life,—the first TRINITY quality of the ideal woman. "The ideal woman corresponds to Life

164

and to Love" (S&H 517:10). Jesus was unable to fully reveal this, as he said, "I have yet many things to say to you, but ye cannot bear them now" (John 16:12.)

These "THINGS" had to await JESUS' SECOND COMING in Womanhood, which he prophesied in Rev. 12:1 with the words, "There appeared a great wonder in heaven...." Mary Baker Eddy tells us: "The second appearing of *Jesus* is, unquestionably, the spiritual advent of the ADVANCING idea of God, as in Christian Science" (*Ret.* 20:22). "The female idea" in the third edition of Science and Health is definitively given the full heavenly trinity of "Life, Truth, and Love," from which she definitively gives to man, out of the fullness of her own nature, the qualities of "Life" and "Truth." The mission of WOMAN starts here, clearly separated in character from man's mission.

Mrs. Eddy did not get her revelation from the Scripture, but *got it directly from divine Mind.* She later found that it coincided with the Scriptures. "No human pen nor tongue taught me what is in Science and Health. I began where the Bible left off." Her writings are the "Comforter" promised by Christ Jesus.

Remember, Jesus said, "When the "Comforter" is come [she] will reveal all things."

(See Alice Orgain's *As It Is,* 46-47, S&H 269:21-25; 123:19-23; My. 179:25-28; 318:31:2).

HANNA?:

The healing Christ named Christian Science could never be crucified; nothing can hinder it except a blurred vision of our Leader. The doom of the crucifixion was the cup the Two Witnesses had to drink. It was the world's hatred of the Science.

Sharon's rose, the Church of Christ, is built upon healing and it must bud and bloom in the human heart. The Second Witness has revealed this; it needs only to be practiced. It is the Word made flesh, or God manifest in the

flesh. This 6th picture shows us that *to separate the Revelator from the Revelation and still maintain Christian Science healing is an impossibility. They cannot be separated.* Our Church is built upon a recognition of her and of her revelation. It is based upon Christian Science healing.

Mrs. Eddy once said, "This Cause depends upon healing, healing and *wisdom*. If these are not added, the salt will lose its savor and this Cause drop down into the darkness of oblivion for centuries."

Again she stated, "The true Science — divine Science — will be lost sight of again unless we arouse ourselves. This demonstrating to make matter build up is not Science. The building up of churches, the writing of articles and the speaking in public is the old way of building up a cause. The way I brought this Cause into sight was through HEALING: and now these other things would come in and hide it just as was done in the time of Jesus. Now this Cause must be saved and I pray God to be spared for this work."

In *Twelve Years with Mary Baker Eddy,* Irving Tomlinson records: "On one occasion, Mrs. Eddy said to a member of her household that the way to establish the Cause through reason is through writing and preaching, teaching and lecturing. This is temporal. But the way to establish the Cause through revelation is by healing, and this is permanent" (p 131).

When the New York Scientists presented Mrs. Eddy with two hundred dollars worth of flowers, she looked at the latter sadly, and afterward, with tears in her eyes said, "But they are not doing the work as I want it. 'If ye love me keep my commandments.'"

In a letter Mrs. Eddy wrote, "The truth in regard to your Leader heals the sick and saves the sinner." Mrs. Eddy is the focal point of this sixth picture; without her there is no Christian Science healing then or now. She must be included in every portion of our healing work [since she can never be separated from her revelation]. She tells us that a

166

soldier's love for his country — America — may save his life. This is because he is loving and fighting for the nation that has a holy purpose; and whether he knows of Christian Science or not, he is protected because he is fighting for this nation's protection. Think what a love for your Leader will do in your healing work.

Mrs. Eddy tells us that *the enemy attempts to sever her from her revelation more than they attempt anything else.* All claims of malicious animal magnetism [illusion, hypnotic suggestion—aggressive mental suggestion] are handled when resistance to her place in Bible prophecy is handled. The tender love that she expressed in her healing work must be emulated, and extended throughout all of *our* healing work too. If we handle the world's hatred of her, that love will come forth abundantly in our healing work.

The tender presence of the Christ, Truth, is always present; it is bountiful and free. Christ comes in man's extremity with love for you and me, mankind, and Mrs. Eddy. The mental purity of the Christ, which is the only real health, makes room in thought for Christian Science healing. If the Christ, Truth, is in you, the body has no more power because sin is removed, and there is room for this Scientific, healing Christ. As God's idea, the Christ, you live and move and have your being in His perfection, [since "the kingdom of God is within you"—is within your consciousness as your true Mind].

Mrs. Eddy's most precious gift to the world was the Science of Christian healing. She alone gave it to us. She is speaking to all mankind and telling them to rise up and walk in this Christ-likeness. It is your divine right.

The two portions of the poem represent the material giving way to the spiritual, the human becoming imbued with the divine. The Christ, not crucified, is shown clearly in this picture. The healing Christ is the proof of its eternality and vitality. God's Church has budded and blossomed in one individual, "manifest in the flesh," said Mary

Baker Eddy; and a recognition of her place will continue this Church built upon healing.

The star of the Christ idea is shining, is healing, is proving, is loving.

Her face is looking for the Mother's presence. She has no idea of herself as the healer. She knows that Christian Science, the Word of God, is the healer. [It is "the kingdom of God within" her consciousness as her right Mind, that is the healer.] Her right hand is pointing to the Christ light — as Jesus' left hand is doing in "Christ Healing." One is the acceptance of the Christ as the healer, the other a scientific active power at work vitally reforming human consciousness. There is enough light so that no human touch is needed.

In this picture, "Christian Science Healing" — exemplified by Mary Baker Eddy — is raising manhood above itself into purer desires, away from all that the bed means. Womanhood has already been touched and is in an attitude of prayer. Manhood is the necessary ingredient to be a firm watcher. Prayer, womanhood, is not enough. Womanhood must lift up and include manhood. Prayer must include watching. Notice that both patient and practitioner are working properly. The patient is receptive who will not move. Notice, too, that the mental work is effective as it is reaching the patient. Her arm is extended.

The artist Gilman records, "During the week past since then I have been making the picture of the illustration 'Christian Science Healing,' and in particular of Mrs. Eddy, as the type of the woman engaged in this picture as healing the sick man. When we were considering the details of the design of the illustration of 'Christian Science Healing,' the question of what was the most spiritually appropriate disposition of the hands and arms, was up for final decision. I reasoned that an attitude of peaceful composure and calmness born of perfect faith in omnipotent Spirit, even perfect understanding of God, should be considered as the most appropriate. I argued that the likeness of the

infinite would realize the perfect reality of all things, hence would have no agitation of mind as to the outcome of the healing thought or divine Mind, and therefore perfect repose and calm in the attitude of the healer should predominate. Mrs. Eddy's reply to this I can never forget. She said, 'Yes, *but Love yearns.*' From this I was led to see that my reasoning was largely the loveless, cold, human, intellectual reasoning that cannot at all see spiritual things in reality, but only the dead literal form of its own vain mortal imaginings. Mrs. Eddy then took an attitude to express her spiritual concept to some extent to me of what the spiritual posture of one spiritually would be who was reflecting the divine healing capacity, in the act of raising from a sick bed one who was being held in the bondage of belief of the reality of evil or error. First, she looked upward with a meekly confident, yearning, a far-away (from material sense) look, and at the same time with her right arm and hand raised with the index finger in a childlike way pointing upward — heavenward. The other arm and hand was stretched out in a downward direction as if toward suffering humanity, appealing and yet joyously all in spiritual purity and adoration."

In a letter to Mr. Gilman, referring to the picture "Christian Science Healing," she wrote:

> *Mr. Gilman,*
> *My dear friend:*
>
> *Do you know what you have done for yourself, for mankind, for our Cause? No, you do not, perhaps, but I will tell you. You illustrated and interpreted my life on the plate that you sent me. "*

As Mrs. Eddy once stated, "I am the unresisting channel through which Love shines with its full healing force." Speaking of the pictures in *Christ and Christmas,* Mrs.

Eddy told the artist, "Now carry out these designs with all the skill of an artist and my story is told in Christian Science, the new story of Christ, and the world will feel its renovating influence."

This bearded old man [in the bed,] symbolizes tired manhood getting ready to give up its false pleasures and pains. He is leaving medicine behind, and will no longer rely upon materiality to temporarily salve his wounds.

Medicine cannot enter the healing work, and you are not a good practitioner if you advise its use, nor a good patient if you use it. You exclude yourself from Christian Science healing if you use it. Notice that his hand is not touching hers, and that is the nature of impersonal Christian Science healing.

Gilman relates, "When she was looking at some of the sketched designs, she laughingly said upon looking at the sketch of the face of the sick man who she was represented as healing, 'There! That man looks just as if he was determined I should not heal him." The old man, tired humanity, cannot resist the loving presence of the healing Christ.

Our dear Leader has already lifted womanhood out of its chair, out of worry for a loved one, into active prayer. You will notice that womanhood is in the light, but manhood is part in and part out. This is much the same as in the picture "Christ Healing" [picture two]. This picture however is far more active than "Christ Healing." The entrance for Truth is wide in this picture, and it symbolizes an actual statement of the thinking of the world. The time has come. Her ear is uncovered, and she is listening for divine direction, the still small voice; and she is also listening for the call of humanity for help.

This picture is coupled with no other picture. It is the center picture. Only by recognizing Mrs. Eddy's place, can we effectively heal in Christian Science. Only by recognizing Mrs. Eddy's place, can Sharon's rose bud and bloom —

the Church prosper and grow among humanity. This picture includes her life and light.

The white robe that she wears is typical of the Christ robe, or Christ-consciousness, without seam or rent. Note how it trails under the bedding to the floor. The white line near the foot of the bed is the continuation of her robe and symbolizes her thought reaching the foundation of sickness and destroying sin. She is destroying animal magnetism and not the symptom. She is bruising the serpent's [old theology's] head. Malicious animal magnetism in its many phases is being handled by Mary Baker Eddy. As Christian Scientists, we realize that Mary Baker Eddy handled every form of sin thrust upon her. The darkness between the robe and her body is the world's problems and sins that she has taken in to heal, but which are not weighing her down as a dark robe would represent. Notice the Christ light about her head showing clearly that she is God's anointed one. [We will grow spiritually] by acknowledging her place, which naturally brings healing and naturally destroys the claims of malicious animal magnetism according to the law of divine Science.

The floor in this picture is the dissolving of the claims of ecclesiastic despotism from the black and white tiles in *Truth vs. Error* (tenth picture) to vague mingling of black and white. Thus error's foundation is being destroyed (dissolved) through the light of Truth. She writes, "The Babylonish woman in the Apocalypse has thrown wormwood into the waters to turn trusting thoughts to hatred against me, the idea; handle this and you will find your patients healed." Again, "Christian Scientists must work *daily* to annul the prayers of the unrighteous, those who unrighteously pray that Christian Science prayers cannot heal the sick." [Mrs. Eddy has nearly 50 references to "daily" in Prose Works alone.]

As Elijah passed his mantle on to Elisha, so did Jesus pass his robe on to Mary Baker Eddy, and with it a double portion.

The Two Witnesses ascended up to heaven in the last verse of chapter eleven of Revelation. Picture number five portrays this. Chapter twelve of Revelation starts with the mission of the Woman God-crowned. This picture portrays chapter twelve of Revelation. The Woman in prayer [looking heavenward] in "Christian Science Healing" symbolizes the fulfillment of the twelfth chapter of Revelation, and symbolizes that this is woman's hour; she has taken the lead. She is the Leader.

The picture "Christian Science Healing," portrays a three-fold treatment, perfect Father-Mother, perfect Son, perfect Holy Ghost [Science]. Without a recognition and appreciation of the Holy Ghost, divine Science or Christian Science, in our healing work, we will not find healing.

The bed in this picture is made out of brass. The figurative meaning of brass is insensibility, baseness, and presumption or obstinacy in sin. There must be a clear recognition of the sin in order to heal it. Sin will not recognize our Leader, and sin does not want to be uncovered and healed. This picture shows that Mrs. Eddy worked tirelessly to take false manhood away from this claim of malicious animal magnetism [hypnotism, error, illusion]. That work enabled her to build her Church.

In *Retrospection and Introspection,* she states, "Nothing except sin, in the students themselves, can separate them from me." (p. 81)

Mrs. Eddy wrote, "I am amazed when I see how little Christian Science healing is done. So much is faith healing, little more." And again, "Unless we have *better healers* and more of this work than any other is done, our Cause will not stand and having done all stand. *Demonstration* is the whole of Christian Science, nothing else proves it, nothing else will save it and continue it with us. God has said this and Christ Jesus has proved it." [Healing in Christian Science is always a case of: "Physician, heal thyself": there is nothing "out there,"

since "God is All." When a patient calls, the practitioner must heal himself of the belief that there is error lurking somewhere. When the practitioner heals himself of the belief that there is evil, the patient is healed, since there is only one Mind, only one "I." When we don't permanently heal ourselves, the healing is merely "faith healing."]

JOHN PAWLIK:
In this illustration we see the healer flooded with the light from the star. All Christian Science healing comes from the light of the star of Boston. Mrs. Eddy tells us in Science and Health: "This light is not from the sun nor from volcanic flames, but it is the revelation of Truth and of spiritual ideas" (504:9-11). "In the name of Jesus Christ of Nazareth rise up and walk" (Acts 3:6). "God was made manifest in the flesh" (I Tim. 3:16). All true Christian Science healing is God made manifest in the flesh.

Here we see the healer with eyes looking upward and with uplifted hand. The mortal-mind helper is looking down to matter. We note that materia medica has been discarded, for the medicines are behind the patient. In this we see old belief leaving the bed — medicine is behind him. The white curtains, representing the first degree, are drawn back, and light coming through brings the theological thought in the home to a state of prayer.

Note the picture on the wall — "Breaking through the clouds." The woman's white robe represents understanding. It reaches the base of the bed, symbolizing her thought reaching the foundation of reality — "the omnipresence of present perfection."

Due to the Rector's illness,
Wednesday's healing service will be
discontinued until further notice.

I THANK THEE, O FATHER, LORD OF HEAVEN AND EARTH, BECAUSE THOU HAST HID THESE THINGS FROM THE WISE AND PRUDENT, AND HAST REVEALED THEM UNTO BABES. — *JESUS*
Picture Number 7

Thus olden faith's pale star now blends
In seven-hued white!
Life, without birth and without end,
Emitting light!

Scriptural basis:
Without father, without mother, without descent,
having neither beginning of days, nor end of life;
but made like unto the Son of God. — St. Paul

ALICE ORGAIN:
The Scriptural text used as a title for picture seven, and the poem accompanying it, together point to "the dawn of a new light" (S&H 35:10), which the "babe" consciousness alone could receive. The Scriptural "basis" given for the

stanzas corresponding to this picture shows that the youth of the little child and the age of the "old" gentleman do not appertain to themselves but symbolize the messages of Science and Health and the Bible as the new and the old. The "wise and prudent" and the "babe" *must* refer to states of consciousness rather than to age and youth, for the Scriptural "basis" denies "beginning" or "ending," and the stanza proclaims "Life, without birth and without end, emitting light!"

Thus this picture illustrates the relative positions of the Bible and Science and Health and the two consciousnesses that type them. The "old" gentleman undoubtedly represents the old heaven and the old earth that pass away before the "new heaven and...new earth" (Rev. 21), typed by the little child, who represents the "new birth," which Mrs. Eddy says is "heaven here" (*My*. 158:12) — neither *born* nor *borne* to earth.

Inasmuch as the first lines of the stanza read, "Thus olden faith's pale star now blends in seven-hued white," they show that the "Christ" (as typed by the woman in white in the sixth picture), being the full trinity of Life, Truth, and Love expressed in one, has gathered all ideas to a common heavenly focus in this picture.

From the first edition of Christ and Christmas, in 1893, up to the last (ninth) edition, in 1910, Mrs. Eddy attributed to Jesus the authorship of the Scriptural title of this picture, but in the last edition she added "Christ" to "Jesus" as author. Jesus prophesied that his second coming would be as the "spirit of Truth." Truth at the point of this seventh picture is a wholly *heavenly* consciousness which must be received on earth through a wholly heavenly channel, which Jesus identified as a little child. "Of such is the kingdom of God [heaven]....Verily I say unto you, Whosoever shall not receive the kingdom of God as a little child, he shall not enter therein" (Mark 10:14, 15). By adding "Christ" to "Jesus" Mrs. Eddy accepted the position that it

was the Christ of Jesus' second coming which prophetically spoke through Jesus when he said, "I thank Thee, O Father, Lord of heaven and earth, because Thou hast hid these things from the wise and prudent, and hast revealed them unto babes."

"The kingdom of God cometh not with observation: neither shall they say, Lo here! or lo there! for, behold, the kingdom of God is within you" (Luke 17:20, 21). St. John was able to see "a new heaven and a new earth" at the same time (as recorded in Revelation 21:1) "because St. John's corporeal sense of the heavens and earth had vanished, and in place of this false sense was the spiritual sense, the subjective state by which he could see the new heaven and new earth....This is Scriptural authority for concluding that such a recognition of being is, and has been, possible to men in this present state of existence" (S&H 573:19)

The poem here reads: "Thus olden faith's [typed by the old man] pale star now blends in seven-hued white! Life without birth and without end, emitting light." This is typed by the little girl who is reading the fiftieth edition of Science and Health, published during the interim between the Boston churches.

When Mrs. Eddy dissolved the First Organization of the Boston church in 1889, she said that she was retiring for the purpose of revising Science and Health, which had last been revised in the sixteenth edition. Her promised revision was this fiftieth edition, which was copy-righted late in 1890 and given to the field in 1891. Thus the little child also types the branch churches, which alone remained during the interval between the dissolution of the First Organization and the formation of the second organization of the Boston church.

Since the field branches, as rooted in the Word as Bride (*My.* 125:26), figuratively kept step with Mrs. Eddy's progressive revelation in Science and Health with Key to the Scriptures, they, as the only organized churches during the

interim between the first and second organizations of the Boston church (1889-1892) subjectively type the fiftieth edition, published in 1891 — the Branch-idea typing the objective fulfillment of the fiftieth edition.

Mrs. Eddy's consciousness was for the first time fully revealed in this fiftieth edition, for it presented the final footsteps in even our present edition. The fiftieth edition proved so complete as to make possible for the first time Mrs. Eddy's later comment, "those who look for me in person, or elsewhere than in my writings, lose me instead of find me" (*My.* 120:2).

Note that in this seventh picture the Bible is closed and there is no light resting upon it, in contrast to the open Bible upon which the light of the star rested in the third picture. Here the Bible is embraced in the light of the open book of the fiftieth edition of Science and Health with Key to the Scriptures.

In this fiftieth edition, Mrs. Eddy for the first time declared under the marginal topic, "Biblical Foundations," "I therefore plant myself unreservedly on the teachings of Jesus, of his apostles, of the prophets, and on the testimony of the Science of Mind [Mind being the only exclusive quality of the fatherhood of God]. Other foundations there are none" (S&H 269:22-25). This declaration took in the whole scope of the Bible.

Mrs. Eddy also for the first time based each and all chapters of this fiftieth edition on Biblical texts. This edition also retained the "Glossary" (added for the first time in the sixth edition), which presented the metaphysical interpretation of the Biblical phases of manhood from Adam to Jesus, and the God-crowned Woman's "man-child" as Truth (added for the first time in the sixteenth edition. Thus the "old" gentleman is able to reassuredly close his Bible in the inspirational consciousness of its fulfillment in Science and Health with Key to the Scriptures.

The Bible is in no sense closed in obliteration or forgetfulness of its contents, for "God requireth that which is past"

(Eccl. 3:15) in embraced memory and its responsive activity. Just as the butterfly emerges from its humble "past" carrying in its beautiful body all of the substance of its previous state except its prior self-confining limits (not forgetting its former body but incorporating it), so the advanced idea embodies the "past" after having merely burst the bonds of its former limitations. Only the limits of one's viewpoint are changed and never the true substance of an idea as its identity.

In this seventh picture the Bible is closed because "olden's faith's pale star (a distant, little understood promise) NOW blends in seven-hued white." Science and Health, the "little book" open, has explained the Bible. Every personage of the Scripture becomes an impersonal quality; Abraham becomes fidelity, Moses becomes moral courage, etc. An article entitled "Jacob's Ladder" in the fourth volume of the *Journal*, June 1886, types "Life, Truth, Love, purity, beauty, harmony, perfection" as "the seven colors of the rainbow," [or Mind, Spirit, Soul, Principle, Life, Truth, Love]. The seven days, or the seven stars, are the seven hues which are gathered into the white light of ideas; — "the rays of infinite Truth (the dry bones of Ezekiel) when gathered into the focus of ideas, bring light instantaneously" (S&H 504:23). Mrs. Eddy's seven synonymous terms, understood as the numerals of infinity, have explained the Bible, because they have gathered all into the white light of ideas.

"The Bible contains the recipe for all healing" (S&H 406:1), but it must be translated into the new tongue of the "INSPIRED WORD," since the translators of the original Word assumed that to be first which appeared second, and is mortal and material. (See *Mis.* 188:5-8.)

Bible admonitions, commands, denials and cross-bearings help to break the bonds of the limiting walls that obstruct the spiritual idea, but without such temporary confines the Bible could not have been demonstrably closed.

178

The "old" gentleman in this picture, typing Bible consciousness, wears heavy glasses, representing unillumined Bible consciousness, which hears, but sees "through a glass darkly." Even St. Paul, in his first Corinthians discourse on Love, said that he then saw "through a *glass*, darkly." St. Paul saw Woman through the limitation of manhood. His (then dim) vision of Woman as typing Love (See S&H 517:10) awaited the channel of womanhood, typed by Mrs. Eddy, for its discovery and revelation.

The Bible, being the revelation of the ascending consciousness of individual man, has come solely through man. Science and Health came through one woman. Woman is generic (all-inclusive), and one woman embraced the whole.

"The Mind or intelligence of production names the female gender last in the ascending order of creation. The intelligent individual idea, be it male [such as manhood, my logic, my intelligence, my creative wisdom, etc.] or female [the love for it that sees it through], rising from the lesser to the greater, unfolds the infinitude of Love" (S&H 508:21). Love is Womanhood. Since "WOMAN" corresponds to Love, she must be exchanged therefor, — the material, transformed into the ideal, disappears.

Man (meaning my manhood, my logic, intelligence, and creative wisdom) can only reach my womanhood (generic man) by taking in and acknowledging my womanhood, and by acknowledging its channel, Science & Health, and its author, Mary Baker Eddy.

This is the open door through which this old man in the picture has seen the impersonal womanhood of Science, with only a CHILD to present it to him; she has no claims to make for anything but her Message. When the Bible is *closed*, the snarly dragon on the outside of the window is shut out, "for the accuser is not there, and Love sends forth her primal and everlasting strain" (S&H 568:29). When the drag-on of Old Theology is silenced, new vision becomes operative.

One shuts the dragon (as seen through the window) out of the room only so long as one inspirationally basks in the effulgent light of Science and Health, until the "Spirit of Truth" that it presents becomes the intelligent inner workings of one's consciousness (the work of the eighth picture.) "*God* never said man would become better by learning to distinguish evil from good" (*Un.* 14:27). (Sex and child-bearing cease.) The embryonic conception of impersonal Truth, which the little child in this picture types, causes the "old" gentleman's consciousness to close the Bible. All the good in the Bible has been embraced in the Principle revealed in Science and Health, leaving nothing unredeemed. The shutting out of the dragon when the Bible is closed types the silencing in the light of Science and Health of the accusative Biblical consciousness.

Note the man's beautiful intelligent face.

The clock in this picture is five minutes past five p.m., denoting the first intelligent step of Christianity (manhood) "towards harmony" or Womanhood, — the spiritual idea of the creative symbols of the Bible. In the numerals of infinity five o'clock types the fifth day of consciousness. Even after the Bible is closed by the "old" gentleman, "the clock of time" against the wall still records its "mortal measurements" (S&H 595:17), for time's "forms" must intelligently "take on higher symbols and significations" to earth sense before "time" is illuminated "with the glory of eternity" (S&H 595:17).

In "the irradiance of Life"(S&H 584:1) "Mind [intelligence] measures time according to the good that is unfolded" (S&H 584:5) in one endless day. This picture types "haste towards harmony"(S&H 586:21), that is, toward rest, but *true* rest, activity in "the spiritual idea." Hence the clock hastens toward the sixth day, the spiritual idea of the male and female, which is needed to support *TRUE* rest. The next picture, number eight, embraces half-rest in whole-rest, because it embraces seven on the same rung of the ladder.

180

Note the old gentleman's hair is white. His suit is dark, and the Bible is close by, but the expression on his face indicates he welcomes the message of Science and Health.

Little girl's face is lighted, although her back is to the window, and there is no artificial light in the room. The light from the Star, the CHRIST CONSCIOUSNESS, beaming through the window, shines on the pages of the opened Science and Health. The light of the textbook's pages reflects back into her face as if from the mirror of divine understanding. "Call the mirror divine Science" (S&H 515:29).

One can readily see that Mrs. Eddy intended to show in this seventh picture the state of consciousness spoken of by Jesus when he set a little child "in the midst" and said, "Except ye be converted, and become as little children, ye shall not enter into the kingdom of heaven" (Matt. 18:3). "The kingdom of God cometh not with observation: neither shall they say, Lo here! or lo there! for, behold, the kingdom of God is within you" (Luke 17:20, 21). It is the little child-consciousness alone that receives the Word without any preconception, and roots itself therein. "Of such is the kingdom of God [heaven]....Verily I say unto you, Whosoever shall not receive the kingdom of God as a little child, he shall not enter therein" (Mark 10:14, 15). [There must be a willingness to learn all things rightly.]

HANNA?:

How are we to enter the kingdom of heaven? The Master tells us we must become as little children. Only the child-like in thought can recognize the two witnesses, accept Christian Science, witness Christian Science healing, and perceive the Day of the Woman. The guileless, the pure, the loving, the humble, are the ones who recognize their Leader, and are willing to see her place in prophecy.

As this picture is revealed through "Christmas Morn," we again find the definition for sheep: "Innocence; inof-

181

fensiveness; those who follow their leader." (S&H 594)

Self-esteem, self-love, hatred, guile, dishonesty, etc., are the sins of the carnal mind—the aspects of animal magnetism—that will keep Christian Scientists from accepting their Leader's place.

This picture is coupled with "Christmas Morn" because it indicates the level of thought we must attain to be able to follow the two witnesses. The book, Science and Health *Key to the Scriptures,* is open. The child-like thought is searching; and this searching is not going unrewarded, as you will notice the radiancy in her face. Her shoes symbolize mortality, but her age symbolizes innocence and inoffensiveness, which is the only way out of the mortal dream. The understanding of the Christ is given only to babes. These are spiritually-minded enough to perceive the message and the messenger. This young girl aptly symbolizes that type of thinking. Pure thinking understands what mature human wisdom does not comprehend. Notice that child-likeness has risen above materiality to a certain degree. She has a support to rest her feet.

Notice that Old Theology has his feet on the floor, on materiality. The child represents the best of the second degree reaching forth for spiritual understanding. His vision is blurred, inadequate, and he thinks he needs ceremonies, creeds and dogmas, symbolized by glasses, to interpret the Scriptures, to view creation and to acknowledge the Christ idea. He must listen to the child-like, the pure in heart, to receive his healing. He must attain the humility, innocence and inoffensiveness, to do so. When the advent of the Woman is revealed, then Old Theology will listen to the child-like.

Why is the child a little girl? Because a little girl is symbolic of the beginning of the understanding of the Woman [Science]. The little girl is a type that has not been recognized in its maturity as yet. Generic man is symbolized by a woman, [which stands for the Christ].

Old Theology will listen to this type of womanhood, though not yet in its mature state. It is a recognition of her divine purpose.

The poem accompanying this picture tells us the message. The pale star of early Christianity is now more visible. It has become full orbed with the revelation of the seven synonyms found in our textbook. The guiding star of being has shone and is shining. It reveals infinite life, the vitality of Christian Science healing, expressing itself in light and understanding. In Science and Health, Mrs. Eddy makes this clear when she says, "Immortal and divine Mind presents the idea of God: First, in light; second, in reflection; third, in spiritual and immortal forms of beauty and goodness" (p. 503). The light is most visible in this picture. The reflection is seen in the child's face; it is the reflection of the Word. The "spiritual and immortal forms of beauty and goodness" are seen when we recognize the woman even to a degree, or as a girl-child. Then comes Christian Science healing.

The Biblical verse with this poem is a reference to Melchisedec, the priest of Salem, a forerunner of the Christ-idea. What then is the true priest? Christ-likeness, the child-like and pure in heart. This child-likeness is the complete opposite of Old Theology who, for thousands of years, has been dwelling in darkness, the darkness of false manhood. Witness the dark clothing on the old man. The Bible is closed to this old man, Old Theology; and he cannot understand it except through the Woman; and she is found in her writings as being read by the child-like. The true priesthood is attained to the degree that we approximate the purity of thought of this little one — in other words, obtain an understanding of the woman's mission and light, although at first it may not be the full recognition.

Mrs. Eddy was able to give us this Truth because, from the time she was just a small child, this purity, innocence,

and inoffensiveness was expressed in boundless measure, and the retention of this purity enabled that consecrated one to give us Science and Health, *Key to the Scriptures,* as the textbook is entitled in the seventh picture.

Christian Science healing comes through the child-like consciousness and a recognition of the Woman. Lectures, teaching, church work, and advertising are poor substitutes for purity; and it is this purity that will bring forth healing.

William McKenzie, a member of Mrs. Eddy's household, wanted her to have the book Science and Health [with Key to the Scriptures] published omitting the "with" but she said, "No, Will dear, the world isn't ready for that yet." That is, she felt she should not force Science and Health on the world *as* the Key to the Bible, but *with* the Key. This [picture] is the only place Mrs. Eddy ever allowed "with" to be omitted. She is telling us that Christian Scientists must recognize this fact and appreciate Science and Health much more than it is now being appreciated.

Adam Dickey in his memoirs of Mrs. Eddy writes, "On one occasion Mrs. Eddy called me into her room and I found her considering a change in the title of her book, Science and Health. Instead of having it "Science and Health with Key to the Scriptures," she proposed making it read, "Science and Health, Key to the Scriptures." She asked me what I thought of the idea and if I understood the import of it. I told her that I did indeed, and that I thought it would be a splendid change as it would at once convey to people the thought that her book was the "key" which unlocked the Scriptures, and not just chapters 15, 16, 17 as would appear from the inscription "Key to the Scriptures," found on page 499 of her book as it stood at that time. Mrs. Eddy was quite pleased with the idea and spoke favorably of it. She talked it over with her publishers and explained that she would like to make this change in the title of her book, provided it did not in any way conflict with her copyrights. Mr. Stewart,

her publisher at that time, made the inquiry from Mrs. Eddy's Boston lawyer, and the word came back that they would not advise her to do this, as it might materially affect the copyrights of her book. Thus our Leader abandoned one of the inspired thoughts that came to her, and which would have enlarged considerably the thought of all Christian Scientists regarding her book, Science and Health."

Mrs. Eddy also asked Mr. William Nicholas Miller in London to try to get the textbook published in England with the omission of "with," but she met the same caution about her copyright from her lawyers there as she did in this country.

The grandfather clock says 5:05; this is a reference to Revelation, chapter 5, which refers to the book being unsealed by the Lion of the Tribe of Judah. "And I saw a strong angel proclaiming with a loud voice, Who is worthy to open the book, and to loose the seals thereof? And no man in heaven, nor in earth, neither under the earth, was able to open the book, neither to look thereon. . . And one of the elders saith unto me, Weep not: behold, the Lion of the tribe of Judah, the Root of David, hath prevailed to open the book, and to loose the seven seals thereof." The Christ has prevailed to open the pages of the book and have them revealed. Only as we become as little children can we remove the signet of error from our own consciousness, because only then can we understand Christian Science, experience healing, and enter heaven.

Time is behind Old Theology with the Bible closed, but there is no time in the revelation of Science and Health. In the book of Revelation, the book dictated by Jesus to St. John, about the Woman, we read from chapter ten verse five, the words of the angel with the little open book: "And the angel which I saw stand upon the sea and upon the earth lifted up his hand to heaven, And sware by him that giveth for ever and ever, who created heaven, and the things that therein are, and the earth, and the things that therein

are, and the sea, and the things which are therein, that there should be time no longer." [Just as there is no time element in the science of mathematics.]

The clock representing time is not behind the little girl. Again we repeat the definition for time given by Mrs. Eddy: "Mortal measurements; limits, in which are summed up all human acts, thoughts, beliefs, opinions, knowledge; matter; error; that which begins before, and continues after, what is termed death, until the mortal disappears and spiritual perfection appears."

There is no limitation or finity, which is the false definition of Euphrates, in this picture. This little child fulfills Isaiah's prophecy that a little child, the Christ-idea, shall lead them.

Immediately after the chapter on 'Recapitulation' in Science and Health, we have the title page, "Key to the Scriptures," and under it the quote:

These things saith He that is holy, He that is true, He that hath the key of David, He that openeth, and no man shutteth, and shutteth and no man openeth; I know thy works: behold, I have set before thee an open door, and no man can shut it. —Revelation.

To the Christ idea, it is an open book, unsealed.

The curtains in this picture are sheer. They are letting in the light. They symbolize the consciousness of the world that has been leavened by Christian Science and the recognition of the Woman. The world's thinking is being parted for the Christ light; it no longer obscures the brightness of divine Light. Mortal mind is therefore giving up its false claims and beliefs.

The star of Truth is clear and angular with Science and Health becoming the light of the world. "God has set His signet upon Science, making it coordinate with all that is real and only with that which is harmonious and

186

eternal." (S&H 472:6)

Are we seeking Christian Science to build bigger churches, nicer homes, more comfortable fortunes, more money, clothes, and all the accompanying pleasures of this world? Are we using Christian Science for mortal gain? That is certainly not Christian Science. If we are seeking His righteousness first, then we are becoming little children, and indeed all will be added unto us naturally and necessarily.

The two witnesses are recognized in "Christmas Morn" as the light shines forth. We must become as little children in order to enter this scientific heaven. These two elements firmly held in consciousness, the Message and the Messenger, lead us to Christian Science Healing.

The third verse of *Blessed Assurance*
will be sung without musical
accomplishment.

TREATING THE SICK
Showing Mrs. Eddy as she worked one hour every
night treating the world. (HMW's insight)
Picture Number 8

The Way, the Truth, the Life — His word —
Are here, and now
Christ's silent healing, heaven heard,
Crowns the pale brow.

Scriptural basis:
Heal the sick. — Christ Jesus

ALICE ORGAIN:
The eighth picture presents The Mother Church whose
mission was "healing and saving the world from sin and
death; thus to reflect in some degree the Church Universal
and Triumphant," (*Manual* p. 19). The woman at the bed-
side is humanly typing "Science" as the "crowning ulti-
mate" of The Mother Church, which Mary Baker Eddy was.

The man asleep on the huge bed, which has neither complete headboard nor footboard, represents the *world* "asleep in the cradle of infancy, dreaming away the hours" (S&H 95:28).

The woman in this eighth picture, typing the work of The Mother Church, responds to Mrs. Eddy's admonition given February 1896, "The hour has struck for Christian Scientists to *do their own work*" (*Mis.* 317:5). Thus, the woman, in spiritual realization of Science and Health's contents, has closed even Science and Health. The reward of her work is described as, "Christ's silent healing, *heaven heard, crowns* the pale brow"—causing error, material sense, to fade out.

World healing is of necessity self-healing; this is the focal point here. Mrs. Eddy says, "sin is to be Christianly and *scientifically* reduced to its native nothingness" (S&H 572:4). Sin must be scientifically healed as the work of The [spiritual] Mother Church, whose foundational commission is "healing and saving the *world* from sin and death" (*Manual*, 19:4-5). [Remember, Mary Baker Eddy *was* the Mother Church.]

This picture is titled "TREATING THE SICK;" its Scriptural basis is Christ Jesus' command, "Heal the sick." All the pictures in *Christ and Christmas* are progressive. Thus the healing shown in this picture is a step beyond the healing shown in picture six.

In the sixth picture, entitled, "Christian Science Healing," the healing work was done "Christianly," in the name of Jesus Christ of Nazareth, *(Christ and Christmas* Glossary, p. 55).

In this eighth picture, "Treating the sick," the work is done *"scientifically,"* through Christ only. "Christ's silent healing, *heaven heard,* crowns the pale brow" [that is, it causes error to disappear—to fade out.]

Treating the sick thus, *scientifically,* transposes sickness to treating sin, and is a much more difficult process than healing the sick because it must be done through

189

the Christ *within oneself*; while the healing through Jesus Christ of Nazareth is outer healing, or healing in the name of another, as in picture six.

Treating the sick scientifically means "physician, heal thyself." When a patient calls with some error to be healed, the practitioner becomes the patient and heals himself of that error, just as a mathematician would "heal" 2x2=5 when he sees it. The practitioner could not heal a single case in Christian Science if he thought the error was something outside his own thinking, since he "is alone with his own being and with the reality of things" ('01 p. 20:8).

This eighth picture shows us that there is a higher process of healing than being forced by another's consciousness to self-see one's own errors. We need not be dependent on the other's consciousness for the final release from suffering that such self-knowledge as self-judgment brings. The human mind must be brought into coincidence with the divine. [This is the work of "the star of Boston."]

This higher healing is through Science, typed by the woman in this eighth picture. She uncovers her own manhood deficiencies (as typed by her manhood on the bed) and through the wrestling of spiritual strength, casts these deficiencies out of her own consciousness of heaven as harmony — harmony between her own human life and its ideals.

"The Way, the Truth, the Life—His word—are *here*, and *now*, Christ's silent healing, *heaven heard*, crowns the pale brow," the poem tells us.

"The pale brow," meaning the FADING OUT OF MATERIAL SENSE, is the character of this whole picture. It represents the human consciousness yielding to its last step, out of individual healing, in order to heal humanity on its ENDLESS UNIVERSAL BED. A condition of human belief is represented here, and *spiritual understanding* is healing the desert of earthly joy.

The man has an intellectual face, the face of "the intellectual wrestler," wrestling with travailing human wom-

anhood. "Intelligence" represents the second step in "ideal man" (S&H 517:9), but it must yield, as in this picture it is yielding, to reach the third step, or Truth.

The purity of thought of both the man and the woman is indicated by the whiteness of the bed covers and the woman's dress. The endless bed represents the world-wide bed. The man represents the world-wide patient. The Woman is the Mother Church [which was Mary Baker Eddy] and which Mrs. Eddy charged to heal "sin and death."

Picture seven showed the *Bible* closed in the light of Science and Health. Here *Science and Health* is closed by the woman. In the consciousness of the spiritual vision the written word yields to the spiritual consciousness of it.

In the sixth picture, the man in the bed is quickened; in the seventh picture, the man in the chair is passive, letting go of a material sense; in this eighth picture, the man lying down in bed YIELDS wholly.

He is universal man yielding to the ministrations of woman as symbol, and acknowledging that divine Womanhood is man's *whole* need.

Picture six shows woman lifting up man by the spoken word; picture seven shows woman lifting up man by the written word; picture eight shows woman lifting up man by the silent word *realized*, "heaven heard." This is not mortal woman, but the silent Christ-realization, in which both man and woman in symbol, "pale" or fade out before the real idea. "Man's reason is at rest in God's wisdom" (*Mis.* 362:5). Here, the prince of this world is judged. Human wisdom and judgment yield to the silent word, and mortal man, with his struggles in human judgment, passes to its native nothingness.

A NOTE FROM THE AUTHOR:

This ends the material from Alice Orgain regarding picture eight. I realize that there are honest differences of opin-

ion about the different possible interpretations of this picture. I have included what I feel *honors* Mary Baker Eddy, and what I thought Mrs. Eddy wanted to bring out in this picture.

Mrs. Eddy told the artist, Gilman, in a letter, April 30, 1897, "Do you know what you have done for yourself, for mankind, for our Cause? No, you do not perhaps, but I will tell you. *You have illustrated and interpreted my life* on the plate (the sixth plate—Christian Science Healing) you sent me" (*Recollections of Mary Baker Eddy*, James F. Gilman, p. 91). Inasmuch as Mary Baker Eddy has told us that *Christ and Christmas* is the story of her life, and since it reveals "the God-anointed mission of our Leader," in picture as well as poem, I believe it is necessary to figuratively identify Mrs. Eddy in *every* picture.

Even in the dismal fourth picture Mrs. Eddy is represented, there typed by the woman who sits in a wheel chair, because the men in the movement at that time had all but crippled her great Christ-movement. How much more would we expect to find her represented in this eighth picture, which illustrates the stanza: "*Christ's silent healing, heaven heard, crowns the pale brow.*"

Mrs. Eddy suffered the agony of the cross to bring us this ineffable, glorious Truth. When the world of sense felt the destruction she was bringing to error—tearing away the foundations of its beliefs, its idols, its illusions,—she was accused of heresy, and anathematized by pulpit, press, and the medical fraternity of her day. Yet to this world of savage resistance, of hatred and cursing, she unfailingly returned love and blessing.

Mary Baker Eddy, God's angel visitor, was sent by infinite Love to break earth's deep sleep and hypnotic dream, to awaken man from his non-stop Adam-nightmare of materiality. It will take centuries for us to fully understand the marvel of her life, of her holy history—to realize who, in the last century and the first decade of this, it was that walked among us.

In *Mis.* 33:8 Mrs. Eddy states, "[The pictures] refer not to personality but present the type and shadow of Truth's appearing in the womanhood as well as in the manhood of God...."

Here, in picture eight, we see Mrs. Eddy's subjective consciousness, at this point typed by her work for the entire world to see its Christhood.

This eighth picture shows Mary Baker Eddy, who brought the Second Coming of the Christ, as the "Comforter." She sits here as the "Comforter" Jesus prophesied and promised, who came into the world to destroy the works of hypnotism—to destroy the illusion that makes us think we are mortals.

Why could she do this?

She could do it because, as the poem says, "The Way, the Truth, the Life—His word—Are *here* and *now*..." The woman in this picture knows that all good is omnipresent. It is *HERE* and *NOW*.

What does she say "crowns the pale brow," causing false belief to *fade out,* leaving nothing present but Love and Love's idea? It is her "treating the sick," "*HEAVEN HEARD,*" in this picture.

What aspect of Mrs. Eddy's life does this picture portray?

It was Mrs. Eddy's custom to take time (one hour) each evening, to sit alone and treat the world—of which this eighth picture, "Treating the sick," is type and shadow.

Clara Shannon and others in Mrs. Eddy's household left record that when Mrs. Eddy returned to their presence after this work for the world, such a love and spirituality flowed out from Mrs. Eddy, that they could scarcely bear it; it brought them to tears. Elizabeth Earl Jones recounts:

> One of the Christian Science helpers in our beloved Leader's home told something of how Mrs. Eddy worked for the world [as she is doing here in picture eight]. Every evening from 8:00 to 9:00, Mrs.

Eddy withdrew to work for the world. This member of her household told that when the hour was up, and she rejoined her household, she was so loving, so tender, so Christ-like, that it almost made one's heart hurt. It touched the tenderest fibers of one's heart. (*Reminiscences of Elizabeth Earl Jones* as quoted from *The Healer: The Healing Work of Mary Baker Eddy*, p.xiii).

Mrs. Eddy said: "I saw the love of God encircling the universe and man, filling all space, and this divine love so permeated my consciousness that I loved with Christ-like compassion everything I saw. This realization of divine Love called into expression 'the beauty of holiness, the perfection of being,' which healed and regenerated all who turned to me for help" (*DCC* p. 224).

The following may be typical of what came to Mrs. Eddy after her hour of "treating the sick" world as shown in this picture:

...last night she has come to revelations that had exceeded anything she had had before, in which she saw plainly that all things were put under her feet and the love of God was so manifest, it exceeded anything she could describe. "All things were dissolved in it; all sense of evil, all antagonism; nothing was left but the sea of God's immeasurable Love." (*Recollections of Mary Baker Eddy*, James F. Gilman) This is what this picture shows.

We are told by Mr. Carpenter and by Alice Orgain that all the pictures in *Christ & Christmas* are progressive. Picture number eight shows Science and Health closed. The written word has yielded to the spiritual consciousness of it, so the book can be closed, just as when we know the multiplication table, we can close the arithmetic book.

Mary Baker Eddy had seen that there is but one "I,"

the divine Principle, God, and that "I" is the "I" that "I am." This "I" that is God is the "I" of everyone. We see a holiness in this eighth picture, as Mrs. Eddy "ponders in thought her infinite, harmonious, Christ-expressing selfhood." She is realizing "Life in and of Spirit, and that this Life is the sole reality of existence." She has seen that since God is All, there isn't God *and* man; there is only God (infinite good) expressing Itself *as* man, (but not as a mortal).

Surely this eighth picture, with its whiteness, shows Mrs. Eddy in her nightly treating of the world.

This picture, with its whiteness [third degree], its looms of Love, shows Mrs. Eddy in sacred communion with her true Mind, treating the world. The light hues are significant, for remember the Joseph E. Johnson notes tell us "the pictures are the object of the references on pages 115-116 of Science and Health: black in each picture is first degree: depravity, (lines 21-24). Grey, in the pictures, is second degree: Evil beliefs disappearing (lines 26-27). White is third degree, namely, understanding (p.116:1)."

Remember also, *Christ and Christmas* reveals the woman's *progressive* mission. Mrs. Eddy told Judge Hanna and Edward Kimball, "The truth in regard to your Leader heals the sick and saves the sinner."

This eighth picture leads to the ninth. In this eighth picture we might see the cross and the crown. The cross represents the working out of all error (all the errors we bear) until they are dissolved through an understanding of the crown of true womanhood, the womanhood that includes manhood.

Why is everything so white in this eighth picture?

Because white denotes "understanding," The woman in this picture has brought the light to shine on error (the first degree) and uncovered it. The "crown" represents the third degree, spiritual understanding, and that is why her work for the world is *"HEAVEN HEARD"* and makes material sense, alias "the pale brow," fade out, as the poem says.

"Treating the sick" demands the ascending "footsteps of Truth" in *one's own consciousness*, in an intelligent introspective process. This picture tells us: "Physician heal thyself"; there is no escape from a reckoning with oneself through intelligent self-judgment and self-wrestling in order to overcome the "the adversary" within. In the February *Journal*, 1886, Mrs. Eddy said, "The hour has struck for Christian Scientists to do their own work..." (*Mis.* 317:5), which again means, "Physician heal thyself," when working for a patient. This means the practitioner is the patient who must heal himself of the belief that there can be error, when "all is infinite Mind and its infinite manifestation" (S&H 468). Here Mrs. Eddy has cast out of her thought all error. Here her divine Mind is the star.

Here we see Mary Baker Eddy as she each night retired for an hour to spiritually work for the world. Her "Christ's silent healing," as she treated the world, was "heaven heard." Her treatment "crowns the pale brow," meaning it causes the fading out of material sense, and leaves nothing present but Love and Love's idea.

Mrs. Eddy's great love for all mankind, and her persistent work of seeing that our real and true divine being, *here and now*, is God — is Mind, Spirit, Soul, Principle, Life, Truth, and Love — is the character of this picture. The whiteness of this eighth picture shows the fading out of material sense; it is the human consciousness yielding to its last step out of a mortal sense of things.

The enormous bed represents the world's false beliefs that have chained man to a matter body that has sin, sickness, and death in its wake. Mrs. Eddy in this picture, by seeing "the omnipresence of present perfection," is healing and delivering humanity from its seemingly endless universal bed. From the fact that Edward Kimball estimated that by 1906 two million cases had been healed in Christian Science, we learn her divine knowing was "crowned."

Why were the millions healed? Because of Mary Baker Eddy's work, and her teaching others how to heal.

As Alice Orgain has explained, the sequence of pictures leading up to this one, "Treating the sick," shows why: in picture six the man in bed was quickened. In picture seven, the man in the chair was passive, letting go of a material sense of things. In this eighth picture, the man lying down in bed YIELDS wholly to the ministrations of woman as symbol, acknowledging that divine womanhood — Life and Love — is man's whole need.

Here the material sense of things has faded out.

Why has it faded out? Because Jesus' prophecy of the "Comforter" is being fulfilled. Mary Baker Eddy has brought the Second Coming of the Christ.

A new era is dawning in human history.

Why?

Because Mrs. Eddy has told us the truth about ourselves. In her first edition of Science and Health — *"the precious volume,"* — she *openly* laid out for us the same truth she taught those who early came for instruction: *"You, my students, are God."* (See the author's other books on Mary Baker Eddy's first edition of Science and Health.)

Gilbert C. Carpenter tells us of the following quote from our Leader, "The reason church Scientists don't make their demonstration is because they believe they are man rather than God [when "man" is only reflection]." Mrs. Eddy later had to hide this great spiritual truth because the people, at the time this first edition was published, were not ready for the exalted truth it contained, and she saw it was "casting pearls before swine." But the one hundred and twenty-five years since then have taught mankind much, and we can today openly bring forth the glorious truth that was revealed to Mrs. Eddy about our *here and now divinity*, which she, here in picture eight, is knowing divinely.

FROM THE FIRST EDITION
OF SCIENCE AND HEALTH

Let us take a look at what God, the Mind of man, revealed to Mary Baker Eddy, and which she published in 1875 in that landmark first edition of Science and Health. For the spiritually-minded, reading the divine revelation in the first edition it is hard to fight back the tears of gratitude for all Mary Baker Eddy did to show us our present "here and now" divinity—"our present ownership of all good" (*My.* 356:1).

The following citations from the first edition tell us what we divinely *are HERE AND NOW* as "Christ's silent healing [is] heaven heard, [and] crowns the pale brow," that is, causes a material sense of things to *fade out*.

On page 11 of the first edition Mrs. Eddy tells us that "...all is mind, and mind produces mind only...." [In the first edition Mrs. Eddy did not capitalize Mind, as she later did in order to distinguish it from mortal mind.]

Page 14 tells us, "*We* are Spirit, Soul, and not body, and all is good that is Spirit...." [Mrs. Eddy characterized Spirit as reality, good, the only, understanding. She characterized Soul as changeless divine identity, Ego.]

Page 39 states, "Jesus regarded himself Principle instead of person: hear his words: 'I am the way, the *Truth*, and *Life.*'" And, "...to know *we* are Soul and not body is starting right." We must heed this starting point!

Page 46:7, "But how are we to escape from flesh, or mortality, except through the change called death? [Answer:] By understanding we never were flesh, that *we are Spirit* [God, reality, understanding] and not matter." What resplendent teaching!

Page 38:5, "...to gain this understanding of Soul, the Principle that gave man dominion over the earth, 'tis necessary to understand one's self Spirit, and not matter." Yes.

198

This is where the study comes in. Mrs. Eddy has many references to "learn" and "learning" in the textbook.

Page 54:11, "To be the recipient of Truth, we must begin to recognize ourself Soul."

Page 59:24, "We must recognize ourself Soul." As we meditate and reflect on the spiritual, we begin to "recognize ourself Soul," a synonym for God.

Page 76:15, "To admit oneself Soul, instead of body [meaning to recognize our true divine identity], sets us free to master the infinite idea."

Page 65:15, *"We are Spirit."*

Page 77:13, "The final understanding that we are Spirit must come." Note: "must." What a bright and lofty promise this is!

Page 77:15, "At present we know not what we are, but hereafter we shall be found Love, Life, and Truth, because we understand them." This statement is also in the second edition of S&H. Could we ask for more? Jesus' prayer in the Garden of Gethsemane comes to mind, "And now, O Father, glorify thou me with thine own self, with the glory I had with thee before the world was [before this dream of life in matter overtook me]."

Page 116:7, "Man has not a separate mind from Deity" —meaning from your real, true Mind, the kingdom of God within your consciousness. This is why we can master any subject because everything about that subject is already within our own Mind, our consciousness. All of math, all of music and of every other subject is already within us. A book can tell us nothing unless we have a deep desire to learn; then it can lead us step by step.

Page 117:14, "Jesus understood himself Soul," a synonym for God. Soul means changeless divine identity, spiritual understanding.

Page 137:20, "He who was God..." Jesus knew that he and "the Father," his own right Mind, the kingdom of God within his consciousness, were one and the self-same.

199

Page 155:32, "That we are Spirit, and Spirit is God, is undeniably true." Let's think about this divine truth about ourself.

Page 153:4, "If you possess Love, Wisdom, or Truth, you have Life,...and you ought to prove this fact by demonstration." We are all destined to prove this as we grow in understanding. Note that in the early editions Mrs. Eddy capitalized Wisdom and Intelligence, which she later decapitalized.

Page 155:13, "Because Jesus understood God...he arrived at the conclusion that he was Spirit and not matter." We must do the same and we shall.

Page 155:25 states, "When we possess a true sense of our oneness with God, and learn we are Spirit [a synonym for God] alone...we shall prove our God-being....That we are Spirit, and Spirit is God is undeniably true." And Mrs. Eddy tells us, absolutely, on page 156:20, "We shall *prove* that we are Spirit." Spirit is a synonym for God, that is characterized as reality, the only substance, good, understanding, etc.

Page 223:15, "When realizing Life as it is, namely, Soul, not sense, or the personal man, *we shall expand into Truth and self-completeness* that embrace all things, and need communion with nothing more than itself, to find them all." What more radiant and exalted status could we ask for than this heavenly, this celestial promise that we have it all within—we have here and now "self-completeness that embraces all things, and need communion with nothing more than itself, to find them all"! This surely is the "kingdom of God within" our consciousness. And note again in the next reference how we will find ourself "more blessed, as Principle than person, as God than as man, as Soul than sense":

Page 227, "The evidence of personal sense, or Life in matter, is utterly reversed in science, wherein we learn there is neither a personal God nor a personal man. ...This is not

losing man nor robbing God, but *finding yourself more blessed, as Principle than person, as God than man, as Soul than sense,* and yourself and neighbor one." Note: You are destined to find yourself the Principle that is Love.

Page 225, "Joint heirs with God are the partakers of an inheritance where there is no division of estate; *we are Spirit,* but knowing this not, we go on to vainly suppose ourself body, not Soul." "That man epitomizes the universe, and is the body of God, is apparent to me not only from the logic of Truth, but in the phenomenon, that is sometimes before my spiritual senses...." Mrs. Eddy, like Jesus, must have seen and felt wonderful truths as she understood "I am Intelligence, and not matter, and that Intelligence is God...." This is true of you, dear reader. The Comforter is teaching us this.

Page 285:18, "God is not a separate Wisdom from the Wisdom we possess"...."We find no diminution of happiness in learning we are Spirit and not matter, Soul and not body; but a vast increase of all that elevates, purifies, and blesses man." What a great revelation this is!

Page 274:4, "Knowing that we are Soul [again, a synonym for God] destroys all sickness, sin, and death."

Page 275, "We cannot reach the Principle, be the Principle unless it is understood." This is why St. Paul urges: "Study to show thyself approved unto God, a workman that needeth not to be ashamed, rightly dividing the Word of truth [God]." Mrs. Eddy has over 100 references to "learn" and "learning."

Page 294:19, To know we are Soul [God] is starting right. But, "if we are sensibly with the body we are not Soul, Life, Love, and Truth, and therefor not in the harmony of being [true changeless divine identity]..." Our real Ego is Life, Love, and Truth. This is the great spiritual *fact* we must learn.

Page 435:11, "Only as we understand the Principle of being are we Spirit.... We are never Spirit until we are God....

201

We become Spirit only as we reach being in God." This is being taught us by Mary Baker Eddy in the Second Coming of the Christ, as she fulfilled Jesus' promise and prophecy to bring the "Comforter."

Page 435, "...we cannot step at once from death to Life, or from matter to Spirit. Only as we understand the Principle of being, and reach perfection, are we Spirit, and eternal." Therefore we must study. Jesus said, "Seek ye first the kingdom of God and all these things shall be added unto you" (Matt. 6:33).

Page 305:25, "Jesus held all that he was, God." He was our example, and we will all, through the spiritual education brought to us by the "Comforter," the Second Coming of the Christ, in the writings of Mary Baker Eddy, arrive at the understanding of our true, "divine Christ-expressing selfhood."

We already are the true Self, God (infinite good) that we seek. If we get our true identity straight, as Mind, Spirit, Soul, Principle, Life, Truth, Love, all else will come.

CHRISTIAN UNITY
Picture Number 9

For Christian Science brings to view
The great I Am,
— Omniscient power, — gleaming through
Mind, mother, man.

As in blest Palestina's hour,
So in our age,
'Tis the same hand unfolds His power,
And writes the page.

ALICE ORGAIN:

The ninth picture types the last estate of Mother as Love (S&H 592:16). It shows "Love wedded to its own spiritual idea ["man child" as Truth]" (S&H 575:3), in heaven (harmony). Heaven is here; the bare feet of both the "man child" [Christ Jesus] and the "mother" [Mary Baker Eddy] fulfill God's command, "Put off thy shoes...for the place whereon thou standest is holy ground" (Ex. 3:5).

Note that Mrs. Eddy puts the man and the woman into a perfect circle. The sphere represents good, the self-existent and eternal individuality. The man and woman are the two hemispheres. This is mother and child (S&H. 565:6-13) as evidenced by the poem, "Mind, *MOTHER,* man;" and also from the scriptural basis, "...the same is my brother, and sister and *MOTHER.*" The wedding of Love to its own spiritual idea is shown by the circle of Love which encompasses the "man child" [Jesus] and "mother," and by their clasped hands signifying union of thought.

The man [Jesus] has taken off his black robe which he wore in the second picture, but it still lies across his lap. Laying off his robe shows dominion. This robe represents the flesh. It denotes the limitation concerning what Jesus was able to teach because people of his time were not ready. He was not able to fully impart his message, because, as he explained, "Ye cannot bear it now," etc. Instead, the man, Jesus, is passing his work on to the woman, to Mrs. Eddy, who bears in her hand a scroll entitled "CHRISTIAN SCIENCE."

The attitude of the "man child" as sitting on "the rock, Christ [Truth]" is one of imparting to woman [Science] all

that he is; while the fact that the woman is standing—
"Stand, not sit" (*Mis.* p. 400)—indicates that she still has
another step to take as Bride [to teach all mankind how
they, like Jesus, have the Mind of Christ, the kingdom of
God within their own consciousness].

This passing of the mantle from man to woman fol-
lows the order of the ascending days of consciousness in
Genesis, for as Mrs. Eddy says: "The Mind or intelligence
of production names the female gender *last* in the *ascend-
ing order* of creation" (S&H 508:21, emphasis added).

Further explaining the order of Genesis, Mrs. Eddy
describes, "the evening and the morning [which] were the
third day" (Gen. 1:13) as "The third stage *in the order of Chris-
tian Science* is ..., letting in the light of spiritual understand-
ing" (S&H 508:26).

Thus the unity of the man and Woman in this pic-
ture lies in the fact that the man, Jesus, recognizes the
ascending steps of Christian Science as one with those of
Genesis. This sequence of ascending steps gives mean-
ing to Paul's statement that "God...created all *things* by
Jesus Christ" (Eph. 3:9). Mrs. Eddy's interpretation lifted
Genesis from the presentation of *things* to that of *ideas*.
Because of this she placed more light upon the Woman's
head than upon man's in this ninth picture throughout
all the editions of *Christ and Christmas*.

In this ninth picture it is realized that there is nothing
left but the manhood and womanhood of God. (See *Mis.*
33:10.) There never was and never will be but one Woman,
and that is Mary Baker Eddy's *revelation of Womanhood
and her identity therewith*. [In *My.* 120:2-4 she says: "Those
who look for me in person, or elsewhere than in my writ-
ings, lose me instead of find me."]

In relation to the unfolding history of church, this ninth
picture also types the wedding of the edifices of The Mother
Church and the Extension. The Mother Church is typed by
the "man child" sitting on "the rock, Christ [Truth]," *Manual*,

p. 19, representing "the cross." The Extension is typed by the Woman [Science], representing "the crown" (*My.* 6:18) — the extension of her teaching into all the world. "It's crowning ultimate rises to a *mental* monument, a superstructure high above the work of man's hands, even the outcome of their hearts, giving to the material a spiritual significance."

This picture correlates with the 16th edition — woman bringing forth the man child in fulfillment of Revelation 12. Throughout the 16th edition of Science and Health Mrs. Eddy dropped the title of Mother, and simultaneously dropped "creator," "intelligence," "wisdom" and "substance" from God to man. This ends the symbol of motherhood, and shows by this ending that it is limited to "half a time" (Rev. 12:14).

From this point on nothing is left but the manhood and womanhood of God [meaning your true divine selfhood]. The whole true manhood at last sits down before Womanhood. "Stand, not sit" (*Mis.* 400:5) shows the relative value of both postures, as The Mother Church sits before the demonstration of Womanhood, divine Science.

It is because Woman [Science], as described in Revelation, has twelve stars in her crown instead of seven, as Jesus had, that the light over her head in this picture is greater. Here in the ninth picture Jesus has laid off his robe; his work is completed. Now it is Woman who must bear the dark mantle of limitation. In this picture Woman's robe is still drab. The woman's robe is drab so long as the man and woman witness as *two* [Science includes manhood as Christianity.], but when manhood and womanhood are one — when Truth is wholly subjective to our consciousness, as in picture ten, then the robe is white. "Then white-robed purity will unite in one person masculine wisdom and feminine love and understanding, and perpetual peace" (S&H 64:22). Then, finally, "A woman shall encompass a man" (Jer. 31:22).

Let it be remembered that *Christ and* Christmas illustrates Mrs. Eddy's progressive mission. "Those who look

for me in person, or elsewhere than in my writings, lose me instead of find me" (*My* 120:2).

HANNA?:

In Science and Health, just prior to Mrs. Eddy's explanation of the twenty-third Psalm, we read, "The Lamb's wife presents the unity of male and female as no longer two wedded individuals, but as *two individual natures in one; and this compounded spiritual individuality reflects God as Father-Mother*, not as a corporeal being" (p 577:4, emphasis added). This statement of Mrs. Eddy's explains Revelation 21:22: "And I saw no temple therein: for the Lord God Almighty and the Lamb are the temple of it."[Your real divine Mind, the kingdom of God within your consciousness and its expression, or manifestation, the Lamb, "are the temple of it."]

This ninth picture and its meaning is coupled with [picture three]"Seeking and Finding." Through Science and Health, Mrs. Eddy has revealed the two witnesses [Christ Jesus and the Science of being, as set forth in Science and Health]. It is the revelation of the same Light, but to human sense it appears as two different revelations. The magnitude of the Light does vary in its brilliance.

The round shape of this picture indicates completeness, the completeness that is reached through Science and Health. The unity of the two appearings of the Light as the same Light, will be seen by the world when the two witnesses are acknowledged. Then and only then will there be universal...religion [universal in reach, all comprehending]. Mrs. Eddy's prediction for this [final understanding] will then be fulfilled. Christianity will then have its new name.

Notice the one ray of light (in this picture 9) reaching the clasped hands, illuminating that unity, that forward step, that progressive understanding. The clasped hands symbolize the unity of the Christ in Christianity and Sci-

ence. If Christian Scientists take Christian Science to the world in that light, creation shows anew.

"EARTH: A sphere; a type of eternity and immortality which are likewise without beginning or end. To material sense, earth is matter; to spiritual sense it is a compound idea" (S&H 585:5).

This compound idea (image and likeness) is generic man [the Christ]. Mrs. Eddy says in Science and Health: "the circle represents the infinite without beginning or end" (S&H 282:6); and "Mind is perpetual motion. Its symbol is the sphere" (S&H 240:14). The star as a symbol is not needed. Christian Science and the two witnesses are the light of the world.

This was a very important picture and had to be included in this work. The Christian Science movement had to see Mary Baker Eddy's place properly. This picture caused more of a stir in the movement than any other picture in Christ and Christmas when it first came out.

[This was mostly because the halo, the light over Mary Baker Eddy's head was more pronounced than that over Jesus. This difference in light corresponds to the number of stars Revelation assigns to the two witnesses. The woman was crowned with twelve stars — "And there appeared a great wonder in heaven, a woman clothed with the sun, and the moon under her feet, and upon her head a crown of twelve stars" — while Jesus held seven. (See '00: 12:3 and *Pul* 83:29)

In Revelation's first chapter, Jesus called "the seven stars" which he held in his right hand "the seven angels of the seven churches," while he called the churches "the seven candlesticks."]

The meaning of this picture is now more clearly discerned. The Master and our Leader have equal missions and importance. Remember that it was a recognition of Jesus which enabled Constantine to help preserve Christianity, and it was the cross on a circular shield that won

the day. Although Christianity was perverted at that time, it none the less was preserved.

Jesus in this ninth picture has laid off his robe — showing dominion; but the woman has her robe still on....Jesus' work is finished so his robe is off. Mrs. Eddy's outer robe is still on, as she is still carrying error [working to reveal good's reality and allness, and error's nothingness]. She is still standing with us.

Mrs. Eddy's lifework revealed the true concept of the Master. At the start of her life's work in 1866, the black robe is on the Master (second picture); that was her understanding of him at that time. Notice it is now put off through her enlarged understanding as demonstrated in Christian Science. The mortal is discarded through the supreme power, or the right hand of Christ. Jesus' right arm holds down the discarded mortal robe.

As an early worker said of Mrs. Eddy, "When she spoke of Christ Jesus it seemed *as if time and space, the barrier of two millenniums and two hemispheres, were swept away. She spoke at this time with ardor of her work on her illustrated poem,* **Christ and Christmas.** *It was evidently dear to her heart."*

One day when [Mrs. Eddy] asked to be left alone and not to be disturbed, [Laura Sargent and Martha Wilcox] both listened attentively for a summoning bell, but none rang. After several hours had elapsed and she had not come out nor called for anyone Laura and Martha began to worry that something had happened. Finally, after a good deal of deliberation, they decided to go in. As they listened at the door they *heard voices*, and as they opened the door to see if everyone was all right, Mrs. Eddy said: 'Girls, why did you disturb me? I was talking with Jesus.'" (*The Healer, The Healing Work of Mary Baker Eddy*, op. cit., p. 170-171)

Mrs. Eddy could talk with Jesus, just as St. Paul did on the road to Damascus, and as Jesus talked with Moses and Elias. "In Science, individual good derived from God, the infinite All-in-all, may flow from the departed to mortals; but evil is neither communicable nor scientific" (S&H 72:23-26).

The woman holds the scroll, *the final and complete revelation of Truth to this age and all ages, CHRISTIAN SCIENCE*. Jesus' mission is finished; his ear is covered. Mrs. Eddy's ear is not covered because her ear is still listening that her work might go on. She is listening that she may still stand with us on the field of battle. Jesus' and Mrs. Eddy's left foot is forward, symbolizing the secondary power over visible error. Notice that her foot is fully revealed; his is not. *Her mission was to reveal the complete workings of animal magnetism, hypnotic suggestion, illusion and bring forth the whole understanding of the Christ — generic man the Christ.*

...Their missions are equal. Note also that there is a stronger beam of light directed upon their heads and a secondary light encompassing them. "God [infinite good] hath thrust in the sickle, and He [infinite good] is separating the tares from the wheat. This hour is molten in the furnace of Soul [true identity, spiritual understanding]. Its harvest song is world-wide, world-known, world-great. The vine is bringing forth its fruit; the beams of right have healing in their light" (*Miscellany* 269). *"The truth in regard to your Leader heals the sick and saves the sinner,"* Mrs. Eddy told Judge Septimus J. Hanna.

Christian Science alone brings to view the great I AM. This all-scientific power gleams from God, through our Mother in Israel — Mary Baker Eddy — and heals humanity. It came from divine Mind and was given to Mrs. Eddy, and she gave it to mankind.

The second witness has come forth. Her mission is fulfilled. It is the same hand of divine Love, the living Christ

idea, that unfolds God's [infinite good's] power and writes the revelation of Truth.

"Christian Unity" [depicted in this 9th picture] is the state of being *one* in Christ, womanhood including its manhood — generic man [or Christ]. Oneness, singleness, as opposed to union which is plurality, joining two or more things into one, a mixture. The two witnesses, *understood*, represent Christianity and Science as *one* — the Christ. The scroll of Christian Science reveals this unity. Oneness is in the Christ, and is the true unity. Science reveals that oneness is not in material organization — political, religious or international. Christ Jesus and Mary Baker Eddy have revealed the unity of the Christ. They have revealed the manhood and womanhood of God, and this has lifted humanity up. Christian Science is the only answer to every ill that flesh is heir to. It is the only answer to individual, local, national and international problems, because it reveals generic man [the Christ]. All this is revealed through Science and Health *with Key to the Scriptures* by Mary Baker Eddy.

It was the picture "Christian Unity" that enabled the workers in the field to go ahead and build the original Mother Church. They did this by overcoming a false estimate of their Leader, [which was] revealed in picture four, "Christmas Eve." Science and Health in picture three leads to the perfection of *generic* man (the Christ) in "Christian Unity." [So again] it is this picture [nine] "Christian Unity" that enabled the Mother Church workers to overcome the false estimate of their Leader given in "Christmas Eve" in picture four.

JOHN PAWLIK:

Christian Unity —

"'Tis the same hand unfolds His power, And writes the page."

In this picture we see Christ Jesus seated, the woman standing; Jesus' feet are hardly visible, while the woman's

foot is wholly so. Christian Science is in the woman's hand, and Jesus' hand is outstretched to approve it. The two are hand in hand, and the light from the star floods all.

Christ Jesus is seated, for his work is completed. The robe is symbolic of the human, to be laid aside. This figure symbolizes healing, raising the dead (those buried in dogma).

The woman is standing, because her mission is just beginning. Her revelation is free from any fleshly taint; it is Christian Science as given in Science and Health. The Mother Church [which Mary Baker Eddy was], the establishment Christian Science Publishing Society, the writing of the *Manual*, all cause the woman's halo to have more light, more inspiration.

"And other sheep I have, which are not of this fold; them also I must bring, and they shall hear my voice; and there shall be one fold and one shepherd" (John 10:16). The poem tells us, "'Tis the same hand unfolds His [infinite good's] power, And writes the page." God's power is unfolded and his [infinite good's] message is given us today by Mary Baker Eddy as it was in Palestine.

During the absence of our pastor, we
enjoyed the rare privilege of hearing
a good sermon when J. F. Stubbs
supplied our pulpit.

TRUTH VERSUS ERROR
Picture Number 10

Today, as oft, away from sin
Christ summons thee:
Truth pleads to-night: Just take Me in!
No mass for Me!

Scriptural basis:
Behold I stand at the door, and knock,
if any man hear my voice, and open the door,
I will come in to him, and will sup with him,
and he with me. — Christ Jesus

Truth knocks at the portal of humanity — the world.
Mrs. Eddy wanted to bring the world up to her own rev-
elation of Truth. Mary Baker Eddy is knocking at the door
of world thought, world consciousness. She writes, "Truth,
independent of doctrines and time-honored systems,
knocks at the portal of humanity and asks, 'Will you open
or close the door upon this angel visitant, who cometh in

the quiet of meekness, as he came of old to the patriarch at noonday?'" (S&H 224:22).

Jesus made a far-reaching utterance when he said, "The kingdom of heaven is like unto leaven which a woman took, and hid in three measures of meal, until the whole was leavened." He was telling us that this woman — Mary Baker Eddy in the Second Coming of the Christ — must place in "Science, Theology, Medicine" the "leaven" of the "Comforter" until the whole of mortal thought is changed "as yeast changes the chemical properties of meal." "When placed under a microscope, the working of leaven looks like a veritable battlefield. There is assault and penetration in the face of determined resistance until peace descends after the whole has been conquered" (Abbingdon's Bible Commentary).

The first step in overcoming error is to recognize it as an illusion, and specifically denounce it. The second step is to know what the fact is, and **HOLD TO IT**. We must see things as **THOUGHTS**; then we can make the exchange and behold the perfect man. The objects of sense must be exchanged for the ideas of Soul (true identity). A matter body is nothing but hypnotic thought. We are dealing with hypnotism, with illusion, when we deal with matter. But all the while that we are under hypnotic suggestion and seeing matter, the omnipresence of present perfection (Mind's ideal) is just as real and just as near as 2X2=4, or as the round earth was when everyone thought it was flat. The constant desire to know ourselves as we really are is "praying without ceasing" — it is silencing the material senses, as "in the quiet sanctuary of earnest longings we deny sin and plead [infinite good's] allness."

ALICE ORGAIN:

The scriptural "basis" of this tenth picture was attributed to St. John in the "Glossary" of *Christ and Christmas* in all editions up to its ninth edition, in 1910, but was then

accredited to "Christ Jesus," as now, in line with St. John's introductory statement of the source of his Revelation as being: *"The Revelation of Jesus Christ,* which God gave unto him . . . and He sent and signified it...unto his servant John" (Rev. 1:1). Thus Mrs. Eddy accepted for the ascended Jesus the Revelation of St. John, of which St. John was but the scribe.

The title of this picture is "Truth versus Error." Truth is equated with manhood (S&H 517:8), yet the main figure in this picture is a woman. Elsewhere Mrs. Eddy has spoken of Truth, typed by manhood, rather than Love, typed by Womanhood, knocking "at the portal of humanity." Here, in this tenth picture, she presents Truth as a woman [Woman as Science]. It follows that Truth is the embraced manhood of Woman. In the City foursquare, [your divine consciousness,] Jesus' second appearing as Truth, or manhood, is embraced in Love, Womanhood, thus giving Womanhood, as Love, the foundation of Truth. This completes Mrs. Eddy's definition of spiritual church in the "Glossary" of Science and Health as "the structure of Truth and Love."

"Union of the masculine and feminine qualities constitutes completeness" (S&H 57:4). "The second appearing of Jesus is, unquestionably, the spiritual advent of the advancing idea of God as *in* [embraced in] Christian Science" (*Ret.* 70:20, emphasis added).

This tenth picture presents Womanhood [Science] as the Bride of the City foursquare, knocking at the third side of the City foursquare. This third side is Christianity, typed by the heavenly branches. Womanhood is pleading for the acceptance of the City's fourth side, *Science,* typed by the second Concord Branch, for until Christianity is one with Science it mistakes "doctrines and time-honored systems" for orderly thinking. In other words, it mistakes the *form* of thought for the *spiritual essence* of idea. Thus the fourth side of the City, namely *Science,* is necessary to protect the spirit of Christianity from human destruction by doctrinal forms.

Christian Science is the revelation of Womanhood embracing Christianity as manhood. When Mrs. Eddy first introduced the descending City foursquare in Science and Health (under the chapter entitled "Wayside Hints" in the sixteenth to the fiftieth edition), she defined this City in the following words:

"The Holy City [Bride (Rev. 21:2)], described in the Apocalypse as coming from God out of heaven [infinite good, "the kingdom of God within you" as your true consciousness], is Christian Science" (S&H 225) — Womanhood. She presented this City in general characterization as "an assemblage of people for high purposes." "An assemblage" suggests its *generic* character. Mrs. Eddy describes in minute and extensive particularization all the active functions of a *literal earthly* city and includes a description of its *manhood* (form) phases, such as sides, foundations, squareness, and gates, which the Bible presents as "walls," "foundations," "foursquare," "measure," and "gates." This detailing of literal city activities showed the fullness of expression which the word "city" types as the generic character of the Bride. Its descriptive embrace of the Bible (form) phases suggests the Bride's encompassment of Christianity, or manhood.

The *walls* of the City were its specific limitations in the unfolding phases of the Word. In her first presentation (in the sixteenth edition of Science and Health, page 233) Mrs. Eddy defined the "walls" as "the Bible, Jesus, Christianity, Science." These are the four progressive phases of salvation of which Isaiah prophesied in his pre-vision of the City foursquare, saying, "...thou shalt call thy walls Salvation" (Isa. 60:18). Manhood,—redemption is the province of Womanhood as Love, for Mrs. Eddy speaks of "all [as being]...redeemed through divine Love" (S&H 26:8). In the current edition of Science and Health the walls of the City are defined by Mrs. Eddy as "the Word, Christ, Christianity, Science." Thus in the unfolding Word, but one side of

216

the City was viewed at a time until the final enclosure of the Bride as Word was complete.

The Woman knocking on the door, MORTAL MIND, in this tenth picture, is "white-robed purity that will unite in one person masculine wisdom and feminine love..." (S&H 64:23). Thus she types *Womanhood* as the composite Bride [Science], or the descending City foursquare (meaning the coincidence of the divine with the human). This will turn us away from sin. As the poem states: *"Today, as oft, away from sin, Christ summons thee!* **[Know nothing of it, because your mind is filled with infinite good**]. Truth pleads tonight, Just take Me in! No mass [no illusion, no hypnotism] for Me!" (But give Me [infinite good, Science] all thy heart — from *sin be cleansed, be free!)"*

Those in the house, in this tenth picture, present a reversal to treading the "winepress" because their "church" is a personal worship on the *outside* instead of an impersonal devotion to idea on the inside of their house [consciousness, the kingdom of God within their consciousness, their true Mind] (S&H 578:17). The sword of Spirit must yield to the inherent power of Love, meaning manhood must yield to Womanhood, they must be *one*. Mrs. Eddy defined "Salvation" as "Life, Truth, and Love understood and demonstrated" (S&H 593:20), that is, as Womanhood. By a long and toilsome upward process for the salvation of others, Mary Baker Eddy thus came up out of the baptismal waters of sacrificial Christianity. This typed manhood, as when she (in 1902) lifted her "man child" (Jesus) up to Womanhood [Science] as his objective Bride.

In reality "man is as perfect now, and henceforth, and forever, as when the stars first sang together, and creation joined in the grand chorus of harmonious being" (*Mis.* 133:3). "The more I understand true humanhood, the more I see it to be sinless, — as ignorant of sin as is the perfect Maker" (*Un.* 49:8).

This tenth picture is characterized by the Woman [Mary Baker Eddy as she is found in her writing] symbolically calling all to her position, namely the City foursquare, meaning the Bride or descending consciousness [infinite good], the coincidence of the divine with the human, that delivers us from sin. This tenth picture thus types the unfolding Word of Chapter XVI of Science and Health, "The Apocalypse."

The Woman knocking at the door (mortal mind), types her Truth element as the last expression of Church form, and her nameless (and, therefore, unbounded) message types her boundless Love-nature. This picture again points to "heaven here, the struggle over" (*My.* 158:13).

Woman [Science] must needs be the channel for the fulfillment of the prophesied knock of Jesus upon world consciousness. Thus, the Woman knocking on the door, in this tenth picture, types *the City foursquare* knocking on the door of world consciousness, repeating Jesus' words, "Behold, I stand at the door, and knock; if any man hear my voice, and open the door, I will come in to him, and will sup with him, and he with me" (Rev. 3:20).

The verses of the poem that accompany this picture urge: "Today, as oft, away from sin, Christ summons thee! Truth pleads to-night: Just take Me in! No mass for Me!"

Inasmuch as *Christ and Christmas* is intended to illustrate Mrs. Eddy's progressive mission, the question here arises, what relationship does she bear to the Woman, typing Bride, and her Message in this tenth picture? Mrs. Eddy directly answers this by identifying herself with the message of the Woman, hence with the Woman herself, when she said, "Those who look for me in person, or elsewhere than in my writing, lose me instead of find me."

In line with this statement, each and every statement in Christ and Christmas corresponds to a phase of Mrs. Eddy's consciousness, and identifies itself with Mrs. Eddy. Thus when the Word was complete, Mary Baker Eddy be-

came the first Bride, for the "adorned" (completed) Word is the bride" (*My.* 125:26).

Christ and Christmas presents the orderly process through the progressive revisions of Science and Health by which Christian Science is unfolded — first to Mrs. Eddy's consciousness, and then, through her, to the human consciousness. This is why Mrs. Eddy hoped all editions of Science and Health would be preserved and read by Christian Scientists.

HANNA?:

After "Christ's silent healing" [is "Heaven heard" (See *My.* 120:2) as shown in picture eight,] the next step that is revealed is for womanhood to begin to knock at the door of humanity. This is revealed in "Truth versus Error."

This day the final appearing, womanhood, repeats the earnest, insistent call to you, "Get away from sin." "Leave its grasp." In this dark hour, true womanhood pleads to be taken into the hearts of mankind. Womanhood wants no ceremony, no dead words. It wants a practical life, changed by the touch of Love. This will happen if only we take in this divine Truth that is Love. False manhood can no longer hold humanity captive through false Pharisaical beliefs, if we take the divine idea into consciousness.

Womanhood is presenting the scroll of Truth which has been revealed through that wonderful event in Lynn, Massachusetts in 1866. The revelation that she [meaning her teaching] is the Woman referred to in prophecy, giving the impersonal Christ to the world, pleads with mankind to just let this Truth in.

What is it that opposes this truth about the woman? It is malicious animal magnetism [hypnotic suggestion, illusion] in its specific claims depicted in this picture, [with its mortal mind merry-making. It is all the claims of the flesh, pleasure in matter, attractions of mortal mind, ease in matter, sensuality, apathy, etc.]

Gilman, speaking about this picture [and of Love's and Truth's appearing] says, "But one [thing] in particular she appeared to emphasize, which called for the representation of Love and Truth's spiritual idea in the most perfect form of feminine youthful beauty that I could conceive, carrying the message of Christian Science Truth, and knocking at the door of a palatial mansion, to represent the abode of material sense."

This palatial mansion is spoken of in the "Allegory" in *Miscellaneous Writings:* "Pausing at the threshold of a palatial dwelling, he knocks and waits. The door is shut. He hears the sounds of festivity and mirth; youth, manhood, and age gaily tread the gorgeously tapestried parlors, dancing-halls, and banquet-rooms. But a little while, and the music is dull, the wine is unsipped, the footfalls abate, the laughter ceases. Then from the window of this dwelling a face looks out, anxiously surveying him who waiteth at the door. Within the mortal mansion are adulterers, fornicators, idolaters; drunkenness, witchcraft, variance, envy, emulation, hatred, wrath, murder. Appetites and passions have so dimmed their sight that he alone who looks from that dwelling, through the clearer pane of his own heart tired of sin, can see the Stranger" (*Mis.* 324:4-18).

It is easy to see that Mrs. Eddy has used this allegory in her illustration "Truth versus Error"; only in this instance it is a woman and not a man.

It is interesting that Gilman and Mrs. Eddy "looked through an old photograph album and looked at pictures in other parts of the house that resembled Mrs. Eddy 'as I used to look,' she said." That eventually Mr. Gilman captured the right idea on canvas goes without saying. He records, "As soon as Mrs. Eddy's eyes rested upon the picture, she was very still for a moment and then she said, 'Laura, look here! look at that picture!' I began to fear that it looked dreadful to her on account of the exposed shoulder and breast, especially when Laura began to say, 'Oh!

Why, Mother, Mother,' but adding, 'Isn't that beautiful!' Beautiful reassured me, and Mrs. Eddy echoed her words, and they both were in that joyousness that finds expression in tears, and Mrs. Eddy was saying, 'It is the perfect representation of the idea I had in thought, but could not exactly describe'...After this I went up to her room where she was ready — her sitting-room chamber, where she writes and attends to her daily work — and sketched her foot for this same picture."

The Revelator of Truth to this age is the spiritual idea. The four square mat on which this spiritual idea stands, has foundation; it is the city four square. The right foot is out and symbolizes dominion over latent error and its claims, the source of all error's visible forms. Notice that the ear is uncovered. She is listening for the call that needs help. There is no star in this picture because there is no symbol of the light needed, *for the woman is the light.* She is clothed in the third degree; she is the spiritual idea — generic man, the Christ. Notice the halo around her head, the light of the Christ understanding, fulfilling "Christ Healing." *Christ and Christmas* reveals the Woman's progressive mission. There is no dingy drab outer robe, because this is the generic idea, the [everywhere present] absolute Truth — the spiritual concept of Woman, or Christ.

The child-like thought at the window perceives this love of Womanhood, but its surroundings will not let it go to Truth. As the child thought grows, it too will lose that child-likeness and become insensitive to the pleas of Womanhood, as their elders are in this picture. The world resists the day of the Woman.

Mrs. Eddy says, "The signs of these times portend a long and strong determination of mankind to cleave to the world, the flesh, and evil, causing great obscuration of Spirit. When we remember that God [infinite good] is just, and admit the total depravity of mortals, alias mortal mind, — and that this Adam legacy must first be seen, and then

must be subdued and recompensed by justice, the eternal attribute of Truth, — the outlook demands labor, and the laborers seem few" (*Miscellaneous Writings* p. 2).

Materialistic mankind...is not awake to the call of womanhood as Truth knocks at the portal of humanity. But the place of womanhood has been established; it needs only to be taken in. The claims of malicious animal magnetism [our ingrained false beliefs] would keep this from being done. The results of lust and hatred represented in the house would keep Truth hidden so its own claims of evil might be maintained and extended. Ignorant thinking is clothed in dark materiality. Notice the blank faces. Lust and sensual pleasure do not hear the voice and call of Truth.

The scene inside is lit with artificial light. Notice the wine. Mrs. Eddy denotes "Wine" as: "Error; fornication; temptation; passion" (S&H 598). This is not a pretty picture. Notice too that the seating of man and woman is reversed from the picture "Christian Unity" which depicts true manhood and womanhood. Woman is being manipulated in this picture.

The little girl has her arms around the little boy protecting him. The children naturally understand that womanhood includes manhood within itself. Isn't it funny to see mortal mind spending so much time dressing up and getting ready to deceive itself?

What is the foundation of all this gaiety and frivolity? The black and white tiles symbolize hypocrisy, and indicate the same two-faced ecclesiastic despotism that was in the first picture trying to appear divine (white) but is really depravity (black). It is ecclesiasticism that would keep tired humanity from seeing the truth of womanhood and Mary Baker Eddy's place. Ecclesiasticism is actively at work to hide the woman's great revelation. The room is mortal mind consciousness manipulated by ecclesiasticism. The drapes that are pulled aside are error's ways of influenc-

ing the world to evil. It says, "See what fun we are having, come and join us."

Our precious Leader conquered every one of these lies about man. Will you follow?

JOHN PAWLIK:

Child thought *sees or perceives* Truth.
TRUTH versus ERROR
Truth pleads to-night: Just take Me in!
No mass for Me!

This tenth illustration pictures the realm of mortal mind; the woman [the Christ is] at the door of mortal-mind consciousness. Through the window is seen the mortal-mind gaiety while only the children at the window welcome Christian Science. The light from the star falls on the woman who is to give true light to all the world.

This picture symbolizes Christian Science presented to human consciousness. The dancing, drinking, pleasure-seeking mortal minds are not interested [in what the woman has to give]. Only innocence and purity can see and welcome the Truth: "...away from sin Christ summons thee!...No mass for Me!" The Christ is to be lived now, without celebration for something that is past and gone. "Behold, I stand at the door, and knock: If any man hear my voice, and open the door, I will come in to him, and will sup with him, and he with me" (Rev. 3:20).

Remember in prayer the many who
are sick of our church and community.

THE WAY
Picture Number 11

No blight, no broken wing, no moan,
Truth's fane can dim;
Eternal swells Christ's music-tone,
In heaven's hymn.

Scriptural basis:
And whosoever liveth and believeth in me
shall never die. — Christ Jesus

ALICE ORGAIN:
This eleventh picture, which at first view seems so mystical, when analytically examined is seen to identify every footstep of Church in both its ascending and descending phases. "The Way" in this picture presents both the ascension and descension, [both the climb upward from earth to heaven, from cross to crown, and the pouring forth of Life, Truth and Love in the message of the descending dove and in the all-embracing radiance of the broad beam of light.]

The Scriptural basis promises, "And whosoever liveth and believeth in me [the spiritual idea (S&H 115:17)] shall never die." This promise of life takes one beyond Mrs. Eddy's definition of "Church" as the "structure of Truth and Love" (S&H 583:12) into the universe of Life. It shows that our life must become divine, and thus one with Truth and Love.

Church as the "structure of Truth and Love" disciplines [and uplifts] the natural life that is one's own seemingly inherent consciousness until that life becomes divine and thus one with Truth and Love in the heavenly trinity of forces. Thence this trinity of Life, Truth, and Love descends to earth as the City foursquare (Revelation 21st chapter; S&H 575) with "omni-action" as its fourth side, before expanding through the footstep of "no temple [no material body] therein" (Revelation 21:22; S&H 576) to the *unwalled* "city of our God (Revelation 22nd chapter; S&H 577) which "has no boundary nor limit."

This "city of our God" is generic spiritual "Idea," boundless, infinite and undying, and it contains the "tree of Life" as "eternal reality or being" (S&H 538:13). This is *our* consciousness when we will have embraced the heavenly forces of Life, Truth and Love. In both the first and second editions of Science and Health we read Mrs. Eddy's prophecy: "At present we know not what *we are*, but certainly *we shall be* Love, Life, and Truth, when we understand them."

This eleventh picture types the "city of our God" (S&H 577), which is reached through the step of "no temple therein," [just as the multiplication table has no physical structure, no material body]. This is the final step demanded after the City foursquare had been descendingly identified in the Word of Science and Health. Thus this picture embraces all the previous elements in *Christ and Christmas.*

Inasmuch as Mrs. Eddy says that each picture in Christ and Christmas presents both "the type and shadow of

Truth's appearing" (*Mis.* 33:9), each and every symbol in this picture, from cross to crown, including its central emblem, (the garlanded cross combining the qualities of both cross and crown), is but the "shadow" of this picture as compared to the broad beam of light embracing each and all.

The crown in this eleventh picture represents the highest point of scientific Christianity as Truth. The broad beam of light impersonally types heaven. It represents all the elements of the heavenly trinity of Life, Truth, and Love in one, or Womanhood [meaning Science].

The deeply rutted mass on the left-hand side of the picture suggests a dragon's body [alias ecclesiastical despotism]. Its water ruts draining off to the stagnant pool on the right-hand side characterize it as the drag-on of age-old Theology. These elements, together with a serpent's upraised garlanded head, were very plain in the picture as Mrs. Eddy left it. In clearer pictures, the serpent is obvious, its upraised garlanded head facing the bare, dark cross in the foreground.

Mrs. Eddy called The Mother Church "the cross." It is typed in this eleventh picture by the large bleak cross in the foreground. In 1908 Mrs. Eddy detached the branch churches from The Mother Church with the statement, "The branch churches continue their communion seasons, but there shall be no more communion season in The Mother Church that has blossomed into spiritual beauty, communion universal and divine" (*My.* 141:26).

In the earliest version of this illustration there was only one cross, a large garlanded cross standing in the foreground where the bleak cross now stands. When Mrs. Eddy added the second uplifted cross in the middle of the picture she transferred the flowers and birds to it, leaving the foreground cross bare. At the same time she garlanded the head of the serpent facing the bare cross, a warning that if the work of The Mother Church as "the cross" should be repeated, it would share the fate of all static Christianity.

The dragon (old theology) of outgrown form would triumph over its spirit, as prophesied by Jesus from the thirteenth to the nineteenth chapter of Revelation, which Mrs. Eddy says, "depict the fatal effects of trying to meet error with error" (S&H 568:8).

The dragon is alternately called "serpent" and "dragon" in both the Bible and Science and Health. (Rev. 12:9, 15, 16; S&H 364:31-2, 567:18-21). [Mrs. Eddy knew that Revelation's chapters 13 to 20 prophesying the "beast," (the "serpent,") and the "dragon," would be fulfilled. "Scripture cannot be broken," as Christ Jesus said.

Mrs. Eddy could not explain this in her time. It was too early. But we are now going through that time — that prophecy of Jesus to St. John.

Why are we going through that time?

Because Mrs. Eddy's *Manual* estoppels *have not been obeyed*, the "rod" of Revelation has been broken.. This is why, in this eleventh picture, we see the "garlanded serpent," facing the big, bare, dark cross in the foreground of this picture.]

It is interesting to note that this garlanding of the serpent's head facing the denuded cross bears an ominous likeness to the prophesied victory of the dragon in the thirteenth chapter of Revelation. In Jesus' prophecy to St. John, the dragon's (serpent's) ten horns were *crowned* with victorious accomplishment.

In the twelfth chapter of Revelation the dragon (old theology) persecuted the woman that brought forth the "man child." It stood before her in the claim of "church" consciousness which had dragged-on its old theological beliefs. This necessitated the "warfare in Science" (S&H 568:6; Rev. 12).

Mrs. Eddy stated, "the ten horns of the dragon typify the belief that matter has power of its own, and that by means of an evil mind [typed by its crowned heads] in matter the Ten Commandments can be broken" (S&H 563:11). It will be remembered that in the Biblical descrip-

tion of the dragon in the twelfth chapter of Revelation, only its seven heads were crowned. Thus only the seven of its ten horns which corresponded to those heads could claim triumph. The dragon's remaining three horns type the success of Womanhood as the trinity of Life, Truth, and Love in defeating the claimed power of the dragon.

That Mrs. Eddy's individual or subjective work was with the serpent's head only, or claimed intelligence, is seen in the prophesy that the woman would "bruise [only] the head" of the serpent" (S&H 534:29 Gen. 3:15).

The sonship of Mother is typed in the center of this picture by the uplifted cross which is garlanded with the heavenly flowers of divine purpose, floral apostles of Deity ["Deity" meaning "the kingdom of God within your consciousness, your own real Mind]. Thus The Mother Church "blossomed into spiritual beauty, communion universal and divine." This eleventh picture shows our journey from cross to crown.

Mrs. Eddy called the Extension "the crown" (of finished Motherhood.) The Extension, symbolizing the extension of Mrs. Eddy's teaching into all the world, to all mankind, is typed at the topmost point of this last picture by a human coronet. Although Mrs. Eddy, the Founder of Christian Science, was not in attendance [at the dedication of the extension], she sent greetings in which she declared that the "crowning ultimate" of the church "rises to a *mental* monument, a superstructure high above the work of men's hands, even the outcome of their hearts, giving to the material a spiritual significance—the speed, beauty, and achievements of goodness" (*My.* 94:24). The extension's true meaning is that Mrs. Eddy's *teaching* rises to a *mental* monument. She emphasized this understanding clearly by not attending any dedicatory service, and never once setting foot in the Extension.

The Light in this eleventh picture types "the gentle *beam* of living Love." Boundless and limitless it pours

down from heaven, its broadest beam being at the point of its earth contact. The descending white bird — a dove, typing heavenly inspiration — might be defined as the impersonal sense of the Woman in the tenth picture bearing her Message of Love. Mrs. Eddy defines "dove" as "a symbol of divine Science" (S&H 584:26), and the descending City foursquare as "the light and glory of divine Science" (S&H 575:7-10).

The Message of the white dove started from heaven in 1902, in the 226th edition, as the Twentieth-Century progressive Revision of Science and Health, spreading the generic ray of Light. It gradually encompassed the labored footsteps of past ascending Christianity to the point where in 1909 Mrs. Eddy said, "The truth of being is perennial, and error is unreal and obsolete" (S&H 265:20), and "Christian Science teaches only that which is spiritual and divine, and not human" (S&H 99:14).

[What were some of these progressive revisions?] In 1902 Mrs. Eddy added the last bracketed interpolation in the statement: "'I am the first and the last: I am he that liveth, and was dead [not understood]; and, behold, I am alive for evermore *[Science has explained me]*'" (S&H 334:25). This was evidence of Mary Baker Eddy's completion of the mission of Jesus as "the masculine representative of the spiritual idea."

Thereupon began the mission of Womanhood, typing "the spiritual idea of God's motherhood" (S&H 562:6), of which idea Mary Baker Eddy was the revelator to human consciousness. The ascended Jesus had prophesied to St. John merely its symbol as a "woman clothed in light, a bride coming down from heaven" (S&H 561:11), just as the prophets had prophesied the form of Jesus' mission, while he revealed its spiritual idea. Like Jesus, Mary Baker Eddy will "remain unto the end" of Womanhood's completed mission in the Bride (Word) as the boundless "city [consciousness] of our God."

Other significant revisions were made in the second of the editions of Science and Health issued in 1907. One change was the substitution of "Thy kingdom is come" in place of "Thy kingdom is within us" in the Lord's Prayer. This change declared that Mrs. Eddy had completed the last step of Jesus' prophesied Church and that the time had come for the fulfillment of Mrs. Eddy's prophetic statement made at the laying of the corner stone of the second Concord Branch, "...it points to the new birth, heaven here, the struggle over" (*My.* 158:12).

A most interesting and vital change in this second edition of 1907 was made in Mrs. Eddy's interpretation of "And I saw no temple therein." Since this sentence was first added in 1891, in the fiftieth edition, "Love" had been capitalized. Now Mrs. Eddy changed the statement to read, "There was no temple, — that is, no *material* structure in which to worship God, for He must be worshipped in spirit and in *love*" (S&H 576:12). This change had been pre-typed by the humanizing of Life, Truth, and Love in 1904 in the mottoes of the second Concord Branch. The statement, "He must be worshipped in spirit and in love," embracingly forges beyond Jesus' statement, "God is a Spirit: and they that worship Him must worship Him in spirit and in truth" (John 4:24). Thus "love" dissipates the boundary and limits of "truth" as considered separately from "love."

Also, in 1907 "Principle and its idea is [not, 'are'] one" was added to Science and Health on page 465, line 17, suggesting that the time had come for the realization of primitive oneness, which knows no separation between the male and female elements. It was time to go beyond a sense of Church as the marriage of the Bride and the Lamb in heaven, or "Love wedded to its own spiritual idea" — wedding implying twoness — to the composite Bride as the Word that was "in the beginning...with God, and...*was God* [your true Mind, "the kingdom of God within," or as your

230

consciousness]" (John 1:1). Therefore there is no need of ascension or descension.

"Divine Science rolls back the clouds of error with the light of Truth, and lifts the curtain on man as never born and never dying but as coexistent with his creator [his creator is your own real divine Mind, "the kingdom of God within your consciousness"] (S&H 557:18). This eleventh picture "points to the new birth, *heaven here*, the struggle over" (*My. 158:12*).

"In Science *individual* good *derived* from God, the infinite All-in-all, may flow from the departed to mortals; but evil is neither communicable nor scientific" (S&H 72:23-26). Thus it is seen that, even humanly speaking, "God requireth that which is past" to sustain the unified manifestation of man in the present, in order that "the divine idea [which] seems to fall to the level of a human or material belief" (S&H 507:31), may be realized to be the expression of the "man, not of the earth earthly but coexistent with God" (S&H 68:32). This fact is fully seen only in proportion as "human generation ceases," for Mrs. Eddy has told us that "proportionately as human generation ceases, the unbroken links of eternal, harmonious being will be spiritually discerned."

Mary Baker Eddy's mission cannot be defeated. Mrs. Eddy has assured us, "If you or I should appear to die, we should not be dead" (S&H 164:17).

Mrs. Eddy calls the process presented in this eleventh picture "The Way" — not her way, your way, or anyone else's way, but "The Way" in which everyone must walk. In fact this picture portrays the progressive "states and stages" of consciousness which Mrs. Eddy in "The Apocalypse" presents as the way by which the human mind becomes so illumined as to see heaven and earth one.

The first "state and stage" is that of subjective consciousness, "the atmosphere of the human mind, when cleansed of self and permeated with divine Love" (*My.*

231

265:24-28). An example of this state, which Mrs. Eddy calls "a present possibility" (S&H 574:2), is "the spiritual sense" of St. John, "the subjective state by which he could see the new heaven and new earth, which involve the spiritual idea and consciousness of reality" (S&H 573:19-23). This was the state of consciousness in which Mrs. Eddy revealed, "Man is as perfect now, and henceforth, and forever, as when the stars first sang together, and creation joined in the grand chorus of harmonious being" (*Mis.* 188:3), [just as 2X2=4 will be forever perfect].

The second stage involves "journeying 'uphill all the way'" (S&H 574:4) with "vials of wrath and consolation." The ascent of human aspirations is clothed in the "sackcloth" of the cross, as typed by the black birds in this eleventh picture, until it rests at last upon the garlanded cross awaiting heavenly "consolation," heaven's Message of Peace from the white dove. "Think of this, dear reader, for it will lift the sackcloth from your eyes and you will behold the soft-winged dove descending upon you" (S&H 574:25).

The third "state and stage" is the City foursquare, typed in this picture by the descending beam of light, for Mrs. Eddy says, "This sacred city [spiritual consciousness]...that lieth foursquare [the last four-walled step of symbolic church] and cometh 'down from God, out of heaven,' represents the light and glory of divine Science" (S&H 575:7).

The fourth "stage" dissipates the walls of the City foursquare so that the boundless "city [consciousness] of our God" can be attained. "There was no temple, — that is, no material structure in which to worship God, for He must be worshipped in spirit and in love," which encompasses but goes beyond "truth." "The shrine celestial," wherein is no symbolism, or walled idea, is typed by the expanding Light which progresses *beyond* "Truth's fane" where the black birds sing on the garlanded cross, the last step in Church.

In the fifth "stage" the Bride [Word] is declared to be a "spiritual, holy habitation [which] has no boundary or

limit" (S&H 577:12). The Light of this habitation as Bride [Word] is Love; thus the broad beam of Light in this eleventh picture embraces all of the ascending footsteps, even the crown, which types Truth at the highest point of human ascension. This is the beam of love Mrs. Eddy speaks of in her poem "Christmas Morn," — "Thou gentle beam of living Love" (*Poems* p. 29).

Thus this eleventh picture takes the final step of illimitable "Idea" wherein "...you see the whole universe included in one infinite Mind and reflected in the intelligent compound idea, image or likeness, called [generic] man [the Christ], showing forth the infinite divine Principle, Love, called God..." (*My*. 269). As Mrs. Eddy quotes from Pope's "Essay on Man," "All are but parts of one stupendous whole, whose body nature is, and God [infinite good, your true Mind that is your true identity] the soul."

HANNA?:

When Mary Baker Eddy and Christian Science are seen inseparable, then we understand the true meaning of the "Star of Bethlehem." The order of *Christ and Christmas* couples the first picture "The Star of Bethlehem" with the eleventh picture "The Way." When we understand that she has revealed Science, destroyed malicious animal magnetism [hypnotic suggestion, illusion, error], uncovered two-faced ecclesiastical despotism, and revealed to the world the true understanding of the Virgin Mary and Christ Jesus, we are ready to understand and realize the Way in our own experience.

No destruction, lack of motivation, or lamentation can obscure the vision of God's [infinite good's] Church, the structure of Truth and Love. God [infinite Mind, Spirit, Soul, Principle, Life, Truth and Love] and His idea is growing in concord — the unity of the Christ. Whosoever liveth (proves) and believeth (understands) the Christ idea, and acknowledges and understands the two witnesses, the Fatherhood

and Motherhood of God's appearing, shall never die, but have infinite progression. This picture shows us the Way.

The Way of the cross, the cross our Master so lovingly bore, ever leads upward towards the crown of rejoicing. You will notice the cross and the crown need to be understood in our human experience. The cross represents the working out of error, all of the errors we bear, until dissolved through an understanding of the crown. The cross is the overcoming of the false concepts of false manhood, [old theology beliefs] and it reaches forth for the crown of true womanhood—the womanhood that includes manhood—generic man.

The first cross is dark black; it is the mortal, the first degree; but Love's light still shines there to show the Way. Notice that the way is wider at the bottom than at the point of the light. The Way always grows narrower as we reach forward for heaven, the crown of righteousness. It is an upward ascending path. The light of Truth must shine upon mortal mind, in its dense darkness, before it can see out of its maelstrom of misery. The woman has brought the light to the first degree.

In Science and Health Mrs. Eddy says, "The floral apostles are hieroglyphs of Deity." (p. 240) Flowers then are symbols of Deity. The second cross is garlanded with morning glories. Mrs. Eddy says, "I love the symbol of the morning glory with its bright promise of the coming of the light" (Twelve Years with Mary Baker Eddy, p. 157). This second cross is the second degree, the human experience. It is lifted aloft on its way with an adherence to the Ten Commandments which stifle and suffocate the claims of animal magnetism [illusion, hypnotic suggestion, error].

The crown represents the third degree, spiritual understanding. Speaking to Mr. Gilman, the artist of Christ and Christmas, about this particular picture, Mrs. Eddy said, "Now I suggest this picture for you to draw that possesses my thought of 'The Way.'. . . Make the crown still fainter

in form but distinct. Put the top of it in line with the top of the plate, thus giving the thought that all matter disappears with the crown or *crowned thought."*

There is no short cut to heaven. There is only the straight and narrow way; the shortest distance between two points is a straight path. The sufferings of sense with its *materia medica* are depicted on the left of the path. The pleasures of sense, that would take us away from the straight and narrow way, are depicted to the right of the picture.

Notice that the birds form a progression of one, two, three and four flying. The highest bird coming down from the crown, from the third degree, is a dove with an olive branch in its mouth. Mrs. Eddy tells us that the dove is "A symbol of divine Science; purity and peace; hope and faith" (S&H 584).

When Noah sent the doves out into the world, you will remember, there were three of them. The first had to return to the ark for protection; this was symbolic and prophetic of the First Advent going forth into gross materiality, of how Christianity was subverted by the intent of ecclesiastical despotism. The second time the dove was sent out, it returned with an olive branch in its mouth. This is symbolic and prophetic of the Second Advent, Mary Baker Eddy, coming to tired humanity. So the dove in this picture is symbolic of the Second Advent as it has an olive branch in its mouth. The third time the dove went out, it did not return, and is a prophecy of that time when the spiritual appearing of the Christ is universal and generic, and there is nothing from which it needs to be protected, hence it does not return to the ark.

This white-winged dove with the olive branch is the Second Advent, Mary Baker Eddy, bringing the understanding of the Christ from the crown, the third degree, into the second degree, proving the "human and divine coincidence." Mary Baker Eddy is the swift-winged messenger that brought us this precious Science. Notice that some

thoughts, birds, are reaching out for the understanding of divine Science. Others are content to wait and watch, others still see its coming, but don't really care.

In Matthew, we read these words of Jesus, "A wicked and adulterous generation seeketh after a sign; and there shall no sign be given unto it; but the sign of the prophet Jonas." (Matt. 16:4) The word Jonas means dove, and this is the only sign to be given — the sign of divine Science.

Mrs. Eddy tells us, "The loss of earthly hopes and pleasures brightens the ascending path of many a heart. The pains of sense quickly inform us that the pleasures of sense are mortal and that joy is spiritual" (S&H 265:26). To the right of the cross, the pleasures of sense would attempt to take us from the upward ascending path and away from the path that would make us outstanding followers of our Leader. The pleasures of sense would keep you away from the recognition of the swift-winged messenger. If you keep your eye, your perception, upon your Leader's place, you will not get off the Way. The pains of sense that try to make us leave the message of divine Science and seek material remedies, cannot have power in your experience if you do not turn from your Leader. It is a straight and narrow path, and the suppositional serpent [old theology] has many ways to take us from the one Way.

On March 27, 1907, Mrs. Eddy stated: "The disciples followed Jesus up to a certain point, and then deserted him, and darkness followed. Follow the way-shower and you will follow the divine idea; turn away from the way-shower and you turn away from the divine idea, which is like turning away from the windowpane, you turn away from the light. It is not my personality you are following, or that you love. You are being turned from the person to the idea. When this is accomplished, then you will be free — in health — to go and do for the world" (DCC, p. 26)

Gilman records, "The New York critics had written that one objection to the Ascension picture (The Way) was that

the scene was located in Concord, New Hampshire (doubt-less owing to the New Hampshire appearance of the trees). I acknowledged to her that I myself had recently thought of that, having had more time to consider it. 'But,' I said after a while, 'I do not know as we need to go back to Jesus' day in Palestine to represent this thought.' To this she quickly agreed and having been called to lunch some minutes before, she arose and saying to me, 'Lunch is ready,' she extended her hand and took mine and led me like a child into the dining room to the table. 'There is too much looking backward two thousand years. They will find,' she said, 'that there is a Way here in Concord as well as in Palestine.'"

The following is recorded in the handwriting of Laura Sargent. "In order to love God, we must honor and love the Way. How can we love God unless we love His idea which shows us the way and which is the Way; and in order to honor and love the Way, we must have a true sense of the individual through whom the Way has been manifested to us, else we are not keeping the law to love our neighbor as ourself, or doing by our neighbor as we would be done by. . . Our whole salvation rests upon the manner in which we treat her, since the Way comes to us through her, and God [infinite good] demands that we love our neighbor by having the *spiritual* sense of our neighbor, and the spiritual sense of our Teacher and Mother as God's idea that we must love and honor."

The clouds are brighter towards the center and darker on the sides. The Christ light illumines every object. The Son of man is again coming in the clouds with great glory. You will notice that there is neither sun nor moon in this picture or in any picture in *Christ and Christmas* because the Sun and Moon, the greater and lesser light, are clearly revealed by His two witnesses.

You must not sit idly by as if you were a perfect human. Six birds are doing just that as they are sitting on the cross.

You must fly out to reach the white winged dove descending from the crown of glory with her message of Science. Try out your mental wings; they might be stronger than you think.

In *The Christian Science Journal,* September 1886 (p. 133), we read, "He alone ascends the hill of Christian Science who follows Christ, the spiritual idea who is the Way, the Truth, and the Life. Whatever obstructs this way, causing mortals to stumble, fall or faint, Divine Love will remove, and uplift the fallen and strengthen the weak, if only they will forsake their earth weights, and 'leave behind those things that are behind, and reach forward to those that are before.' Then, loving God [Mind, Spirit, Soul, Principle, Life, Truth, Love] supremely, and their neighbor as themselves, they will safely bear the cross up the hill of Science."

Mrs. Eddy wrote in 1907, "What is the way-shower? There is a human and a divine meaning. A way-shower is that which shows the way; it must be some thing or some one. Jesus was the Way-shower, the Christ with him, and if he had not been, where would we be? He showed the way as the masculine idea of Principle, then woman took it up at that point — the ascending thought in the scale — and is showing the way, thus representing the male and female Principle (the male and female of God's creating)."

From "Prevention and Cure of Divorce" (*My.* 269)—

This time-world flutters in my thought as an unreal shadow, and I can only solace the sore ills of mankind by a lively battle with 'the world, the flesh and the devil,' in which Love is the liberator and gives man the victory over himself.

Truth, canonized by life and love, lays the axe at the root of evil, lifts the curtain on the Science of being, the Science of wedlock, of living and of loving, and harmoniously ascends the scale of life. Look high enough, and you see the heart of humanity warming and winning. Look long enough,

and you see male and female one — sex or gender eliminated [only the Adam-dream said man was separate from woman—that manhood is separate from his womanhood—that there were two instead of one]; you see the designation *man* meaning woman as well, and you see the whole universe included in one infinite Mind and reflected in the intelligent compound idea, image or likeness, called man, showing forth the infinite divine Principle, Love, called God, — man wedded to the Lamb, [to all of infinite good] pledged to innocence, purity, perfection. Then shall humanity have learned that "they which shall be accounted worthy to obtain that world, and the resurrection from the dead, neither marry, nor are given in marriage: neither can they die any more: for they are equal unto the angels; and are the children of God" (Luke 20:35.36).

8 new choir robes are currently needed, due to the addition of several new members and to the deterioration of some older ones.

IN SUMMARY OF *CHRIST AND CHRISTMAS*

We have come to the end of the Alice Orgain and Hanna? explanations of Mary Baker Eddy's *Christ and Christmas*. We have seen that these eleven pictures, as Mrs. Eddy informs us, tell the story of her life. It is the story of the Second Coming of the Christ—the fulfilling of Christ Jesus' prophecy and promise of the "Comforter" that would come and reveal all that the people in Jesus' time, two thousand years ago, were not ready for, as they were just coming out of mythology.

Each picture shows that we must learn the truth about ourselves as Jesus and Mrs. Eddy taught and demonstrated. When "the kingdom of God is within you," when it is your own true Mind, we can see why Jesus could teach, "I and the Father [Mind, the divine Principle, Love] are one." Learning that "the kingdom of God is within" us—is our own right Mind, our true consciousness—gives us power with unlimited potential. As Mrs. Eddy writes, "Know then that you have sovereign power to think and act rightly" (*Pul.* 3:7).

We are told that each picture in *Christ and Christmas* represents a part of Mary Baker Eddy's life and of her great revelation of good's allness, and error's unreality.

In the first picture we see the "star of Bethlehem," which is really "the star of Boston." (See *Mis.* 320.) The picture presents the chaotic panorama of Woman's mission to lift up Christianity to oneness with Science. Christianity is typed by man, and Science is typed by Woman. In this first picture the darkness is being scattered as the "star looks down upon the long night of materialism—material religion, material medicine, a material world; and it shines as of yore, though it 'shineth in darkness; and the darkness comprehended it not.' But the day will dawn and the daystar will appear, lighting the gloom, guiding the steps

of progress from molecule outward and upward in the scale of being" (*Mis.* 110). Woman is Science, the revelation with whom its revelator is one.

The second picture presents woman being raised from theological beliefs, beliefs called Christianity. She (Mary Baker Eddy) is being lifted to newness of light in Spirit in response to the call from the kingdom of God active within her consciousness since she was a child.

"Eventually all must learn that good alone is real and nothing inharmonious can enter being, for Life is God [infinite good]. Sometime we shall learn how Spirit, the great architect, has created men and women in Science. We ought to weary of the fleeting and false, and to cherish nothing which hinders our highest selfhood" (S&H 68:4).

The third picture presents the woman, Mary Baker Eddy, sharing her revelation with others. She had seen that humanity can't escape eventually realizing its divinity. She said she saw the love of God encircling the universe and man, filling all space; and that this divine love so permeated her consciousness that she loved with Christ-like compassion everything she saw. "This realization of divine Love called into expression 'the beauty of holiness, the perfection of being,' which healed and regenerated all that turned to me for help" (DCC p. 224).

From this, Mrs. Eddy knew that the final understanding that we are Spirit must come because under the microscope of Spirit matter disappears. In the first and second editions of Science and Health Mrs. Eddy wrote: "At present we know not what we are, but hereafter we shall be found Love, Life and Truth, because we understand them."

The fourth picture presents the crippling effects of renegade students. It shows the opposition of apathy to the woman's vision. This apathy is occasioned by the tendency of the woman's would-be followers to retain old forms and beliefs, and to merely worship the new vision. Christianity must be seen as Science, for the new wine of

Spirit cannot be put into the old bottles of the letter without losing both.

Mary Baker Eddy's divine revelation—that evil is unreal, and that man, being one with his Principle, is therefore free and perfect—is destined to be universally understood and demonstrated. But before this can happen, "the consciousness of corporeality, and whatever is connected therewith, must be outgrown."

The fifth picture presents womanhood rising above the limitations of church and looking for a vision higher than that of the other witness, who is worshipping Christianity. This picture "Christmas Morn" is the healing of the previous picture "Christmas Eve." Mrs. Eddy in 1903 wrote a letter to some students in which she said, "May this dear Christmas season be to you a Christ risen, a morn, the break of day. There is nothing jubilant attached to the birth of a mortal—that suffers and pays the penalty for his parent's misconception of man and of God's creation. But there is joy unutterable in knowing that Christ [our true being] had no birth, and that we may find in Christ, in the true sense of being, life apart from birth, sorrow, sin and death. O may your eyes not be holden, but may you discern spiritually what is our redeemer" (*DCC*, p. 128).

We must recognize Mrs. Eddy's life work as the Second Witness. She brought the Second Coming of the Christ, and fulfilled Jesus' promise and prophecy of the "Comforter," that would reveal all things, all truth.

The sixth picture shows that woman had found her vision in the God-crowned Woman in heaven who must bring forth her own "man child" (manhood) as the truth of her own consciousness.

In a letter to Mr. Gilman, the artist, Mrs. Eddy wrote him regarding this sixth picture:

"Do you know what you have done for yourself, for mankind, for our Cause? No, you do not, perhaps, but I

will tell you. You illustrated and interpreted my life on the plate that you sent me."

Mrs. Eddy once stated, "I am the unresisting channel through which Love shines with its full healing force."

As Elijah passed his mantle on to Elisha, so did Jesus pass his robe on to Mary Baker Eddy, and with a double portion.

The seventh picture's Biblical verse with its poem is a reference to Melchizedek, the priest of Salem, a forerunner of the Christ idea. The true priest is Christ-likeness, the child-like and pure in heart. This childlikeness is the complete opposite of Old Theology, which for thousands of years has been dwelling in darkness, the darkness of false manhood. Witness the dark clothing on the old man. The Bible is closed to this old man. He cannot understand it except through the woman; and she is found in her writings, as being read by the child. The true priesthood is attained to the degree that we approximate the purity of thought of this little one, that is, obtain an understanding of the woman's mission and light.

Mrs. Eddy was able to give us this Truth because, from the time she was just a small child, purity, innocence, and inoffensiveness were expressed in her in boundless measure; and the retention of this purity enabled that consecrated one to give us Science and Health.

The eighth picture presents Mary Baker Eddy knowing that "The Way, The Truth, the Life—His word—are *HERE AND NOW,* as the poem says. "[Her] Christ's silent healing, *heaven heard,* crowns the pale brow," means it causes error to disappear, to fade out. Mrs. Eddy has told us that *Christ and Christmas* is the story of her life. "The pictures refer not to personalities but present the type and shadow of Truth's appearing in the womanhood as well as in the manhood of God..."(*Mis.* 33:10).

The woman in this eighth picture knows that all good is *"HERE AND NOW."* This picture tells of Mrs. Eddy's

custom to take an hour each evening to sit alone and work for the world—to know that "all is infinite Mind and its infinite manifestation." In this picture the written word has yielded to the spiritual consciousness of it, just as when we know the multiplication table, we can close the arithmetic book.

The ninth picture shows us the perfect circle which denotes completeness. In Science and Health we read, "The Lamb's wife presents the unity of male and female as no longer two wedded individuals, but *as two individual natures in one; and this compounded spiritual individuality reflects God [infinite good] as Father-Mother*, not as a corporeal being" (S&H 577).

That statement of Mrs. Eddy's explains Revelation 21:22: "And I saw no temple therein," meaning I saw no mortal corporeal body therein. Our true divine being is the temple, since "the kingdom of God is within [us]"—is our true Mind and consciousness. Mrs. Eddy said Jesus demonstrated this "in his mighty, crowning, unparalleled, and triumphant exit from the flesh"(S&H 117:21). An early worker said that "...when Mrs. Eddy spoke of Christ Jesus it seemed as if time and space, the barrier of two millenniums and two hemispheres, were swept away." The worker added that Mrs. Eddy spoke at this time of her illustrated poem, *Christ and Christmas*. It was evidently dear to her heart.

In this ninth picture Jesus' mission is finished. The woman holds the scroll, the final and complete revelation of Truth to this age and all ages, "CHRISTIAN SCIENCE."

"The truth in regard to your Leader heals the sick and saves the sinner," Mrs. Eddy told Judge Septimus J. Hanna and Edward Kimball.

The tenth picture tells us to get away from sin. Woman [Science] knocks on the door of humanity, asking us to *"Get away from sin,"* "Leave its grasp." In this dark hour, true womanhood pleads to be taken into the hearts of mankind. It wants a practical life, changed by the touch of Love, our

real Mind. Only a false sense of things—illusion, hypnotic suggestion, or what Mrs. Eddy called animal magnetism, keeps us from seeing what we really are as Mind, Spirit, Soul, Principle, Life, Truth, Love, "the kingdom of God within [our consciousness]."

The woman knocking at the portals of humanity is clothed in the third degree. She is the spiritual idea, generic man.

This picture shows that the child-like thought welcomes the truth.

Our Leader conquered all the lies that false beliefs tell about us. Will we follow and do likewise?

The eleventh picture: Here we see the Way, the Truth, and the Life. "You see the whole universe included in one infinite Mind and reflected in the intelligent compound idea, image or likeness, called man, showing forth the infinite divine Principle, Love, called God [our own right Mind, "the kingdom of God within" us as our true consciousness]—man wedded to the Lamb, pledged to innocence, purity, perfection. Then shall humanity have learned that 'they which shall be accounted worthy to obtain that world, and the resurrection from the dead, neither marry, nor are given in marriage: neither can they die any more: [even as 2x2=4 cannot die], for they are equal unto the angels; and are the children of God [of Science]'" (*My.* 269, Luke 20:35, 36). This, therefore, is Christ's plan of salvation from the divorce that took place in the Adam dream.

> The choir invites any member of
> the congregation who enjoys
> sinning to join the choir.

Mary Baker Eddy's Residence in Chestnut Hill.

CONCLUSION

Dear reader, we have now come to the end of this book. We have seen the marvelous, illumined life of our Leader as it was prophesied by Isaiah 54, and as it is unfolded for us in the chapter, Atonement and Eucharist, and throughout her poem, *Christ and Christmas.*

Why is its record important to you?

Because it is not only the story of Mrs. Eddy's life; it also tells the truth about you. Anything that is true about Mary Baker Eddy and about Jesus is, in reality, also true about you.

Mrs. Eddy, the highest expression of the divine idea in human form since Christ Jesus, lived a divinely mental life—infinitely above just a bodily form of existence. Her history is a holy one. She followed Christ in all she did, wrote, and taught, and the love, the spiritual purity and selflessness that motivated her gave her great wisdom. Therefore it is safe to follow her as our forever Leader.

Mrs. Eddy spent forty-four years endeavoring to open the eyes of men to their present divinity. The world was little ready for the divine revelation she was giving it, for only spiritualized thought can perceive spirituality. Few understood *what the enemy was*, or what she taught regarding it.

But this understanding will come. Because of Mary Baker Eddy's teaching, every individual is destined to learn he is Mind, Spirit, Soul, Principle, Life, Truth, Love, and that his body consists of qualities and attributes of these seven synonyms for God. You are incorporeal, divine, but always spiritually tangible and recognizable as were Moses and Elias at the transfiguration scene. The *you* that we see is the tangible, *visible* expression of your *invisible* Mind, Spirit, Soul, the Principle that you are.

There is nothing the carnal mind resists more relent-lessly than the truth, which robs it of its power to procre-ate. But, once chastity and purity are enthroned, the carnal mind's power to maintain itself through corporeal cre-ation—through human birth—will vanish. "Mankind is face to face with the last enemy, human birth," Mrs. Eddy said, "and knows it not." (Preserved by Gilbert Carpenter, Sr.)

"The *real you*," Mrs. Eddy said, "never had a material conception or birth. The real you was not born of the flesh, of mortal mind, illusion, and is not the reflection of mortal beliefs. Your true identity has always been the 'I am that I am'—the *I AM* that God is."

The you that we see is the visible expression of the *in-visible* you—your invisible Mind, Spirit, Soul, the Principle expressed as the visible you.

In *Science of Man*, answering the question: "What is man?" Mrs. Eddy wrote:

"You are not man or woman, you are the Soul [true identity, the Ego, spiritual understanding—you are the Principle, which is Mind, Spirit, Soul, as one, expressing itself as Life, Truth, and Love]; and that which is called man, are the shadows and ideas of you." Mrs. Eddy had just previously said: "You will please remember as the leading points in Science, that man has neither substance nor intelligence, that these belong to Soul [a synonym for God—"the kingdom of God within you, your real Mind and divine consciousness] and that Soul reflects itself in man; therefore man is the reflex shadow of the Soul [of spiritual understanding] and borrows all substance, in-telligence, and life from the Soul [your true divine 'I' or Ego]." In the first edition of Science and Health Mrs. Eddy tells us many times that *we are Soul*.

We learn in Science that spiritual facts have always been; they never were created, just as 2x2=4 never was cre-ated; it has always existed.

How The Healing Is Done

When an individual seeks help from a spiritual healer, the healer is now the patient; as the Bible says, "Physician, heal thyself." So the healer turns to God, Mind, Spirit, Soul, Principle, Life, Truth, Love, and knows that all that God, (infinite good,) is, man is. God, (infinite good) constitutes man's being; "man is the expression of God's being" (S&H 470:23), just as the sunbeam is an expression of the sun or is the sun itself expressed. This is why Jesus could say: "When thou seest me thou seest Him that sent me." So when we see man, we see God or *you*, the creative Principle expressing itself. And, we should heal as quickly as a mathematician heals 2x2=5, meaning instantly. This is why early practitioners who understood the teachings of Mrs. Eddy sometimes had 100 patients a day *and healed them all.*

When the practitioner realizes this, it stops the curse of universal malpractice from operating. It stops the malpractice that says you are a mortal born of the flesh—this is the malediction laid on every human being. Universally we ascribe to ourselves the sins of the carnal mind. When this universal malpractice is removed we see only God's presence.

No matter what error is presenting to us, as practitioners, it is always a matter of "physician, heal thyself." "Error comes to us for life," Mrs. Eddy said, "and we give it all the life it has." We are never face to face with anything except our own ignorance of truth or our understanding of truth. If we miscalculate in arithmetic it doesn't change mathematical reality.

If the hypnotism of the five physical senses causes us to see matter, corporeal bodies, sin, disease, death, we must instantly know that these are not real entities with "life, truth, intelligence [or] substance in matter" (S&H 468:9); and we must know that we are dealing only with our own consciousness, where, in reality, "All is infinite Mind [our

Mind], and its infinite manifestation, for God is All-in-all" (ibid). All we ever need, when anyone calls for help—as Mrs. Eddy is telling us here—*IS TO CORRECT OUR OWN THINKING*. When we "behold in Science the perfect man," then the monstrous lie that we are corporeal bodies instead of divine, spiritual consciousness alone, dies out because it never was other than hypnotic suggestion, illusion. "And by his stripes (his struggle to know the truth about all mankind) ye were healed." Remember, "The Christian Scientist is alone with his own being and with the reality of things" (*Mess. '01.* 20:8). There is nothing "out there" to heal. Even the physical scientists today see that there is no matter, that all is consciousness.

"Objects of sense, when correctly understood, are really ideas of Soul. There are not two groups of creation," Mrs. Eddy told Martha Wilcox, after explaining to her that "when a sense of personality rises up before our thought and makes us think it is something outside and separate from our thought, we must see *it is all WITHIN OUR THOUGHT. If it wasn't, we could not heal a single case.* If it wasn't mental; if it wasn't something *within our thought,* we would have no dominion over it." When "I" know that a patient is God's presence, that knowing is oneness with God; and one with God is a majority.

"This supposititious mortal mind," Mrs. Eddy said, "outlines itself as a belief [illusion] of material personality, with form and conditions, and laws and circumstances—in fact, with all the phenomena that are embraced in what is called material life and personality" (*DCC* p.200). Then she said that not one solitary thing in this whole fabric of supposititious evil is true, and it is up to us to detect that all these mental phenomena are only aggressive mental suggestions coming to us for us to adopt them as our own thought. She said that error comes to us for life and we give it all the life it has.

Our instant reaction to error should be, "God is the only power, the only presence. I am a divine being, now, here; so "get thee behind me, Satan [hypnotic suggestion]."

Understanding is the hinge on which everything turns. Infinite good's creation consists of qualities and formations of divine character which include every spiritual quality and attribute of the Mind that is Love. Once you spiritually understand this, you will no longer believe the lie that you live in a physical body, or have a material personality; but you will realize you have a divinely mental individuality, a spiritual identity, having the consciousness only of good. The time is coming when that "manner of love which the Father hath bestowed upon [you]" (I John 3:1) will be realized. You will then know that the infinite Mind that is God is your Mind; that divine intelligence, infinite good, is your substance, and Love is your Principle.

In everything Mrs. Eddy wrote, it was always your Life—omnipresent, divine Life—that she was talking about. Mrs. Eddy wanted us to see: "I don't have to pray to God for Life, I *am* Life. I don't have to pray to God for Truth, I *am* Truth. I don't have to pray to God for Love, I *am* Love. Jesus proved this, and everything Jesus was we are. He was our example. Mary Baker Eddy wanted you to see that the "I" of you is God. She wanted you to turn to this "I," the kingdom of God within your own consciousness, and listen for its voice so that it can reveal itself to you—*REVEAL TO YOU YOUR DIVINITY*. When this "I" within you speaks, error disappears because it was never there, just as in mathematics, when you comprehend 2x2=4, then 2x2=5 disappears because it was never there. Error is never anything but illusion, hypnotic suggestion.

The vast human illusion constituting the human or mortal mind can only be dissolved by the light of spiritual understanding—the knowledge that "Love alone is Life," and Love constitutes our being.

251

Once this light of divine understanding comes to us, we must continue to study and learn, so that we can see this light embracing all others. No matter what the cost, "sell all thou hast" and pay the price—pay the price of watching every thought. Moses, the prophets, Jesus, the apostles, and Mary Baker Eddy are our examples. Only by watching our thinking to see that it is in accord with reality, do we learn our oneness with infinite good, and realize our "present ownership of all good" (*My* 356:1).

Death is powerless against a correct understanding of the "I" that is God, the "I" that you are—"the kingdom of God within you." This "I" that you are "will never leave you nor forsake you."

Because the kingdom of God is within you, all knowledge of music, mathematics, and every other subject *IS ALREADY WITHIN YOU*. This tells you that you do not learn anything from a book. If you want to learn music or mathematics, you culture your sense of these subjects, you practice what you learn, as you learn it. To a person who knows nothing of arithmetic, giving him a book on that subject would mean nothing to him. But as he step by step begins to learn that 2x2=4, and keeps learning, he step by step can become a mathematician. He can become a mathematician because all of mathematics is already within him. It is the same with music. To give someone who knows nothing of music a Beethoven score, would mean nothing to him; but if he has a deep desire to learn, he can become a musician. It is the same with learning our divinity, our God-being. Jesus said, "Seek ye first the kingdom of heaven, and all these things [—the ability, finally, to do what Jesus did] shall be added unto you." This is why Mrs. Eddy has many references to "learn," "learning." and to "practice."

Christian Science has come to reveal heaven: "Thy kingdom is come: Thou art ever-present" (S&H 16:31)—*I am come; my kingdom of heaven is within me*. I am the temple of the living God. The plane we are now on is the only

plane. Therefore, "Awake, thou that sleepest, arise from the dead; and Christ shall give thee light."*

"In the beginning was the Word, and the Word was God," the Principle of all being. This "Principle" of all being is the "I or Ego" (S&H 588:9-11) of each individual. "There is but one "I or Us," Mrs. Eddy taught. There can be no "Us" unless one sees himself as the One that is one with God. It is only because this "I" is the I of everyone that there can be spiritual oneness. This is also the reason healing can take place, because as the practitioner *sees the truth for his own "I," he sees it also for your "I" since there is only one "I."* "I am that I am," and that "I" is the I of all, of everyone. This is why the Bible says, "Physician, heal thyself," and why "one on God's side is a majority."

It is your "I," your consciousness, that is God. And out of this divine consciousness which you are—as you go to the kingdom of God within—flows spiritual understanding. Today you are gaining the realization of it through an understanding of the Science, the "Comforter" Jesus promised, the Second Coming of the Christ which Mary Baker Eddy brought in her writings.

"The hour is come, the bride (Word) is adorned" (*My.* 125:26). "Come hither," the revelator urges, "I will show thee the bride, the Lamb's wife." (Rev. xxi:9). "Come hither!" Mrs. Eddy repeats, "Arise from your false consciousness into the true sense of Love, and behold the Lamb's wife,—Love wedded to its own spiritual idea" (S&H 575:1-3).

What is the spiritual idea that the bride—the Word (the teaching that Mary Baker Eddy brought in the Second Coming of the Christ) is wedded to? It is wedded to the *spiritual understanding* of all Mary Baker Eddy has written in the Second Coming of the Christ, which includes the teach-

*See Stanford Veira's book: *Awake Thou That Sleepest*. Available from Rare Book Company and Bookmark]

ings of Christ Jesus. Then, as a result of this spiritual understanding, "cometh the marriage feast [your marriage to Life, Truth, and Love, where you find you are Life, Truth, and Love, bodiless bliss], for this revelation will destroy forever the physical plagues imposed by material sense [by universal hypnotic suggestion]" (S&H 575:4).

Mrs. Eddy writes: "Had we the understanding of our God-being or the omnipotence of Truth, we should have no fear of matter [illusion], and having none, our bodies would become harmonious and immortal; a belief of Substance-matter would then give place to the understanding of Substance-Spirit, for the spiritual body is the only real one, and tangible as the material."

What is this "Substance-Spirit" that Mrs. Eddy speaks of, and that St. Paul says is "freely given to us of God" (I Cor. 2:11-12)? This "Substance-Spirit" is "our present ownership of all good" (*My. 356:1*). God [infinite good] has freely given us all that God (Mind, Spirit, Soul, Principle, Life, Truth, Love) is. Our work is to let this great truth awaken us to a spiritual understanding of All good *that is ours HERE AND NOW.*

Don't let worry kill you off—let the church help.

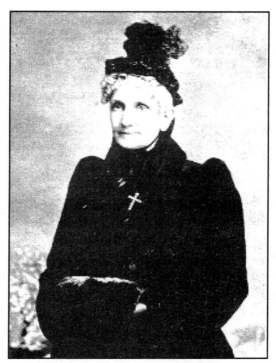

Mrs. Eddy, as she looked about the time of her last class in 1898.

"NEVER ABANDON THE BY-LAWS!"

Pleasant View.

Dictated. Feb. 27, 1903

Christian Science Board of Directors.

 Beloved Students:

 I am not a lawyer, and do not suffi-
iently comprehend the legal trend of the copy you enclosed to me to suggest any
changes therein. Upon one point however I feel competent to advise namely: Never
~~change~~ abandon the By-laws nor the denominational government of the Mother Church. If I
am not personally with you, the Word of God, and my instructions in the By-laws
have led you hitherto and will remain to guide you safely on, and the teachings
of St. Paul are as useful to-day as when they were first written.
 The present and future prosperity of the cause of Christian Science is largely due
to the By-laws and government of "The First Church of Christ, Scientist" in Bos-
ton. None but myself can know as I know, the importance of the combined senti-
ment of this Church remaining steadfast in supporting its present By-laws. Each of
these many By-laws has met and mastered, or forestalled some contingency, some
imminent peril, and will continue to do so. Its By-laws have preserved the sweet
unity of this large church, that has perhaps the most members and combined influ-
ence of any other church in our country. Many times a single By-law has cost me
long nights of prayer and struggle, but it has won the victory over some sin and

(over)

256

WORKS ON CHRISTIAN SCIENCE
BY
REV. MARY BAKER G. EDDY.

325

Address all inquiries to JOSEPH ARMSTRONG, C. S D.
95 FALMOUTH STREET BOSTON MASS

Pleasant View,
Concord, N. H.

(2)

saved the walls of Zion from being torn down by disloyal students. We have proven that "in unity there is strength."

With love as ever
Mary Baker G. Eddy

N. B. I request that you print this letter before our Church is ready.
M. B. E.

The concert held in Fellowship Hall
was a great success. Special thanks
are due to the minister's daughter,
who labored the whole evening at the
piano, which as usual fell upon her.